How ~~to Photograph~~
CANADIAN ROCKIES

by **Darwin Wiggett**

Altitude Publishing
Canadian Rockies / Victoria

Dedication

This book is for my grandparents, Buster and Grace, who introduced me to the Canadian Rockies at an early age.

For more examples of Darwin Wiggett's incredible photography of the Canadian Rockies, be sure to get a copy of *Dances with Light*. It is available at bookstores across Canada. Or get in touch with Altitude Publishing by phone, fax or email. See this page for the appropriate addresses and numbers.

Dances with Light: The Canadian Rockies
by Darwin Wiggett
ISBN 1-55153-230-1
9" x 12" hardcover, $39.95

Copyright 2005 ©Darwin Wiggett

All rights reserved. No part of this book may be reproduced in any form or by any means, electronic, mechanical or digital, without prior written permission from the Publisher.

National Library of Canada Cataloguing in Publication
Wiggett, Darwin, 1961-
 How to photograph the Canadian Rockies / Darwin Wiggett.

Includes index.
ISBN 1-55153-641-2

1. Photography of mountains–Rocky Mountains, Canadian (B.C. and Alta.)
2. Rocky Mountains, Canadian (B.C. and Alta.)
I. Title.

TR660.W54 2005 778'.936711
C2005-900663-3

We acknowledge the financial support of the Government of Canada through the Book Publishing Industry Development Program (BPIDP) for our publishing activities.

Altitude Publishing Canada Ltd.
The Canadian Rockies / Victoria
Head office: 1500 Railway Ave.
Canmore, Alberta, T1W 1P6
1-800-957-6888
www.altitudepublishing.com

Layout & design:
 Scott Manktelow
Editor:
 Jennifer Groundwater

Printed in Canada
by Friesens Printers

Altitude GreenTree Program
Altitude will plant two trees for every tree used in the production of this book.

Front cover top – Moraine Lake and Wenkchemna Peaks at dawn (Mamiya 645 Pro-TL, 35mm lens, f-16, Singh-Ray Warming Polarizer Plus, Singh-Ray 2-stop hard edge grad, Fuji Velvia 50 slide film)
Front cover bottom (left to right) – Spillway Lake and the Opal Range (Mamiya 645 Pro-TL, 35mm lens, f-22, Singh-Ray Gold-N-Blue Polarizer™, Singh-Ray 3-stop soft-edge grad. Fuji Velvia 50 slide film); Strawberry leaves in fall after a frost (Mamiya 645 Pro-TL, 80mm macro lens, f-16, Fuji Velvia 50 slide film); Black Bear on the side of the Icefields Parkway (Canon EOS-1N, 28-70mm lens at 70mm, f-4, Fuji Provia 100 slide film); Fireweed below Mount Crowfoot at Bow Summit from the Num-Ti-Jah public parking area (Canon EOS-1N, 20mm lens, f-22, Singh-Ray 2-stop hard-edge grad filter)
Back cover top – Wedge Pond in the fall (Mamiya 645 Pro-TL, 80mm lens, f-11, Singh-Ray A-13 Warming Polarizer Plus, Agfa RS100 slide film)
Back cover bottom – Wedge Pond in early fall after fresh snow (Mamiya 645 Pro-TL, 80mm lens, f-16, Singh-Ray A-13 Warming Polarizer Plus, Fuji Provia 100F slide film)
Frontispiece – Cavell Lake and Franchere Peak (Mamiya 645 Pro-TL, 55mm lens, Singh-Ray 3-stop soft-edge grad, Fuji Velvia 50 slide film)

Fall colours along Bow Lake (Mamiya 645 Pro-TL, 45mm lens, f-22, Singh-Ray Warming Polarizer Plus, Singh-Ray 2-stop hard-edge grad filter, Fuji Velvia 50 slide film)

Table of Contents

Acknowledgments

Books are more than just words and pictures on a printed page. They represent the cumulative life experience of the author. So many people have touched my life in meaningful ways that it is tempting to list everyone that has helped shape the person I am. Rather than do that — and bore the reader with an endless list of names — let me just say to all those people who have crossed paths with me, thank you for your time and your influence. I really appreciate it.

On a more concrete level, this project could not have been completed without the help of the following people. First, thanks to my wife, Anita, and my son, Alex for their continued love, support, and understanding.

Peter Jeune at The Camera Store in Calgary has for many years supported this poverty-stricken photographer with generous loans of equipment. For this project, Peter went above and beyond his already generous nature. Indeed, without Peter's support this project simply would not have been completed. Not only did Peter provide a high-end digital camera to use for the project, but he also organized all the peripheral equipment necessary for shooting digitally (laptop, power adapters, battery chargers, and software). Thank you, Peter!

I also want to express my gratitude to Bob Singh and Weir McBride of Singh-Ray filters for their long-term support of my photography endeavours. A look at the photo captions in this book is testimony to how much I rely on Singh-Ray filters to help me capture mountain light. I want to thank Anita Dammer, Wayne Lynch, Jim Hutchison, and Mark and Leslie Degner for reading early drafts of this book. Not only did they point out the obvious errors, they also helped the book read much better.

I also want to mention Dr. David A. Boag, my thesis advisor when I was a graduate student in zoology at the University of Alberta. His influence dramatically changed the way I look at the natural world, and his patient editing of my early attempts at writing helped me gain the confidence to put my writing "out there" for general consumption.

Finally, special thanks to Jennifer Groundwater, for her fantastic job at final editing; to Scott Manktelow for design and layout; and to Stephen Hutchings for believing in this idea.

Opposite – Mount Kidd and roadside rock pile at the Reflecting Pools (Mamiya 645 Pro-TL, 35mm lens, f-22, Singh-Ray Warming Polarizer Plus, Singh-Ray 2-stop hard-edge grad, Fuji Provia 100F slide film)

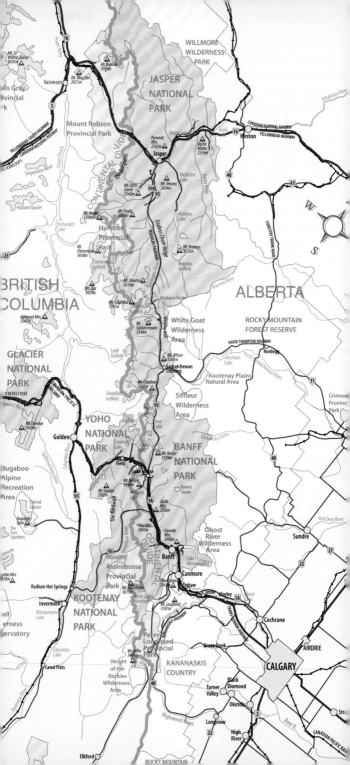

Introduction

Most guidebooks use the introduction to tell readers "how to use this book." Well, there isn't much to say here that isn't self-explanatory to anyone simply thumbing through the book. If you are a novice photographer, or new to photographing mountains, then chapters 1 through 4 will give you the basics of mountain and nature photography. Hopefully, even advanced shooters will gain some insight into the specialized techniques used in mountain photography by reviewing these chapters. Chances are the majority of readers will be more interested in chapters 5 through 10, which describe in detail the best places, times, seasons, and techniques to make great photos in Banff, Jasper, Kootenay, and Yoho National Parks and in Kananaskis Country. If you want to be in the right place at the right time for the best photo opportunities possible in the mountains, then you've picked up the right book.

Most folks who buy this book will do so while visiting one of the Canadian Rocky Mountain national parks. For those of you in this category, just flip to the appropriate chapter, find the location nearest you, and use the information to help you capture some wonderful images. If, on the other hand, you have bought this book in advance of your visit so that you can plan a detailed shooting schedule, relax. Flexibility is the key when visiting the mountains. Often the weather won't co-operate with your planned sunrise location, because it will rain when you want sun, or be clear when you want it cloudy. No matter how carefully you plan in advance, things will change once you get here. My best advice is to "go with the flow." Don't be too bent on getting any single specific shot. If the shot of your dreams depends on a clear sky at sunset, you could easily spend two weeks setting up every evening, waiting for the light. Why waste your entire visit waiting for one shot? Use this guide to figure out where to go when it is sunny or cloudy. If you learn to play with the hand nature deals you, you'll come away with many stellar images.

For those of you wanting to know the absolute best season to visit the Canadian Rockies, it depends on your interests (wildlife, landscape, recreation, or flowers). Here is a brief breakdown of what each season has to offer. I'll leave it to you to decide when it is most appropriate for you to visit the parks.

December through March: This is the prime season for winter landscapes, with abundant snow and low-angled, warm light all through the day. The days are short, so photography rarely begins before 8 a.m. and often ends by 4 or 5 p.m., especially in December and January. For those interested in winter sports photography, there is plenty of opportunity for shooting skiing, snowboarding, snowshoeing, dogsledding, and ice climbing.

April and May: This is the season of transition from winter to spring. Here you can get huge spring snowfalls or extremely mild days when everything melts. The lower elevation lakes become ice-free by May,

Opposite – Map of the Canadian Rockies, from Kananaskis Country to Jasper

while the high peaks are still covered in deep snow; by late May the vegetation in the lower valleys begins to leaf out. This time of year sees few tourists and the campgrounds that are open will often be nearly empty. Only the lower elevation and south-facing trails are snow-free for hiking, and most of the backcountry roads will still be closed, so access to some of the best photography sites can be limited.

June: With fresh green throughout the valleys, and the high peaks still sugar-frosted with snow, June is a splendid month for landscape photography. All the campgrounds and backcountry roads are open by June 15, but the crowds are still relatively thin. Most hotels also offer low-season rates early in the month. This is the best month for spotting bears before they move up into the high alpine. June contains the longest days of the year, when photographers interested in capturing the dawning and waning light of a clear day will be up by 5 a.m. and to bed after 11 p.m. June is also the rainiest month.

July and August: By mid-July, even the high alpine trails are snow-free, and the hiking season begins in earnest. This is also the time for sighting baby animals and for photographing vast alpine meadows coloured with delicate wildflowers. The warm, sunny days of the summer high season also see the return of larger crowds, busier highways, and more expensive accommodation.

September: My favourite month of the year. The crowds are thinning, all the trails and roads are still open, and the scenery and wildlife look their absolute best. The elk are in rut, and fog and mist are common in the mornings, adding atmosphere to landscape photography. September is the driest month of the year, usually offering weeks of superb weather for hiking and photography. It just doesn't get much better than this. Occasionally, you'll even get an early-season snowstorm that coats the fall colours with a white frosting that looks absolutely stunning. If I only had two weeks out of the year to visit the Canadian Rockies, I would pick the last two weeks of September.

October and November: These are the quietest months of the year. It's too early for skiing, too cold for hiking and camping (except by the most hardened outdoorsy types), and the parks are all but empty during these two months. Late-season fall colours, early snowfalls, the bighorn sheep rut, plenty of roadside wildlife, and the crystalline edging of the lakes icing over are the subtle rewards to nature photographers who venture into the parks during this time.

The truth of the matter is this: there is no bad time to visit these parks. Wise photographers will make a point of returning numerous times over the years, each time during a different season, to get the full flavour of these visually stunning natural treasures.

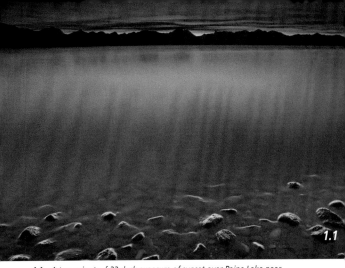

1.1 – A two-minute, f-22 dusk exposure of sunset over Paine Lake near Waterton Lakes National Park, Alberta (Canon EOS Elan, 24mm lens, Singh-Ray 3-stop soft-edge grad, Velvia 50 slide film)

Chapter 1
The Necessary Equipment

Experienced photographers realize it is the photographer who makes images great, not the gear. Give Rembrandt a pack of crayons and he would still create masterpieces. Vision, creativity, talent and skill underlie great photography; your camera and accessories are merely the tools you use to achieve this.

Even so, many novice photographers mistakenly believe that by using "great" equipment, they'll create first rate images. I often hear the comment, "Wow, your pictures are wonderful; you must have a really good camera!" Hidden in this comment is the belief that if they owned the same gear, their photos would be just as good.

For example, while I was making photo 1.1, a man approached and asked what I was photographing. I thought the scene before us spoke loudly and clearly, but rather than explain the obvious, I suggested he look through my viewfinder. His only comment was "Wow! That sure is a great camera you have there!" Meanwhile, dangling around his neck was a camera easily worth twice the value of the camera I was using.

I firmly believe that stunning photography can be made with the equipment you already own. The most important skill needed for fine photography is visualization (see Chapter 2). Buying the latest and greatest gear will not necessarily make you a better photographer; it will just reduce the size of your bank account.

Equipment should only be purchased if it helps you translate your personal vision into a photograph. For example, I most often use a wide-angle lens, a variety of filters, and a sturdy tripod. Various combinations of this equipment help me to create images that show grand expanses of landscape that are tack-sharp from foreground to background, and evenly exposed from top to bottom. Someone else, who

Features to Consider in Buying a Camera

There are as many types of cameras as there are photographers. Great images can be made using almost any kind of camera, from a 100-year-old wooden 4x5 field camera weighing in at dozens of pounds to the latest compact digital marvel weighing in at a few ounces. Again, camera choice is subjective and personal. Listed below are features I consider critical in a camera because of the way I like to shoot. Most of these features either help me produce sharper images or give me greater creative control. These considerations may or may not be important to you.

A Tripod Socket
Having the ability to attach your camera firmly to a tripod opens up a world of creative possibilities not available to photographers who use hand-held cameras, such as subject-motion studies, night photography, and light-painting. It also increases depth of field by making the use of smaller apertures possible. As well, image sharpness improves significantly with the use of a tripod.

Manual Selection of Aperture and Shutter Speed Controls
Because choice of aperture and shutter speed greatly affect the look of an image, I believe the photographer should be the one telling the camera which aperture or shutter speed to use, not the other way around. Programmed shooting modes do not allow for this creative expression.

Exposure Compensation or Manual Exposure Control
Modern cameras do a remarkable job of making accurate exposures. Nevertheless, they still make mistakes, and an experienced photographer will often use exposure compensation or manual exposure override to correct these errors. More importantly, the photographer can use adjustments in exposure for artistic expression. For example, one may wish to portray an image in soft pastel colours, and overexposing the scene can do this. An approaching thunderstorm might look more threatening if the looming clouds are underexposed relative to the camera's recommended setting. In the end, the manual control of exposure is just one more tool that the skilled photographer can use for personal artistic expression.

Depth of Field Preview
With this feature, you can view the actual depth of field (those areas of the scene that are in sharp focus in front of and behind the object on which the camera is focused) as you adjust the aperture of the lens. Without depth of field preview, you can only guess how much of the scene will be rendered sharply at the aperture you have chosen.

Long Exposure Capability
In my opinion, some of the best images of mountains happen in the magical twilight at dusk and dawn. Exposures can easily run from 15 seconds to two minutes. If your camera does not allow such long exposures, you'll miss out on this genre of low light photography (see photo 1.1)

A Cable Release Socket or Self-Timer
Long exposures and tripod-mounted cameras require a cable release or self-timer to trip the shutter button to ensure that the camera does not move or vibrate at the time of exposure.

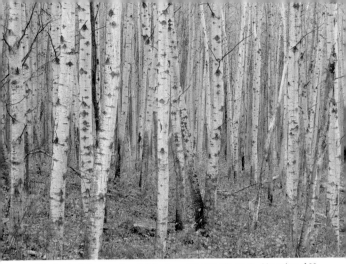

1.2 – Barrier Lake aspen forest, fall colours (Mamiya 645 Pro-TL, 80mm lens, f-22, Fuji Velvia 50 slide film)

shoots in a more interpretive style, might shun the use of a tripod, or prefer a smaller, more portable camera, or use only zoom lenses. Neither approach is better than the other; both are simply reflections of the equipment needs of two stylistically different photographers.

Since I make my living from photography, I select equipment that will give me the highest technical quality possible (image sharpness, size and resolution) at a price that I can afford. Similar equipment might be overkill for many hobbyists, especially if you rarely make an enlargement bigger than an 8x10. The message here is simple: let your personal needs guide your buying decisions. Take the gear recommendations within this book with a grain of salt. What works well for me, or for other professional photographers, may not be the best solution for you.

Besides, chances are you picked up this book for the information it contains on locations; you already have your gear in hand and are ready to go. The last thing you need to think about is buying new stuff (especially when you are already on an expensive vacation.) You make a great photo by going out and shooting, not by agonizing over the specs of the "perfect" camera.

Chapter 2
Learning to See: The Art of Communicating with Light

Cameras record the light falling on a subject in a mechanical and objective manner. Humans, on the other hand, "see" objects with a subjective bias. Our very survival can be hinged on an emotional reaction to the objects in our environment. If the average person were to stumble upon a grizzly bear at close range, he would not immediately notice the sun highlighting the silver-tipped fur on the bear's back. He probably wouldn't register the sparkling of the wet drool moistening its left upper canine. Indeed, he wouldn't even notice that his white T-shirt has created a wonderfully bright sheen to the bear's shaded eyes. These are the things that an experienced photographer might marvel at, even while racing back to the safety of the car. To develop as a strong photographer, you must learn to see things less as "subjects" and more as objects that reflect light.

Learning to see is about understanding light, and how light affects the look of an object. The same subject photographed under different kinds of light can take on hugely different looks. (See photos 2.1a and 2.1b for an example). Talented photographers use their understanding of light to enhance the viewer's emotional response to a subject. In portraiture, for example, men are often photographed with strong, direct sidelight that enhances facial surface texture. Wrinkles, whiskers, chin clefts, and jaw lines become more pronounced with direct sidelight, which amplifies facial features that most of us associate with rugged masculinity. In contrast, when the subject is a woman, she may more often be portrayed as "soft" and feminine. This is accomplished by using diffuse frontlight that tends to flatten and hide skin imperfections while emphasizing colour and tone so that the eyes and lips are enhanced.

Nature photographers can use the same lighting techniques that famous portrait photographer Yousuf Karsh used to create his emotion-filled photos. However, whereas portrait artists can move and vary their lights to suit the subject, the nature photographer must wait until the "right" light comes along. Let's take a closer look at the language of light and how it affects the look of the mountain environment.

The Language of Light
There are three main categories of light on any landscape.
1. Light Quality: Is the light soft and diffuse (e.g., an overcast day), or harsh and specular (e.g., midday sunshine)?
2. Light Direction: Where is the light coming from? Is it coming from the side, the front, or the back of the subject?
3. Light Temperature: What is the colour or temperature of the light? Is it warm, yellow sunrise light, cool blue light at dusk, or the "neutral" light of midday?

The Ramparts in Jasper's Tonquin Valley – 6:00 am, but one day apart.
Left (2.1a) – *Heavy overcast creates a moody blue light.* **Right (2.1b)** – *The rising sun on a clear morning suffuses the peaks and reflection with colour.*
(both images; Canon EOS-1N, 20mm lens, f-22, Fuji Velvia 50 slide film)

1. Light Quality

Light quality can be divided into two categories: diffused and specular light.

On overcast days, the light from the sun is diffused through the clouds. This produces a broad light source that wraps around objects and reduces shadow intensity. Diffused light is often referred to a "soft" light, because shadows are indistinct. Diffused light occurs at times other than under cloudy skies: for instance, at dawn and dusk before the sun lights the landscape, in the shade on sunny days, or in fog. All of these conditions produce soft, shadowless light.

Digital sensors and film love diffused light because it is low-contrast (the range of brightness between light tones and dark tones is compressed) and all tones can be easily recorded. Many photographers prefer diffused light because subjects are evenly lit, and are easy to expose properly. Intimate nature scenes, macro photography subjects, wildlife portraits, flowers, waterfalls, people portraits, and forest scenes often look their best when photographed under diffused light (see photo 2.2). Specular or "harsh" light is produced from a bright, point source of light (in nature, that is the sun) that results in high contrast. Shadows are strongly defined, and the range of brightness between light and dark tones in the scene is extreme — often beyond what film or digital sensors can record accurately. The skilled photographer must understand how the camera records specular light. Generally, the shadows in such light will record in-camera as pure black, while the highlights will record white without detail. The photographer learns to use this high-contrast light and the limited tonal reproduction of film and digital sensors to his or her advantage, to create scenes that are stark and graphic. Alternatively, he or she must learn to manipulate the light in a scene in order to reduce the contrast to levels that film and sensors can record (see chapter 3).

Although specular light is the most difficult to work with and to expose properly, it is also the light with the most drama, the light that

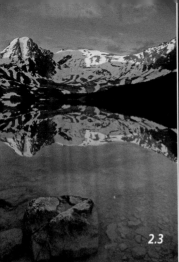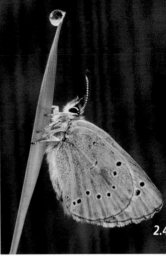

Left (2.3) – Frontier Peak, Mount Robson Provincial Park, BC (Canon EOS-1N, 20mm lens, Singh-Ray 3-stop soft-edge grad, Singh-Ray Gold-N-Blue Polarizer™, 1/2 at f-22, Velvia 50 slide film) Right (2.4) – Front light is used to highlight the pale colours and varied tones of the butterfly with a dark green background. (Canon EOS-1N, 100mm macro lens, 1/15 at f-8, Fuji Velvia 50 slide film)

gives power to the grand mountain vista. Tame the wild beast that is specular light, and you will have a potent tool for dramatic expression (see photo 2.3).

2. Light Direction

Understanding the direction of the light (whether it is coming from in front of, behind, or from the side of the subject) may sound elementary and intuitive, but what many novices do not understand is that light direction has a powerful effect on how the subject looks.

Frontlight

When you shoot with the sun behind you, that is called frontlight. Use it whenever the scene has strong tone or colour. For example, a pink

Film or Digital?

Deciding between a film camera or a digital one is like deciding between a Ford or Chevy, a Mac or a PC, Coke or Pepsi, blondes or brunettes. The choice is highly personal, and what works well for one person may be a bane to another. One type of camera records light on a silver-based piece of emulsion, the other, on a digital sensor. In the end, the results are usually very similar even if the process is different.

I use both film and digital cameras, and my choice depends on relatively minor issues of convenience, cost and circumstances — not on some perceived difference in the end result. Indeed, I challenge you to find any difference between the digital and film images published in this book. The content, exposure, composition, lighting, and point-of-view expressed in a photo are always more important to the success of the image than is the medium used to capture it. Choice of camera type is personal. Don't let the zealots in either camp sway you with their persuasive arguments without first examining your own preferences and requirements.

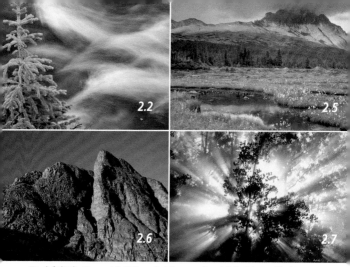

Top left (2.2) – Overcast light is perfect for recording detailed shots of intimate scenes such as this spruce tree in front of a rushing stream. *(Canon EOS-1Ds, 70-200mm lens, 1/3 at f-22)* *Top right (2.5)* – Employ front lighting at sunrise and sunset, when coloured light paints the peaks and clouds in a variety of hues, as seen here in this image of Mount Oldhorn in Jasper's Tonquin Valley. *(Canon EOS-1N, 28-70mm lens, Singh-Ray 2-stop hard-edge grad, 1/4 at f-22, Fuji Velvia 50 slide film)* *Bottom left (2.6)* – Sidelight enhances the rough textures in the mountain environment more than any other kind of light. *(Canon EOS-1N, 24-85mm lens, Singh-Ray A13 Warming Polarizer, 1/8 at f-11)* *Bottom right (2.7)* – Fog in an aspen forest turns mystical under the influence of backlight. *(Canon EOS-1N, 70-200mm lens, 1/250 at f-11, Fuji Velvia 50 slide film)*

flower in a green field would look great lit from the front, as would yellow aspen leaves against a blue sky. In general, frontlight works well whenever the subject has varied tones and colour. (see photo 2.4).

I usually avoid photographing a mountain that is evenly lit from the front. Most mountains are all about texture, and frontlight destroys or degrades texture. In addition, the majority of mountains in the Canadian Rockies are grey limestone slabs devoid of varying tonality and colour. The situation changes at sunrise and sunset, when you do get coloured light. At dawn, the mountain summits are the first to light up, flushing with pink, then red, then orange. As the sun rises higher in the sky, a wash of yellow is the last of nature's morning palette to infuse the peaks. (The reverse order is true for sunset.) If you photograph just the peaks, you'll get textureless orange rock set against a blue sky. Take those same coloured peaks and compose them with an interesting foreground — such as a lake, a river, or a meadow of wildflowers — and you have a recipe of tones and colours that works well with frontlight (see photo 2.5).

Sidelight

Sidelight emphasizes texture. Any subject that has strong texture will look better when photographed in sidelight. Mountains — with their plunging crevasses, hanging glaciers, rocky pinnacles, and boulder-strewn avalanche slopes — are strongly textured landscapes, so they frequently look best when thrown into three-dimensional relief through the use of sidelight. If you want to know where the strongest sidelight is in a scene, face the sun, and then turn 90 degrees away from it. Chances are, the mountains you see in front of you will look

pretty nice if you photograph them from this angle. If you want to reduce haze in the scene, darken the blue sky, or saturate the colours, try using a polarizing filter. Polarizers work best when the light source is at a 90-degree angle to the subject; perfect for sidelit mountains (see photo 2.6).

Backlight
Backlight emphasizes shape and form. The most extreme form of backlight is a silhouette in which the subject shows no colour, detail, or texture at all…just shape. Backlit objects that are translucent (leaves, clouds, feathers, fur, ice) will appear almost mystical, emanating their own luminosity. For me, backlight has the greatest mood and magic of all light directions, because it is so abstract and dramatic. But — and this is an important "but" — backlit scenes are by far the most difficult to expose properly. However, when you succeed, the images can be powerful (see photo 2.7).

3. Light Temperature
Over the course of a day, the colour of light changes dramatically. At sunrise and sunset, the light has a strong, orange-yellow colour, while at dusk it is blue. Midday light appears "neutral" and has no obvious colour cast.

Daylight film is designed to produce neutral colours in midday light. Often, however, the colour in a scene is far from neutral. In this case, our brains make adjustments for the light and "correct" the colour cast. Unfortunately, film does not. Most novice photographers are surprised to discover that shadows are blue, not grey, as our eyes perceive them. One of the skills required by photographers is the ability to see colour casts the same way as film does, and to use these colours to affect the mood of the photo.

Digital cameras offer automatic white balance, where the camera adjusts the white balance of the scene to neutral, just the way our eyes do. This is useful if we want neutral colours (in portraits or product shots, for example), but nature is full of mood, and colour is a key component in translating mood into our photos. For this reason, I recommend that digital cameras be set to "daylight" white balance to take advantage of the changing colour and mood of light.

Your job as a photographer is to recognize how light shapes our subjects, and to use the language of light to communicate with our viewers. When confronted with a scene, your first reaction should not be immediately to pull out your camera. Instead, you should first imagine how the scene in front of you might look under various types of light. For example, you discover a location with a pristine alpine lake surrounded by soaring craggy peaks. How should you photograph this scene? You could come back when the sun is low on the horizon, skimming the rugged peaks with strong, warm sidelight, emphasizing texture. Or maybe backlight might be more appealing, with the peaks silhouetted against a twilight sky and reflected in the calm of the lake. Or how about using frontlight, in which you could capture the first rays of the morning sun painting the peaks orange to contrast with the deep blue colour of the shaded lake in the foreground (see photos 2.8a, 2.8b, and 2.8c).

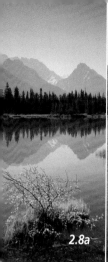 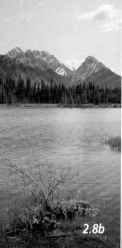 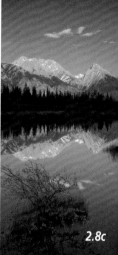

2.8a *2.8b* *2.8c*

*The same scene can look strikingly different over the course of the day, as seen in this series of photos of Spillway Lake in Kananaskis Country taken in the morning (**left: 2.8a**), at midday (**middle: 2.8b**) and at sunset (**right: 2.8c**). (Canon EOS-1N, 24-85mm lens, f-22 for all photos)*

The more understanding you have of the language of light, the more freedom you have to convey a specific subject in exactly the manner you want. You can use light to communicate your moods, your impressions, and your view of the subject at hand. You move from being a documentary photographer to an expressionary image-maker. Therein lies the power of photography as a vehicle of expression, and, to get there, you must know the language of light.

Photo Tip: The Magic Hour

Want to create ethereal images of the Canadian Rockies? Well, forget the comforts of your cozy bed, forgo the tasty tall latte and Belgian waffles, and set your alarm early — really early (as early as 5 a.m. in the summer). The most magical light of the day happens from a half-hour before sunrise to a half-hour afterward. Miss this magic hour, and you miss the best possibilities for memorable photos. In winter, even nature sleeps in, so you might have time for a hearty breakfast before the sun edges its way out of bed between 8 and 8:30 a.m.

On the Alberta side of the Rockies, most views of the soaring peaks are from the east. At first light, the peaks are kissed by the delicate orange and red hues of the rising sun. If clouds fill the sky, they, too, will be suffused with colour. As well, fog and mist are much more likely at sunrise than sunset. These elements can sometimes merge to produce heavenly conditions for photography (see photos 2.1b, 2.3, and 2.5, for example). In addition to the great light, early risers may also be rewarded with active wildlife and no crowds. Even at the most popular scenic overlooks, you'll often be alone, just you and the ephemeral light.

There is an old saying in photography: "f-8 and be there." This means that the best photos are a product of being in the right place at the right time — the technical aspects of the craft are secondary. Get up and out for the mystical hour and you'll be ready at the right time. For the right place, refer to the detailed guidelines in the Photo Locations section of this book.

Chapter 3
Capturing the Light: Essential Photographic Techniques

It's one thing to understand how light affects the look of a subject; it's quite another to learn how to capture that light with your camera. Film and digital sensors "see" light differently than our eyes do.

Imagine a bright sunny day in Banff. You and your friend are sitting on an outdoor patio, having a cold brew and discussing the great photos you took earlier in the day. Your friend wears a Calgary Flames baseball cap. During the conversation, you barely notice that the visor of his cap casts a shadow over his eyes and upper nose. Your eyes can easily see detail in both the shadowed and brightly-lit part of his face, but film and digital sensors can't. An experienced photographer would know right away that making a portrait of your ball cap-wearing friend in bright sun would be a problem. The photographer, knowing the limited abilities of film and digital sensors to see extremes of brightness, has two choices: live with the limits of the camera's abilities, or reduce the contrast to levels that can be captured by the camera. Let's take a look at these choices.

Working with Contrast

In this instance, you accept the light you are given and work with the limitations of in-camera capture. If you set your camera to "auto" or "program" mode, the results will likely be a pretty crummy portrait of your lunch partner. Most cameras will select an exposure that is an average between the bright and dark areas, and you'll end up with a photo in which your friend has pasty, overexposed skin and darkly shadowed eyes. Great if he's trying out for the next instalment of "Jason, Lunch Ghoul of Banff," but definitely not flattering!

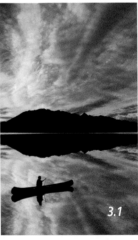

3.1

Here's the dilemma. If you expose properly for his sunlit skin, his eyes will disappear under a deep, dark shadow — very mysterious! If you expose properly for his shadowed eyes, his sunlit face and the background will disappear in a sea of white overexposure — very ethereal!

3.1 – By exposing for the brightly lit sky, the mountain and canoeist become silhouettes, creating a stark, graphic image. (Canon EOS-1N, 20mm lens, f-11, Singh-Ray 2-stop hard-edge grad over sky portion of image, Fuji Velvia 50 slide film)

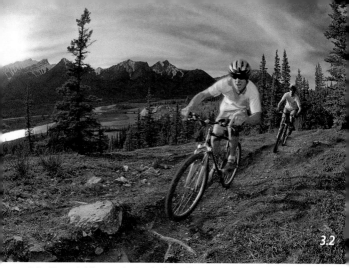

3.2

3.2 – Mountain bikers on the Overlander Trail in Jasper. I used flash to fill in light on the shadowed side of the face of the lead biker. To keep the flash from killing the shadows and ruining the natural look of the light, I underexposed the flash by 1 1/2 stops using the flash exposure compensation dial on my camera. (Canon EOS-3, Canon 550EZ flash, 15mm fisheye, f-8, Kodak Supra 100 print film)

The point here is that, under high-contrast light, you can't have it all. Something's got to give.

The same rules of contrast apply to nature photography. In high-contrast light, you can't maintain detail in dark shadows and bright highlights at the same time. So, as the photographer, you must decide whether highlight detail or shadow detail is most important (see photo 3.1). Imagine a hormone-charged, six-point bull elk bugling on a hillside, silhouetted against a bright blue sky but in the shadow of a nearby mountain. Expose for the sky, and the elk becomes a black outline against a blue background — pretty cool! Expose properly for the elk, and the sky becomes pure white, without detail — very stark and appealing. In this case, you have taken the limitations of in-camera capture and used these limitations to your advantage to create a graphic representation of nature. Neither photo is what the human eye sees, but each makes a valid photograph.

Manipulating Contrast

Meanwhile, back at lunch, your friend is on his third cool one and he simply refuses to take off his baseball cap. (Didn't his folks teach him any manners?) How can you possibly get a decent shot that shows detail on his bright face and at the same time in his shadowed eyes? There are only two possibilities: either to increase the amount of light to the shadows, or to decrease the amount of light to the highlights, until the contrast between the two extremes is within the range the camera can manage to capture.

Adding Light to the Shadows

The easiest way to add light to the shadows is to use flash. Pop a flash on the camera, put the camera on "program" mode and voila, you have detail in the shadows — sometimes way too much detail! To use flash more subtly, you'll need to reduce its exposure to a point where

it fills in light to the shadows but does not create that harsh "deer in the headlights" look (complete with glowing red eyes). Most modern camera systems have flash that can be set with exposure compensation. Often it is as simple as dialling in one and a half or two stops less exposure (–1 1/2 or –2 exposure compensation) to the flash. Refer to your camera manual for details on flash exposure compensation.

In nature photography, flash can often look contrived, so I try to avoid it at all costs (unless I want to create a distinctly "artificial" look on purpose). But other nature shooters use flash to great effect to add highlights to the eyes of wildlife, to fill in foreground detail in landscapes, and to create strong macro images. The point here is that flash is a very useful tool to use to even out exposure extremes by kicking light into the shadows (see photo 3.2).

Another way to add light to the shadows is with a reflector. A reflector can be anything that reflects light onto a subject, from a white t-shirt or the lid of an aluminium garbage can to a professional collapsible photo reflector. Back at the restaurant patio, you can kick light onto your friend's face by having him sit near a white wall, or by using a white plate to direct light under his baseball cap. Reflected light looks more "natural" than fill flash (unless the latter is handled skilfully) and is a powerful tool for nature photographers. In macro and close-up photography, anything from crumpled tinfoil to a small hand mirror can be used to brighten shadows effectively (see photos 3.3a and 3.3b).

Flash and reflectors are the most common ways of adding light to brighten shadows, but any light source can be used. I have successfully used flashlights, car headlights, camping lanterns, streetlights, and even road flares. Anything that emits light can be used to fill in shadows. Often the results will be otherworldly, but just as often the effect can be aesthetically pleasing (see photo 3.4).

Subtracting Light from the Highlights
Back on the patio our baseball-capped model munches away at lunch. You pretend the heat is getting to you. "Gee, this sun sure is hot!" You ask the waiter to move you to a table in the shade. In doing so, you have succeeded in reducing the contrast range of the highlights relative to the shadows to a range recordable in-camera. In effect, you have put the highlights in shadow, too.

In nature photography, you can also manipulate the highlights by putting them in shadow. In macro photography, it's easy to cast your shadow over a subject on a sunny day, and doing so will often improve your photos (see photos 3.5a and 3.5b). However, keep in mind that shading a subject will give the image a blue cast. This is most noticeable when using slide film. To correct the blue cast, try using a warming filter over the lens if using film (e.g., an 81C filter is my favourite). If shooting digital, try dialling in the "cloudy" or "shade" setting for the white balance to counteract the blue cast.

Another method of reducing the brightness of the highlights is to diffuse the light source. In the studio, a photographer can make the light more diffuse (softer) by adding a softbox or large studio umbrella to the flash. In nature, diffusing the light is more difficult, but it can be done. For example, you could use a piece of white cloth or a commercial diffuser to soften the highlights in a macro or close-up shot.

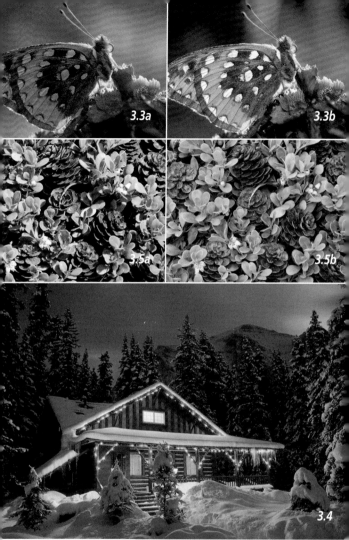

Top (3.3a and 3.3b) – In **3.3a (left)** the front side of the butterfly is in shadow, and although there is detail in the shadows, we could use a reflector to help brighten things up. In **3.3b (right)** I used a crumpled piece of tinfoil to add light to the shadowed side of the butterfly. (both images Canon EOS-1N, 100mm macro lens at f-8, Fuji Provia 100F slide film)

Middle (3.5a and 3.5b) – Pinecones and bearberry shot in open sun. The range of tones in **3.5a (left)** is too extreme for the camera sensor to record both dark and light tones with detail. In **3.5b (right)**, I cast the shadow of my body over the scene, reducing the contrast range to a level recordable in-camera. (Canon EOS-1Ds, 100mm macro, f-22)

Bottom (3.4) – This cabin at Lake Louise looked wonderful when lit with Christmas lights at dusk. Unfortunately, the lights were not bright enough to illuminate the porch area of the cabin fully. Master photographer Daryl Benson recognized that there would be dark shadows, so he strategically hid several Coleman lanterns on the porch of the cabin. Then the photographers under Daryl's tutelage simply waited until the brightness of the lit cabin was equal to or slightly brighter than the ambient light. (Mamiya 645 Pro-TL, 45mm lens, 8 seconds at f-8, Fuji Velvia slide film)

3.6 – Photographers using "light tents" on close-up subjects. I don't recommend these as tools to use in nature photography, because not only is a light tent a pain to lug around, setting one up can damage the vegetation around your subject. If you want diffused light, wait until nature gives it to you. Light tents have no place in national parks. (Canon AE-1P, 50mm lens, Fuji RDP 50 slide film)

Photo Tip: Use a Map, Compass or GPS for Better Photography

By now you recognize that good photography is all about putting yourself in the right place, at the right time, for the light that is most appropriate for the way you want to portray your subject. Now, how do you get there? The most important tools I have in my arsenal of photo equipment are not lenses, tripods, or filters, but rather topographic maps and a compass (and, more recently, a GPS).

Whenever I plan a visit to a new area to do photography, the first thing I do is purchase a topographic map of the region. Most bookstores, gift shops and convenience stores in the Canadian Rockies stock detailed topographic maps of the parks and regions covered in this book. My favourites are the maps published by Gem Trek Publishing. These maps full of useful information about roads, trails, and landmarks; I find them indispensable for planning where and when I will visit a specific location. For example, by looking at the contours and orientation of mountains, lakes, streams and ponds, I can decide if a location

is probably best at sunrise, midday, or sunset, based on my knowledge of how different types of light in general render a scene. In fact, many of the locations described in this book were first scouted on a map and then later visited in person at the optimal time for shooting. A map is also helpful for naming the peaks, creeks, lakes and rivers that you are photographing.

I supplement my map use with a compass or GPS while on location to determine exactly where the sun will rise or set in a given location at a given time of the year. Often, based on the compass or GPS readings, I'll know precisely when a specific location would most likely be worth visiting. Learning to use a map and compass takes some skill and knowledge, but it's definitely worth doing, especially if you are serious about landscape photography. Fortunately, for the Canadian Rockies, I have already done the work for you. Each location listed in this book tells you the best time of day to visit for the optimal light. All you need to do is show up and shoot!

Unlike shade, diffused light maintains the lighting direction and colour cast inherent in the scene but at a level recordable in-camera.

Some macro specialists use "light tents" made of white plastic to diffuse the light in their macro scenes (photo 3.6). Not only are these miniature greenhouses great for lighting, but they also work well for blocking wind. And they work even better for collecting heat; fifteen minutes in one of these babies and you'll be sautéed! The best solution, if you want diffused light, is to wait for it. Wait for a cloud to block the sun, or wait for an overcast day. I simply couldn't imagine what would happen to a meadow of wildflowers if every photographer traipsed out there with a personal light tent. Even though some tools of photography work well, it behooves us to use those that damage the environment the least.

The final mechanism of subtracting light from the highlights is through the use of camera filters. Surprisingly, many photographers think filters are only useful for "faking sunsets" or adding special effects to images. For me, filters are as necessary in my photography as a camera, lens and tripod. Let's look at the use of filters in mountain photography, and how these filters help reduce the brightness of the highlights.

Filters — In-Camera Light Modifiers

The Polarizing Filter

In my opinion, the polarizer is the most important filter for landscape photography. Many photographers know that a polarizer is useful for making blue skies richer and for removing reflections from glass and water, but a polarizer does so much more. Even on overcast days, a polarizer has strong effects. It won't turn a grey sky blue, but it will help to saturate the colours in the scene by removing glare from reflective surfaces. For example, on overcast days every wet leaf, blade of grass, and stone reflect light from the overcast sky. These reflections mute the colours significantly. Adding a polarizer will tone down these bright highlights and increase colour saturation. Simply screw a polarizer onto your lens and spin it around, and you will see the colours intensify. Try photographing such a scene with and without the polarizer, and you will see an amazing difference in the final photos (see photos 3.7a and 3.7b).

Using a polarizer is easy: just screw it on your lens, look through your viewfinder, and then rotate the filter until you see the effect you want. Sometimes, you won't see any change as you rotate your polarizer. This happens because polarizing filters only work when the light is perpendicular to the direction your camera is pointed. If the light is behind you — or if you are shooting directly into the light — a polarizer has no effect. But if the light is to your right or left side, or directly overhead (midday sun or overcast light), the filter will work its magic, removing reflections, darkening blue skies, cutting through haze and saturating colours. This is one filter you've got to have! (see photos 3.8a and 3.8b for a comparison of a sidelight image shot with and without a polarizer).

Most polarizers have a slightly blue colour cast to them. Although they saturate colours, they often leave a noticeable bluish pall to the photo. This is especially apparent in slide film (as opposed to print

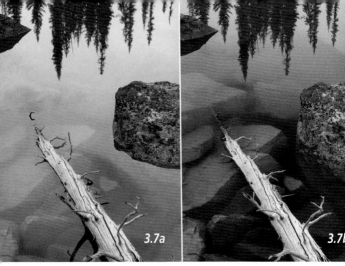

*This scene was photographed in overcast light without (**left: 3.7a**) and with a polarizer (**right: 3.7b**). The increase in colour saturation through elimination of reflective glare is the obvious benefit of using a polarizer. (Canon EOS-1Ds, 28-70mm lens at 53mm, f-22)*

film.) To avoid getting the blues, look for a "warm-toned" polarizer, which combines a warm (slightly yellow/red) filter with a polarizer. These combo filters are wonderful. My most-used and favourite filter is definitely the Singh-Ray Warming Polarizer Plus (www.Singh-Ray. com). Other companies — such as Heliopan, Tiffen, and Hoya — also make warm-toned polarizers.

Love it or Hate it — The Blue-Yellow Polarizer

This is one special effects filter that people either love or hate. Originally developed by Cokin, this filter is a combination polarizer that colorizes reflective highlights in a scene either metallic blue or yellow/ gold while adding an overall warm colour cast to the whole photo (see photos 3.9a and 3.9b).

When I first got the blue-yellow polarizer (Cokin 173), I was blown away by what it did to a scene: everything reflective transforms magically to contrasts of yellow and blue. I shot almost everything with this filter! But now, I am much more selective in its use. There are times when this filter verges on magical, producing images that are transcendent in quality (compare photo 10a with photo 10b). Many times, though, the results just look "gimmicky." Often, if I am not sure how a scene will respond to polarization, I will shoot three versions of the scene, one without a polarizer, one with a polarizer and one with the blue-yellow polarizer. Once I see the completed images, it becomes easy to choose the version I like best (see photos 3.11a, b, and c).

If you want to try this filter, the Cokin versions are available at most camera stores and are relatively inexpensive. I recommend the P-series size (much bigger than the more common A-series) because it is less likely to vignette (be partially visible in the picture frame causing darkened edges to the photo) when you're using wide-angle and zoom lenses. Your local camera store can set you up with the filter, a filter holder, and an adapter ring for your lenses. The Cokin P-series holder is becoming something of an industry standard — other manu-

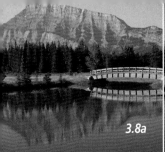

Cascade Pond in Banff photographed under strong directional sidelight without (left: 3.8a) and with a polarizer (right: 3.8b). Besides a boost in saturation and a reduction in tonal range, the warming polarizer used here also diminished the blue cast seen in the original photo. (Canon EOS-1Ds, 24-85mm lens at 48mm, f-11)

Photo Tip: How to Create Killer Silhouettes

No, I am not talking about the knife-wielding shadow in the shower scene of *Psycho*, but rather strong silhouettes of iconic mountain subjects (elk, hikers, climbers, sheep, and mountains).

1. First, you need a simple, bright, and preferably colourful backdrop (a sunset sky, brightly lit mountain peak, sparkling water, or a cascading waterfall).

2. Next, you need a graphically strong subject for the foreground, either one that is backlit by the sun or one that is shadowed from the sun, but set against a background that is brightly lit. For people silhouettes, try to avoid baggy clothes and overlapping limbs, as it is easy for silhouettes to be unreadable if one body part merges with another.

3. Third, you need to expose the background properly. I recommend using the spot meter setting in your camera to meter the background only. Most silhouettes look best against a bright backdrop, so I recommend overexposing the background one stop more (+1 exposure compensation) than you would normally select. If your camera does not have a spot meter, take a tight reading of only the background without the main subject in your frame. Add +1

in exposure compensation to whatever your meter says is the proper exposure, and lock this exposure on your camera.

4. Recompose and shoot your subject against the bright background. Silhouettes work best if they fill no more than 50% of the picture area. A frame-filling silhouette contains too much dark area relative to light, and often feels visually "heavy."

5. If you have time, try various exposures around the one stop (+1 overexposure), especially if using film. Sometimes even more overexposure will help add "airiness" to the image, while other times using the camera's meter recommendation will give stronger, more saturated colours to the background. I will often shoot a series of four exposures (one at the camera's meter reading, and then three more at +1/2, +1, and +1 1/2 exposure compensation).

6. Finally, reap the rewards of your photographic talent. It seems a well-crafted silhouette is always a crowd pleaser. Everyone will wonder, "How do you get that shot?" Only you will know how easy it really was! Sure beats the old method I used to use: a black cardboard cutout of an elk propped against every sunset.

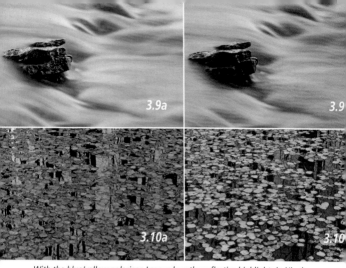

*With the blue/yellow polarizer, I can colour the reflective highlights in Nigel Creek metallic blue **(top left: 3.9a)**, or warm gold **(top right: 3.9b)** simply by spinning the polarizer around on the front of my lens. (Canon EOS-1N, 70-200mm lens, f-22, Singh-Ray Gold-N-Blue Polarizer™, Fuji Velvia 50 slide film) These aspen leaves in a pool of rainwater under cloudy skies look pretty mundane when photographed without filters **(bottom left: 3.10a)**. Pop on a Cokin Blue/Yellow polarizer and the scene bursts into life **(bottom right: 3.10b)**. (Canon EOS Elan, 80-200mm lens, f-22, Fuji Velvia 50 slide film)*

facturers are making filters that fit into this smart "one-holder-for-all-lenses" system. The Cokin filter holder system allows you to use the same filters on all your lenses, no matter what the size of your front lens element (up to 82mm front-thread diameter).

If you find you like the look of the Cokin Blue/Yellow polarizer, but you want professional quality sharpness, the answer is Singh-Ray's Gold-N-Blue™ Polarizer. Cokin's version works well on lenses in the 20mm to 85mm range, but with longer lenses you definitely start to see a loss in image sharpness. With the Singh-Ray filter there is no sharpness loss with any lens used. However, there is a price for quality, as the Singh-Ray version is about three to five times more expensive than the Cokin version.

Digital cameras do not like the blue-yellow filters. It seems the effect of the filter is greatly exaggerated with these cameras, even when they are shot using "daylight" white balance. The filter not only colours reflective highlights gold or blue, it adds a strong warm, yellowish cast to the rest of the scene; something that film likes but digital sensors hate. It takes some knowledge of photo manipulation software to get a blue-yellow shot on a digital camera to look like the film version.

Grad Filters — Necessary, If a Bit Complicated

In my opinion, graduated neutral density filters — also known as grads — which began to be commonly used in landscape photography in the 1980s, have revolutionized landscape photography. (Now, of course, computers and digital cameras are causing another photographic revolution.) Often, the sky is so much brighter than the land that film or digital cameras have a hard time retaining details in both areas of a scene. Grad filters were created in response to this problem. These filters are half clear glass (or optical resin) and half neutral (e.g.,

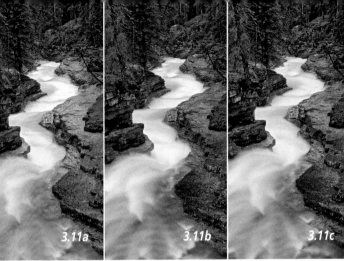

3.11a 3.11b 3.11c

These three photos of Beauty Creek in Jasper show how different the same scene can be rendered by using no filter (left: 3.11a), a warm-toned polarizer (middle: 3.11b) and the Cokin Blue/Yellow polarizer (right: 3.11c). (Canon EOS-3, 28-135mm lens, f-16, Fuji Velvia 50 slide film)

grey) glass of varying density. With a grad filter, both a bright sky and a dark foreground retain proper detail. Without a grad filter, the same photo may have a bald, washed-out sky (see photos 3.12a and 3.12b).

There is a trick to using these filters. First, you must realize that grad filters really only work well with wide-angle or normal lenses (e.g., anything shorter than 80mm). Second, you will need a Cokin holder — available at most camera stores — to hold the grad in place (photo 3.13). Once the filter is on your camera, look through your viewfinder and pull the grad up and down in its holder until the feathered transition between grey and clear glass meets the transition between the sky and the land. You want the transition zone on the grad to blend into the horizon line. This is easier on the prairie than in the mountains!

For precise placement of the grad line, you'll need a camera that has a depth of field preview button. Make sure your camera is set at the aperture at which you desire to take the photo. Keep in mind that smaller apertures give a harder edge to the grad filter's transition zone. Press your depth of field preview button and wiggle the grad filter in the Cokin holder until you see the grad line, then place the filter line precisely where you want it to blend (e.g., on the horizon, over a reflection, or where light and shadow meet). Deciding which type of grad filter (see below) and which density to use takes some practice, but the efforts are well worth it.

For pros and serious amateurs, Singh-Ray makes two main versions of grad filters for different types of scenery (see photo 3.13). One has a hard-edged transition zone, and one has a soft-edged transition zone. For example, I use hard-edged grads where the horizon is defined (e.g., photos 3.12a and 3.12b) and soft-edged grads where it isn't. A perfect place to use soft-edged grads is on reflections shots of mountains in lakes. Pull the dark part of the grad over the sky and mountain and the feathered transition down over the reflection. In this way, the darker part of the grad filter is over the brighter sky and mountain while the feathered part dims the reflection a tad and leaves the foreground

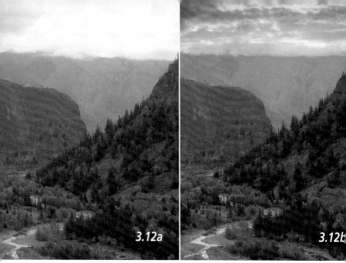

These two images show how effectively grad filters can be used to rein in bright skies. No filter was used in **3.12a (left)**, and a 2-stop hard-edge grad was used in **3.12b (right)** to darken the sky. (Canon EOS-1N, 28-70mm lens, f-16, Fuji Velvia 50 slide film)

water rich with detail (see photo 3.14a and 3.14b).

Grad filters come in various strengths where the darker part is from one to five stops darker than the clear part. I have a set of six grads that meets 90% of my needs. These are Singh-Ray's one-, two-, and three-stop hard-edge, and the one-, two-, and three-stop soft-edge neutral density grad filters. I often combine two grads (e.g., a two- and a three-stop filter) to give me more strength to dim strongly backlit landscapes at sunrise and sunset. This combination lets me have a fiery sky combined with a detailed and properly exposed foreground. Without the grad filters, the foreground would be black or the sky white on film.

To determine which strength filter to use, first, meter the foreground, then meter the sky. Calculate the difference in f-stops between

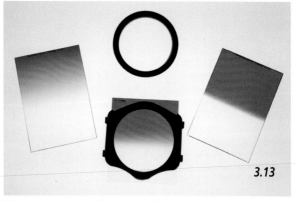

3.13 – In the centre is a Cokin P-series holder with a Cokin P121 grad filter. Above the holder is a lens adapter ring to attach the holder to a lens. To the right is a Singh-Ray 3-stop hard-edge grad, and to the left a Singh-Ray 3-stop soft-edge grad.

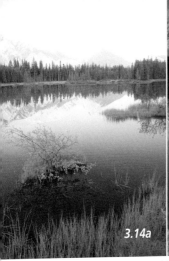
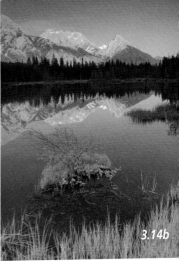

*In **3.14a (left)** the image was exposed for foreground detail, but the bright mountains became washed out without help from a grad filter. A 3-stop soft-edge grad (**right: 3.14b**) was necessary to reduce the brightness of the mountain and its reflection to levels similar to that in the foreground grasses. (Canon EOS-1Ds, 24-85mm lens at 35mm, f-22)*

the two areas (e.g., three f-stops). Whatever the difference is, use a grad filter that is one f-stop less than this difference (in this case, a two-stop filter) or your skies will look too dark and phony. If this sounds like higher math, it is! The alternative is to take one photo with each density of grad filter you own and then pick the best exposure at home or on the digital camera preview screen. With a little practice, you'll soon know instinctively which strength filter is best to use.

For beginners, I recommend the Cokin series of grey (neutral density) grads. These are "medium-edge", come in one- and two-stops of density (P120 and P121 respectively), and are good, general-purpose filters that will help you decide if grad filters are for you. If you shoot lots of sunrise and sunset photos, or like to shoot in mixed light where part of the landscape is in shadow and part in light, or have lots of big skies in your photography, then grad filters will make your images much stronger. If, on the other hand, you are a sunny, blue-sky shooter, a polarizer is the only filter you might need to consider.

Some digital shooters suggest that they do not need grad filters, as they can simply expose one for the foreground exposure, and another for the sky. Later, at the computer, they can merge the two different exposures for one perfect image. I agree you can do this, but I would prefer to capture the image with my camera as perfectly as I can, so that I can spend less time at the computer. Merging two exposures requires some expertise in photo software, requires that each image is in perfect register (shot on a tripod, with no camera or subject movement between exposures), and takes valuable time in the digital darkroom. The more you can perfect an image in-camera, the better, so grad filters continue to have an important place in my camera bag.

Multiple Filters for Total Highlight Control

Often, I end up using both a polarizer, to cut the brightness of reflective highlights, and a grad filter, to hold back brightness in the sky and mountain peaks at the same time. This filter combination allows

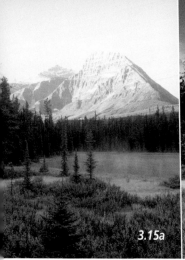
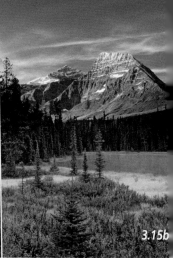

Left (3.15a) – A warm sunrise lights Mount Fryatt in Jasper, but the contrast is so extreme that what I saw before my eyes couldn't be captured in-camera. So out came my "secret weapon", a polarizer and a grad filter used in combo to reduce the brightness of the highlights relative to the shadows (foreground).

Right (3.15b) – I used a Singh-Ray Warming Polarizer Plus to reduce reflective highlights on the mountain and the foreground vegetation and to add overall warmth to the image by counteracting the blue cast. Over this I used a Singh-Ray 3-stop hard-edge grad pulled down over the mountain to the tree tops to reduce the brightness of the sunlit sky and the mountain further. The result is a photo that more closely represents what my eye could see, but what the camera couldn't record. (Canon EOS-1N, 20mm lens, f-22, Fuji Velvia 50 slide film)

me to produce images in-camera that would be almost impossible to capture otherwise (see photos 3.15a and 3.15b), and is my "secret weapon" for stunning mountain imagery.

With the Cokin filter holder, you can easily hold a grad filter and a polarizer at the same time and adjust each filter to give you the perfect in-camera highlight control tool. Some photographers use duct tape rather than a Cokin holder to hold multiple filters over the lens. This latter approach works when you might need multiple grads at different angles for precise tonal control. Whatever means you use to get the filters over your lens, grad filters and polarizers are wonderful tools for controlling the brightness of highlights in your photos. If you have never tried them, might I suggest you give them a spin?

By now you have learned that much of capturing light in-camera is about contrast control and manipulation. Because our eyes see a much wider range of light and dark than film or digital sensors, we must either work with the limitations of the recording media, or manipulate the light to suit the media. Once you realize that cameras "see" light differently than the human eye, you can use this understanding to capture images that represent scenes more the way the eye sees them. Doing so will make your imagery more powerful and appealing.

Chapter 4
Designing the Picture Space: Simple Guidelines for More Effective Compositions

Have 10 photographers set up on the same scene and you'll get 15 different compositions (or more!). How you organize the subject and supplemental elements of a scene within the borders of your photo is a very personal endeavour, and not one that can be dictated by a rigid set of rules. Indeed, the composition and design of a photo is often the defining stylistic component that sets one photographer apart from the crowd. It is a vehicle of personal expression where there is no right or wrong, only interpretations. However, there are general compositional guidelines that, when followed, produce images that communicate more strongly with the viewer. The four most common mistakes of beginners are: no clearly defined centre of interest, too small a subject in the frame, too much clutter in the photo, and the subject too small in the frame. Below are some compositional rules or guidelines designed to overcome these shortcomings.

No Clearly Defined Centre of Interest
"Honey, what is this supposed to be a photo of?" If you hear this, then your composition has no clear centre of interest. Nothing will bore a viewer faster than an image that appears to have no topic. Just because *you* know what the shot was supposed to portray does not mean others will. A well-defined centre of interest will solve this problem.

"Wait," you say, "That shot was a picture of a forest; there is no centre of interest in a forest; it is a picture of a bunch of trees. Isn't that obvious?" When we talk of a subject like an elk or a flower, there is an obvious, simple, single centre of interest we can place anywhere in the frame. With a landscape scene, there are multiple "subjects" that must be organized so that our composition leads the viewer's eye through the frame in structured manner, so that the whole image is the subject — not just a single element within the frame (compare photos 4.1a and 4.1b). Sound complicated? Well it isn't, really, if we start simply and work our way towards more complex compositions.

Subject Too Small in the Frame
Is the subject too small in the frame? The surest way to better compositions is to fill the frame with the subject. Get closer, and, when you think you are close enough, get closer again. By filling the frame with your subject, you'll make it obvious to the viewer what the photo is supposed to be about. In photo 4.2, the viewer is not sure if this is supposed to be a photograph of a deer or a photograph of a deer in the forest. As presented, the photo is confusing.

Too Much Clutter
All too often, the backgrounds in photos have far too much clutter, stuff in the frame that serves no purpose but to distract our eyes away

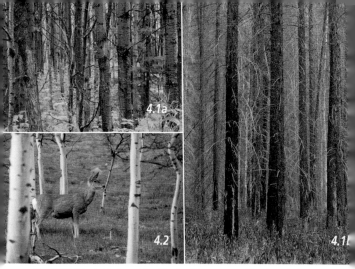

Top left (4.1a) – A poorly composed image. Viewers may not be clear what the photographer is trying to show. (Canon EOS-1Ds, 24-85mm lens at 85mm, 1.0 second at f-20) Right (4.1b) – This image is more clearly about a forest, since the composition has focused on the strong graphic lines of the tree trunks. (Mamiya 645 Pro-TL, 150mm lens, f-22, Velvia 50 Slide film)
Bottom left (4.2) – An image showing the most common compositional errors of novice photographers. (Canon AE-1P, 50mm lens, f-4, Fuji RD50 slide film)

from the main subject. Clutter will be most apparent if it is much brighter or much darker than the subject. In photo 4.2, the bright tree trunks are distracting, especially where the trees appear to be growing out of the deer's body.

Subject Centred in the Frame

Most beginning photographers place the subject dead centre in the frame, a position that is visually the most static composition. Normally, you want the viewer's eye to wander with interest around the entire picture area. By having the main subject right in the middle, you discourage further exploration of the picture area. In photo 4.2, placing the deer in the centre of the frame discourages further exploration of the rest of the photo. The only reason our eye moves away from the deer to the background is that the bright tree trunks are so distracting.

Photo 4.3 shows a wildlife portrait with a stronger composition. The single subject, a raven, fills the frame, so there is no question what the photo is about. There are no distracting elements in the background to pull our eye away from the subject, and the main point of interest (the bird's face) is not centred, but is placed in a dynamic position of the frame according to the "rule of thirds" (see following page). By following three simple guidelines of composition, I have made my photo stronger than it would be otherwise.

If you're now thinking, "Ah! But I don't have a powerful telephoto to fill my frame with animal portraits, so my subject will always be small in the frame!", relax. When your animal, person, or flower doesn't fill the frame, it doesn't mean the photo will be bad, just that you have to rethink your compositional options. Elements in the background will begin to take prominence as your main subject becomes smaller. The key to successful composition in these cases lies in balancing and

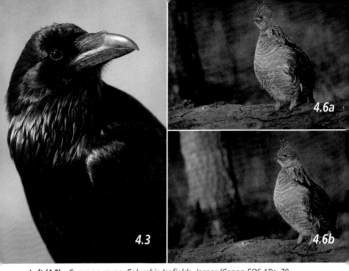

Left (4.3) – Common raven, Columbia Icefields, Jasper (Canon EOS-1Ds, 70-200mm lens at 200mm, 1/320 at f-4.5)
Right (top: 4.6a and bottom: 4.6b) Ruffed grouse (Canon EOS Elan, 300mm lens, f-5.6, Fuji Velvia 50 slide film)

tying together your main subject with background elements.

For example in photo 4.5, my wife Anita did not have a long enough telephoto lens to fill the entire frame with the short-eared owl. Because she recognized that the owl would occupy a small portion of the frame, she chose to include background elements that would add to the photo visually rather than distract from the main subject. Our eyes are immediately drawn to the owl because of its placement in the image (rule of thirds), and because it is lighter in tone than the rest of the image. After gazing at the owl, our eyes are pulled to the right by the dark tree trunks. The two branches, leaning left, lead our eyes back to the owl to start the circular exploration of the frame all over. A successful composition forces the viewer's eyes to explore the entire frame.

Photos 4.6a and 4.6b show how easily you can improve a composition simply by being aware of the visual weight of secondary elements in a photo (in this case a tree trunk). In photo 4.6a, I framed the ruffed grouse centrally, and the tree trunk to the left became a distracting element. By shifting my framing to the left, the tree trunk now became a secondary compositional element that not only serves to balance the visual weight of the grouse, but also serves as a sight line leading our eyes through the frame back to the grouse.

Landscape photos involve multiple elements that are much harder to compose successfully than wildlife, people or flower photos. The key to successful landscape composition is that all the elements, across the entire frame, work in harmony to create a whole. By looking at natural elements as simple shapes (a mountain is a triangle, a rock is a circle, a lakeshore is a horizontal line), we can arrange these shapes so there is visual balance and accord.

Because shapes have meaning in our lives, we can also use the placement of shape, form and line in our photos to communicate emotion. For example: diagonal lines represent action and are visually dynamic, while horizontal lines evoke tranquility and stability; thick

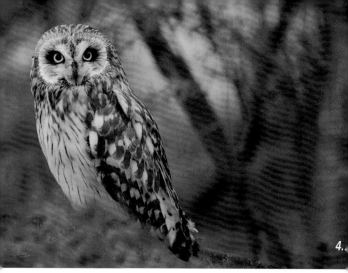

4.

4.5 – Short-eared owl by Anita Dammer (Canon EOS-3, Canon 100-400mm lens at 400mm, f-8, Kodak Supra 100 print film)

The Rule of Thirds

4.4

4.4 – Canon EOS-1N, 70-200mm lens, at 200mm, f-22, Fuji Provia 100F slide film

If you divide your picture space horizontally and vertically into thirds, the intersection of these divisions will create four points that represent the most dynamic junctures for subject placement. I used the rule of thirds to place the lily pads at one of these intersections (see photo 4.4 above). Had the leaves been centred in the composition, the photo would be much less dynamic. Note also how the reflections of the clouds in the water are also divided up according to the rule of thirds. There are three main clouds in the photo and each cloud occupies one of the thirds of the frame. By moving my camera around and trying different angles, I found a composition where all the elements of the scene fell into visual harmony. If you have never designed your photos according to the rule of thirds, give it a try and see how your compositions improve.

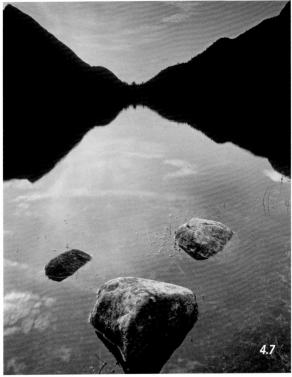

4.7 – Canon EOS-1N, 20mm lens, f-22, Cokin Tobacco grad filter, Fuji Velvia 50 slide film

lines represent strength; thin lines, delicacy. Squares and rectangles are solid and stable, while triangles represent power, strength, and endurance. Curvy lines like an "S" represent motion and restlessness; circles symbolize completion, wholeness, and warmth.

For those photographers who have not thought much about this aspect of composition and design, I'd suggest picking up a basic book on composition in art. Having a deeper understanding of the emotional cues that shape, line, and form trigger in viewers will help make your photos resonate more clearly.

Let's look closely at a couple of landscape photos to try to understand better why the design of the picture space in these shots makes for compelling compositions. Photo 4.7 illustrates the importance of structure in the design of a well-balanced photo. We recognize the shapes in this photo as concrete objects (mountain, sky, water and rocks), but, from a design point of view, the photo is made up almost entirely of triangles. The largest triangle is the water, and it provides the base for the photo. The rocks in the water form an inverted triangle pointing up to the sky that itself is an inverted triangle. Inverted triangles feel unstable but powerful. Add two additional triangles —the two silhouetted mountains — and we have a composition full of potential

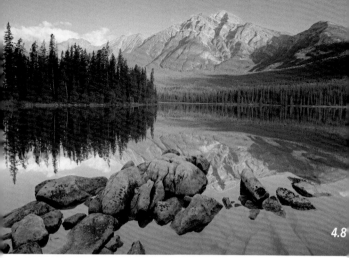

4.8

4.8 – A classic composition of Pyramid Lake and Pyramid Mountain in Jasper National Park. (Mamiya 645 Pro-TL, 45mm lens, f-22, Singh-Ray 2-stop hard-edge grad filter, Fuji Reala 100 print film)

dynamic tension and power. All we need to do is organize the elements appropriately into the picture space. Here, I have again used the rule of thirds and placed the sky in the upper third, the reflection of the sky in the middle third, and the rocks in the lower third of the frame. The overall image has become stable and harmonious, because all the shapes within are visually in balance.

Photo 4.8 is also a classic composition, with both the horizontal and vertical frames divided into thirds. Horizontally, the sky and mountain are in the upper third, the mountain reflection in the middle third, and the foreground rocks are in the lower third of the frame. Vertically, the silhouetted trees make up the left third, the evenly-lit tall peak makes up the middle third, and the shadowed peak makes up the right third of the frame. The rocks form a leading line from lower left, taking our eye to the reflection and to the mountain, effectively tying the elements in the photo together. From the mountain, our eyes are drawn to the dark silhouetted trees to the left and then back down to the lower left corner to start the viewing cycle all over again.

Composition is something that will become intuitive the more you look at photos, the more you photograph and the more you analyze the photos you have made. In the field, I make compositions more by "gestalt" than by thoughtful analysis. I simply move the camera around, up and down and side-to-side, trying various angles until the composition feels right. Once I find something that clicks — something where the sum is greater than the parts — I mount the camera on the tripod and finesse the composition further. I think it is critical to go by feel in the field, as this most often produces the most meaningful images. It's too easy to overanalyze while shooting, and, in the end, produce perfectly composed but stale images. You'll get more personality in your photos by reacting more to your heart rather than your head. Yes, the rules of composition often yield better photos, but use these rules merely as guidelines, or you will lose flexibility and spontaneity in providing your own interpretation.

Chapter 5
Kananaskis Country

Scores of Calgarians consider picturesque Kananaskis Country — an area seldom visited by tourists — their own mountain playground. Travel to the park any time during the week (except in July and August) and you'll see very few other people. On summer weekends, it's considerably busier, but even then a short jaunt onto the trails will whisk you away from the crowds.

Kananaskis Country is comprised of numerous zones strung along the eastern slopes of the Rockies of Alberta. The zones include the drainages of the Kananaskis, Elbow, Sheep, and Highwood rivers. By far the most popular — and most scenic — area of Kananaskis Country is along Highway 40, from its intersection with the Trans-Canada Highway to the heights of Highwood Pass, some 68 kilometres farther south. This stretch of road includes an incredible variety of terrain and wildlife, from forested foothills with grazing elk to a high alpine pass with foraging grizzlies. For me, Kananaskis Country is the hidden jewel in the crown of the Canadian Rockies. Indeed, it is so spectacular that a whole book could be devoted to its photographic exploration. Here, I'll concentrate only on the Highway 40 section of Kananaskis. I hope it will serve to whet your visual appetite for further explorations into Alberta's best-kept secret. All distances are from the intersection of Highway 40 with the Trans-Canada Highway. Happy discoveries!

Lower Kananaskis River

Where: The lower Kananaskis River is easily accessible from three points, all clearly marked: Canoe Meadows day use area (kilometre 5.9), the Barrier Lake Visitor Centre (kilometre 6.9) and Widow Maker (kilometre 8) day use area. From any of these three locations, you can get down quickly to the river for scenics and action photography of kayakers, rafters, or canoeists in the swirling whitewater of this stretch of river. A 2.2 kilometre riverside hiking trail connects all three areas.

When: Water levels on the Kananaskis River fluctuate daily through flow control upstream on the Barrier Lake Dam. In general, in summer months, the taps are turned on after 9 or 10 a.m., triggering not only a thundering flow of water, but also a mass influx of whitewater thrill-seekers. On sunny days, the best light is from midmorning to late afternoon, perfectly coinciding with the peak flow of water and visitation by adventure sport enthusiasts. An Internet search using the words "Kananaskis River" and "Transalta" will bring up a web page with the daily flow schedule.

How: At Canoe Meadows, the best strategy is to hike through the group campground upstream to the obvious gravel road that heads west towards the river. From here, you can follow the shore-hugging trail downstream past numerous rapids and "holes" to photograph the whitewater rodeo that occurs daily in the summer. I always ask permission before photographing anyone here because, as a professional, I need a model release to be able to publish the photos. But even if you are shooting for fun, it is always wise to ask permission first. Some folks are just learning whitewater technique, and seeing a

Kayaking at Hollywood Hole, Lower Kananaskis River (model-released photo by Mark Degner)

long lens following their every move can be unnerving and distracting. Plus, some people simply don't want to be photographed, and they have a right to privacy, even when engaged in a public activity on a public river.

From the Barrier Lake Visitor Centre it is just a short hike down to the river. When you reach the water's edge, turn downstream and follow the shoreline for about 300 to 400 metres, where you will meet another path angling left and down to a berm that juts into the river at a wonderful set of rapids called "Santa Claus." This is a more intimate spot to photograph whitewater sports. It lets you get right into the action and communicate with the folks on the water. Back on the river trail, about 100 metres farther downstream, there is an expanse of plume-like horsetail (*Equisetum*) that carpets the forest floor and makes for wonderful nature images on overcast days.

Photo Tip: Model Releases

It used to be that anyone could be photographed in public without worry to the photographer. Now, with privacy rights becoming more and more important, a wise photographer should never photograph anyone in public without their permission. Verbal permission is no longer enough. To protect yourself, you now need a signed "model release" that clearly spells out your intended uses of the photograph (a search on the Web for "photography" and "model releases" will get you started if you're not familiar with these legal forms). "Wait a second," you think, "I'm not a professional and I don't plan to publish my photographs, so why do I need a model release?" Well, you never know what will happen to those photos. Even just displaying the photos on your personal web page or entering them in a photo contest can get you into serious trouble. As the old saying goes, better safe than sorry. If you can't get a model release, or are too shy to ask permission, then you are better off not taking photos of strangers.

Wild Gaillardia in wildflower meadow near Barrier Lake Dam (Canon EOS-1N, 300mm lens, f-5.6, Fuji Velvia 50 slide film)

The Widow Maker site also offers some good opportunities for action photography with Class 3 rapids just below the parking lot. For photographers who want less walking and more whitewater action close to the car, this is the place to visit. Be sure to ask about "Hollywood Hole," which is really fine for capturing whitewater action.

Barrier Dam Day Use Area

Where: A well-signed, popular day use area at the north end of Barrier Lake (kilometre 9.1).

When: The best light is from sunrise to midmorning, and from late afternoon to sunset.

How: Barrier Lake is not one of my favourite mountain lakes. To me, it has an industrial feel, with its obviously dammed north shore, power lines skirting the western edge, and a stark shoreline devoid of vegetation. The mountains aren't particularly impressive here, and the wind is often blowing enough to make reflection shots nearly impossible. It's anything but the classic Canadian Rockies mountain lake. Even so, good images can be made here in spite of the lake's shortcomings. Mornings are especially good, as eastern light skims across the lake, side-lighting Mount Baldy and infusing colour into any cloud floating in the sky. Depending on the combination of light and atmospheric conditions, sunrises here can range from sublime to subtle (so subtle you blink and the drama is over!). The same goes for sunsets. If clouds loom in the sky, you can get spectacular under-lighting. Much of what makes Barrier Lake an occasionally great photo destination depends on drama in the sky. If it is clear, go somewhere else, because Barrier Lake will surely disappoint you.

Luckily, the Barrier Dam day use area offers other opportunities besides the lake. Hike west along on top of the dam to a fork in the gravel road. The upper fork continues along the north shore of the lake to the Stoney trailhead (2.5 kilometres away); the lower fork is a

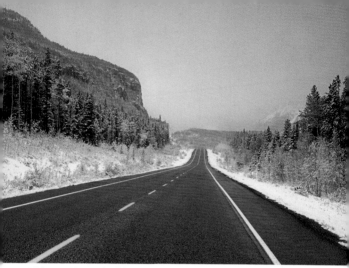

Highway 40 just north of the Barrier Lake day use area turnoff (Mamiya 645 Pro-TL, 55mm lens, f-22, Singh-Ray Gold-N-Blue Polarizer™, Singh-Ray 2-stop soft-edge grad, Fuji Velvia 50 slide film)

service road leading down below the dam to the Barrier Lake substation. Squeeze between the chain link fence and the erosion wall on the right side of the substation. About 100 metres downstream, you'll see a delicate, tumbling cascade on the right side that looks great in overcast or afternoon light. In summertime, there is a wonderful wildflower garden at the foot of the falls that can entertain photographers for hours.

Hike north up the hill above the Barrier Dam day use area parking lot for more flower-filled meadows and long views across the meadows to Mount Baldy. Midmorning and late afternoon are the best times for capturing panoramic views of the meadows and mountain. If you are interested in flower portraits, wait for a calm, overcast day.

Barrier Lake Day Use

Where: A signed day use area on the east side of Barrier Lake (kilometre 11.5).

When: Midmorning to midday, late afternoon and overcast days.

How: I especially like the lower parking lot for the great aspen forest that surrounds it. On calm, cloudy, or rainy days, this is a fabulous location to photograph intimate scenes of the white-barked trees set in a sea of green undergrowth. Scattered across the forest floor are numerous species of wildflowers that add a splash of colour to the scene. In mid- to late September, the forest ignites with vivid yellows, oranges, and reds. The winding road to the parking lot provides easy vantage points for views into the forest, or makes a nice subject itself. I have often lost myself for hours here in the fall, happily exploring the intimate details of this forest.

The upper parking lot is the trailhead for the Barrier Lake trail. Ascend the stairs and follow the track to a high ridge looking south down Highway 40 and the south arm of Barrier Lake. This view is best from midmorning to midday or in late afternoon light. This ridge offers

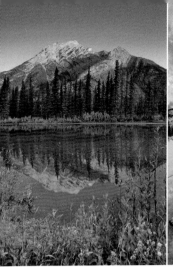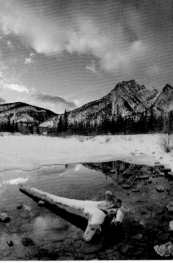

Left – Mount Lorette reflected in Lorette Ponds (Mamiya 645 Pro-TL, 35mm lens, f-16, Singh-Ray Warming Polarizer Plus and Singh-Ray 3-stop hard-edge grad filter, Fuji Velvia 50 slide film) **Right** *– Mount Lorette and Lorette Ponds in winter (Canon EOS-1N, 15mm fisheye, f-8, Kodak Supra 100 print film)*

views north to the main body of Barrier Lake. It's also a great place to get aerial views of the aspen forest directly below. The hike to the ridge is short (about 10 minutes) and worth the fight against gravity.

Mount Lorette Ponds

Where: A marked day use and picnic site on the left side of the highway (kilometre 18.9).

When: Sunrise to midmorning and late afternoon (and sunset, in winter).

How: The Lorette Ponds are dotted with paved pathways, a railed fence, and numerous picnic tables. The challenge here — possible, but tricky — is to find good views of the lake and mountain backdrop (mostly Mount Lorette to the west) without all the man-made clutter. I like the views from the southernmost pond. Follow the trail from the parking lot, hang a right at the pond, cross the footbridge and continue along the shoreline on the right. Somewhere in here you'll find a spot where all human evidence is hidden from view. In winter, there are often a few small windows of open water for nice reflection shots. Wander around all three ponds, and you are sure to find somewhere that appeals to your own visual sensitivities. Just watch your backgrounds, as Highway 40 often sneaks into the picture unnoticed.

Beaver Pond Day Use Area

Where: Turn at the sign for the Sundance Lodges (kilometre 21.5), and immediately you will come to a T-intersection. A right turn will take you into Sundance Lodges, but turn left to the Beaver Pond area. Park at the first little pull-off on the right side of the road beside the beaver pond; from here, a number of footpaths will take you to various vantage points along the shore of the beaver pond.

When: Sunrise to midday, late afternoon to sunset.

How: This site provides a close-up view of an active beaver pond.

Top left – Beaver (by Wayne Lynch, Nikon F4, 600mm lens at f-5.6, Kodachrome 64 slide film) *Right* – Wedge Pond and Mount Kidd in fall at sunrise (Mamiya 645 Pro-TL, 35mm lens, f-16, Singh-Ray 2-stop hard-edge grad, Fuji Provia 100F slide film) *Bottom left* – Boundary Ranch aspen meadows in fall (Mamiya 645 Pro-TL, 45mm lens, f-16, Singh-Ray Warming Polarizer Plus, Fuji Provia 100F slide film)

Although it's mostly good for intimate scenes, there are also a number of vantage points that provide long views across the water toward Mount Lorette to the north and Mount Kidd to the south. In general, I find that midmorning and late afternoon light works well here and the strong sidelight at these times benefits from the use of a polarizing filter. Sunrise and sunset can also be rewarding, with reflection shots of colourful skies and silhouetted trees being the appealing end product. If you're lucky you might also get photos of the beavers.

Boundary Ranch
Where: At kilometre 25.8, you'll see the signed entrance to Boundary Ranch on your left. Park at the first pull-off on the right, just past the entrance to the ranch.
When: Sunrise to midmorning, evening to sunset.
How: On the right side of the road, opposite Boundary Ranch, wide-open meadows with scattered stands of aspen trees can be used to frame portraits of the distant peaks. I love it here in late May, when the fresh leaves are lime green, and then again in late September, when the crisp days of autumn adorn the trees in hues of gold. Wander away from the road and out into the meadows for a greater variety of views. A polarizer will remove the reflective glare from the leaves and saturate colours. If it is overcast, head back to the Boundary Ranch turnoff and explore the large aspen forest. I like to use a short telephoto lens in the forest to create abstract compositions of the white-barked trees.

Wedge Pond
Where: A well-signed day use area just south of the Mount Kidd RV Park (kilometre 30.4).
When: Best from sunrise to midmorning; also good in the evening until sunset.
How: Wedge Pond is a perennial favourite among Calgary nature

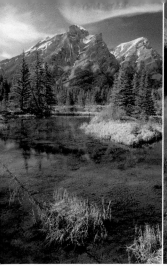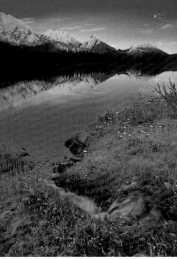

Left – Mount Kidd at the Reflecting Pools (Mamiya 645 Pro-TL, 35mm lens, f-22, Singh-Ray Gold-N-Blue Polarizer™, Singh-Ray 2-stop soft-edge grad, Fuji Velvia 50 slide film) **Right** *– Spillway Lake and the Opal Range (Mamiya 645 Pro-TL, 35mm lens, f-22, Singh-Ray Gold-N-Blue Polarizer™, Singh-Ray 3-stop soft-edge grad, Fuji Velvia 50 slide film)*

photographers. The pond is relatively small, easy to walk around, and surrounded by some stunning mountain peaks. From sunrise to mid-morning, the pond can be magical, with light dancing across Mount Kidd and the Wedge. Throw in the odd moose grazing on the submerged vegetation and you have all the elements for classic mountain photography. In the fall, the scattered aspen trees lining the shore add a colourful accent to an already picture-perfect scene. It doesn't get much better or easier than this. At other locations, one has to work to make great images, but Wedge Pond continually dishes them out free and easy. It's hard to resist the siren calls of Little Miss Wedge. One visit is never enough!

Mount Kidd Reflecting Pools

Where: About one kilometre south of the signed Galatea Lakes trail-head turnoff is a series of small reflecting pools on the right hand side of the highway (kilometre 30.4). This spot is not signed. You'll have to park on the shoulder of the highway.

When: Sunrise to midday; in the fall and winter, evening to sunset.

How: Like Wedge Pond, this location continually calls me back. Talk about a classic mountain scene. Mount Kidd looms ruggedly large over the scene, and the small reflecting pools are tranquil and verdant. It's hard to imagine designing a more perfect scene, except for one thing — Highway 40 runs close to the ponds and often sneaks into the right side of the picture. Although I have photographed here dozens of times, I have yet to meet another shooter at this spot.

Kananaskis Lakes

Where: Look for the major turnoff from Highway 40 onto the Kanan-askis Lakes Trail (kilometre 51.2) and the core recreational area of Peter Lougheed Provincial Park.

When: Any time.

Top left – Mount Wintour and Pocaterra Marsh (Canon EOS-1Ds, 24-85mm lens at 37mm, 2 seconds at f-22, Singh-Ray Warming Polarizer Plus)

Top right – Tree stumps, Upper Kananaskis Lake, North Interlake day use area (Canon EOS-1Ds, 24-85mm lens at 35mm, 1/4 at f-20) *Middle left* – Close-up of driftwood from Interlakes Campground (Canon EOS-1Ds, 100mm Macro, 1/30 at f-20) *Middle right* – Mount Sarrail, Mount Foch, and Mount Fox and Lower Kananaskis Lake (Canon EOS-1Ds, 24-85mm lens at 30mm, 13 seconds at f-20, Singh-Ray Warming Polarizer Plus, Singh-Ray 1-stop soft-edge grad)

Bottom left – Mount Indefatigable and meadow area off Lakeshore Drive (Mamiya 645 Pro-TL, 45mm lens, f-22, Singh-Ray 2-stop soft-edge grad, Fuji Velvia 50 slide film) *Bottom right* – Upper Kananaskis Lake from Upper day use area (Canon EOS-1N, 20mm lens, f-22, Singh-Ray 3-stop soft-edge grad, Fuji Velvia 50 slide film)

How: There is a lot to see and do in this area! The myriad lakes, trails, campgrounds, and day use sites in this area are mind-boggling. Let me tempt you with some of the highlights.

Spillway Lake and Peninsula Day Use Area

Turn off the Kananaskis Lakes Trail onto the gravel Smith-Dorrien Spray Trail (Highway 742). After a few minutes, look on your left side (to the east) for Spillway Lake. This is a classic Kananaskis photo stop for sunset views of Mount Wintour, Gap Mountain, and the Elk Range. Although it is often overlooked in the morning in favour of other photo stops, this spot also looks great with backlight. Just past Spillway Lake is the Peninsula day use area on the north shore of Lower Kananaskis Lake. Be sure to walk out on the short peninsula path — accessible from the far end of the parking lot — for long views south down the lake. These are best from sunrise to midmorning and from evening to sunset. When leaving the Peninsula day use area, watch on your right side just before entering the Smith-Dorrien Spray Trail for a photogenic waterfall created as Kent Creek enters Lower Kananaskis Lake (best in overcast or afternoon light).

Pocaterra Marsh

Back on the Kananaskis Lakes Trail, immediately south of the Smith-Dorrien junction, on the left side of the road, is a wide, marshy meadow perfect as a foreground for framing reflections of Mount Wintour to the east (midday to sunset).

Photo Tip: Seasonal Variations on the Same Composition

Left – *Mamiya 645 Pro-TL, 45mm lens, f-16, Singh-Ray Warming Polarizer Plus, Singh-Ray 3-stop hard-edge grad, Fuji Provia 100F slide film.*
Right – *Mamiya 645 Pro-TL, 45mm lens, f-16, Singh-Ray Warming Polarizer Plus, Singh-Ray 2-stop hard-edge grad, Fuji Reala 100 print film*

You can add some intriguing contrasts to your Rockies portfolio by photographing the same composition in different seasons. For example, I like the section of Highway 40 near the Mount Kidd reflecting pools for its dramatic views towards Mount Kidd. In a setting like this, you could repeat the same composition over the course of a day (morning, midday, and evening, for example), or you could repeat the same shot in different seasons at the same time of day. Here are two views of Mount Kidd and Highway 40 that illustrate the powerful effect that can be achieved by photographing the same scene in different seasons.

Lower Kananaskis Lake from Interlakes Campground (Canon EOS-1Ds, 24-85mm lens at 30mm, 1/5 at f-11, Singh-Ray 2-stop hard-edge grad filter)

Lakeshore Drive

Just south of the Elkwood campground, at the bottom of a hill, is Lakeshore Drive, which leads to a private cottage area. At this intersection, on the right side, is a small meadow with views west to Mount Indefatigable (good from sunrise to midday). Several hundred metres farther south on the Kananaskis Lakes Trail, on the left, is a larger meadow with panoramic views east to the Opal and Elk Ranges (midday to sunset).

Lower Lake Day Use Area

At this signed turn-off, follow the road to the picnic site, where there are expansive views west to Mount Indefatigable, Mount Lyautey and Mount Sarrail. You can choose from a variety of foregrounds here: the vast, willowy meadows, the rocky shores of Boulton Creek, or the reflections in the Lower Kananaskis Lake (best from sunrise to mid-morning).

Upper Lake Day Use Area

From the parking lot and dam area, views to the west provide good photo opportunities from sunrise to midday. If it is overcast, consider hiking west along the south shore of Upper Kananaskis Lake to Sarrail Falls (1.2 kilometres). The falls are multi-tiered, so be aware that there is more to photograph than just the lower tier from the footbridge over Sarrail Creek. Hike up the steep banks along the creek for other possibilities. A wide-angle zoom (e.g., 24-85mm) and a short telephoto zoom lens (70-200mm) are the perfect companions at Sarrail Falls.

Panorama and Interlakes Campground

If you are camping, consider staying at one of the lakeside campsites in the Interlake campground. Here you will have expansive views east to the Opal and Elk Ranges, perfect for evening and sunset light and good for backlit dawn photos. Otherwise, just stop at the Panorama parking lot for similar, but not as extraordinary, views.

Left – Bull moose, Valleyview Trail *(Canon EOS-3, 300mm lens, f-5.6, Supra 400 print film)* *Right –* Opal Falls *(Fuji GA645, 45mm lens, f-8, Agfa RS100 slide film)*

North Interlakes Day Use Area

Here you have two options. You can proceed left and follow the eastern shore of the lake, or go right and follow the north shore. For morning photography, I prefer the eastern shore. About 400 metres along this trail, there are weathered tree stumps and driftwood, remnants of the forest that was logged to create the lake. The stumps are eerie, haunting reminders of the ecological cost of hydroelectricity. Stark, graphic, and disturbing compositions can be made here, very much in contrast to the typical images of beauty that most nature photographers aim for. For sunset, try the north shore, and for a good lactic acid burn, carb up for the heart-busting climb up Mount Indefatigable (2.7 kilometres to the top — good anytime, but lunch at the top is a sweet reward, especially if you remember to haul chocolate in your pack).

Valleyview Trail

Where: Back on Highway 40, take the first left south of the Kananaskis Lakes Trail turnoff; this well-marked gravel road is the Valleyview Trail. It's open from mid-June through September.

When: Best in the mornings and in overcast light.

How: Your first stop is the Elpoca viewpoint day use area. Trees mostly obscure the view west, but that's okay. The real reason you are here is to see Opal Falls. Take the path on the east side of the parking lot (near the outhouse), follow it for a few minutes, and then take the first footpath to the right. Continue on this fork through the forest until you get to an open area that overlooks the Opal Creek Canyon. From here, continue until you see Opal Falls through the trees over your left shoulder. Follow a branch of the path going left (at the time of this writing, it was the third left after the open area). This is the best route to the falls. The total distance is about one kilometre from the parking lot. Be prepared: the last section of the trail is steep. The falls are raw and wild, knifing through a plunging gap in a soaring,

weathered headwall. They are well lit on sunny days, from midday to midafternoon; otherwise, go when overcast. This place never fails to impress me.

Next stop is the Elpoca Creek bridge. Here you get an aerial view over the Elpoca Creek Canyon west to the Kananaskis Lakes area. Sunrise to midmorning light is good for overall scenics here; overcast light is good for views into the gorge. If it is cloudy and the sky might underlight, I like sunset here. There is a wide range of highlight and shadow in this scene, with its dark canyon to bright sky, so it will take all your technical skills (good grad use, or digital stitching of highlight and shadow exposures) to pull off a decent shot.

Your last stop along the Valleyview Trail is Lakeview day use area. You might be able to squeeze a shot or two out of this location using a telephoto lens, but for the most part, the big views that were once here are overgrown with trees.

Elbow Pass

Where: Turn off Highway 40 at the Elbow Pass day use area (kilometre 62).
When: Any time.
How: Start by buffing up your hiking boots. It's 1.3 kilometres to Elbow Lake, a very appealing and beautiful destination. The lake, ringed by lovely peaks, is exceptionally photogenic any time throughout the day, since a trail circles it, but is best in the morning and evening. Elbow Lake is a fine introduction to backcountry camping for novice back-packers, but photographers can still get there early, or stay late, as the hike to the lake takes only 30 minutes. I prefer the scenery beyond the lake up into Elbow Pass itself, with its undulating, rolling meadows reminiscent of the highlands of Scotland. The best scenery is about a one-hour hike past Elbow Lake. Here you can find stunning views across boulder-filled meadows to Tombstone Mountain and the Piper Creek Valley.

Highwood Pass

Where: A marked parking lot at the height of Highway 40 (kilometre 68).
When: Any time.
How: Highwood Pass is the highest point crossed by a paved road in Canada. But it's more than just some geographical point of inter-est. Not only is the pass photogenic, it is a jumping-off point for sev-eral stunning alpine hikes (Pocaterra Ridge, Ptarmigan Cirque, and Arethusa Cirque). As well, the section between the Elbow Pass day use area and Highwood Pass consistently yields numerous grizzly and black bear sightings —especially in late June and early July. The best time for both scenery and wildlife photography is early morning and late evening, but a hike up to one of the cirques can be good any time of the day for Columbian ground squirrel, marmot, pika and white-tailed ptarmigan photos. Normally, I hike with a minimum of gear (e.g., a camera, polarizer, tripod, and 24-85mm lens), but when hiking the pass I always lug along my 300mm lens to take advantage of the abundant wildlife.

Opposite – Highway 40 at Highwood Pass (Mamiya 645 Pro-TL, 45mm lens, f-16, Singh-Ray Warming Polarizer Plus, Singh-Ray 2-stop plus Singh-Ray 3-stop hard-edge grad, Fuji Velvia 50 slide film)

Chapter 6
Banff National Park

Banff National Park is Canada's oldest and most famous park. Its reputation for rugged beauty, abundant wildlife, and great hiking and skiing is known worldwide. This popularity is reflected in the millions of visitors Banff receives. Although the numbers seem overwhelming, it is still surprisingly easy to leave the throbbing crowds behind and experience the quiet, serene, and wild side of Banff. And no, you won't need to hike for kilometres, or stay in isolated backcountry lodges to achieve this solitude or to connect with nature. Much of what appeals to nature photographers is awaiting discovery at the nearest roadside pull-off. Banff has 350 kilometres of public roadway, so there is a lot to explore. Here are a few of my favourite drives in Banff National Park. (Note: the Banff section of the Icefields Parkway is covered in chapter 9, page 93.)

Lake Minnewanka Loop
Where: A well-marked road accessible off the Trans-Canada Highway from the easternmost interchange into the town of Banff, or by following Banff Avenue in Banff to its furthest point north.

When: Any time of day, but be aware of the seasonal closure on the western part of the loop from November 15-April 15. You can still get to Lake Minnewanka by car along the eastern part of the loop via Two Jack/Johnson Lake.

How: Abundant in scenery, wildlife, and human history, the Lake Minnewanka Loop is a perennial favourite for photographers, enhanced by the distinctive peaks that provide memorable backdrops for the area's three lakes. Friendly critters abound, and the photography is as easy as stepping out of the vehicle and snapping a shot. Here are the highlights to watch for as we circle the loop in a clockwise direction.

Cascade Ponds — Kilometre 0.3
Acres and acres of picnic grounds, complete with man-made ponds and arching bridges, greet the visitor to Cascade Ponds. In the summer, when water fills up these old gravel pits, it's possible to make splendid reflection shots of Mount Rundle and Cascade Mountain from sunrise to midmorning. But somewhere in every shot you take, there will be a picnic table, a bridge, an outhouse, a pathway, or a person, so if you're looking for wild scenics, Cascade Ponds may disappoint you. Rather than fight to eliminate human evidence from my photos, I photograph Cascade Ponds for what they are: a manicured picnic site set among picturesque peaks. If you want an easy introduction to wildlife photography, the Columbian ground squirrels that frolic in the meadows here are very obliging.

Lower Bankhead — Kilometre 3.3
The abandoned coal-mining town of Bankhead will surely delight history buffs. Scattered amongst mounds of coal slag and runaway rhubarb are the remnants of an anthracite mining operation. Here you can frame disintegrating coal carts and concrete pilings against the

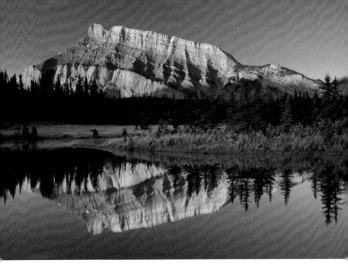

Mount Rundle at sunrise reflected in the Cascade Ponds (Canon EOS-1Ds, 24-85mm lens at 42mm, 1/2 at f-13, Singh-Ray Warming Polarizer Plus)

distant mountains. If you are up for a little creative photography, you can use a flashlight to wash warm light over the standing walls of the old buildings at dusk. The resulting photos will often be haunting and ghost-like, perfect treatment for a mining town long since dead.

Upper Bankhead — Kilometre 3.8

A large picnic area, overrun with lap-friendly Columbian ground squirrels, serves as a launch site for further explorations into the history of Bankhead. One kilometre along, you'll find the skeleton of another concrete building and some collapsed mine shafts. Just above the building is a fine view down across Lake Minnewanka (best from midday to sunset). Continue for another four kilometres to C-Level Cirque for views of a tiny alpine lake and a large rockslide, home to pikas and hoary marmots. This is also a good place to search for spruce grouse.

Lake Minnewanka — Kilometre 5.9

Lake Minnewanka is a large lake popular with boaters as the only lake in Banff National Park that allows motorized boats. Scuba divers come here to explore a submerged ghost town, and sightseers ride the tour boats for stunning views along this 24-kilometre lake. Photographers, on the other hand, seem less impressed. The road travels right across the dam, and the shoreline here is stark and unappealing. The boat launch area looks like a commercial fishing harbour. In short, Lake Minnewanka falls short relative to its more popular cousins like Moraine Lake, Vermilion Lakes, and Lake Louise. As time is a commodity for most park visitors, and even more so for "serious" photographers, why waste precious light on a tarnished jewel when shinier trophies await your attention elsewhere? Well, even a barnyard turkey has its own beauty, if we care to look for it, and Lake Minnewanka is full of hidden charm. The 1.4-kilometre stretch of shoreline from the parking lot to Stewart Canyon has strong potential both at sunrise,

Photo Tip: Use Your Feet!

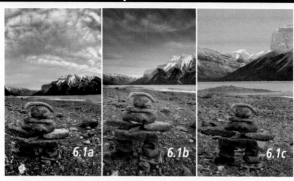

Left (6.1a) – Canon EOS-1Ds, 15mm fisheye lens, 1/3 second at f-20
Middle (6.1b) – Canon EOS-1Ds, 20mm lens, 1/4 second at f-22
Right (6.1c) – Canon EOS-1Ds, 70-200mm lens at 70mm, 1/15 second at f-22

Many outdoor photographers forget that the most important tools in photography are their feet. These photographers just don't walk around enough and explore a scene's potential. How often have you just jumped out of the car, zoomed in or zoomed out your lens until you got the framing you wanted, snapped the shot and then motored off? The same scene can be rendered very differently depending on the focal length to which you set your zoom lens and where you are standing in relation to the subject with that zoom setting. For example, I came across this wonderful inukshuk cairn on the shores of Lake Minnewanka in Banff. Rather than just pull out my trusty zoom lens and shoot the cairn from where I discovered it, I decided to explore this subject using different types of lenses. First, I put on my extreme wide-angle lens (a 15mm fisheye) and walked right up to the cairn. I was only inches from the inukshuk, and photo 6.1a was the result. Notice how the Inukshuk is huge relative to the size of the mountain in the backdrop. Next, I backed off a few feet, stuck on my trusty 20mm wide-angle lens and shot the cairn again (photo

6.1b) — now the background becomes more prominent than in the first image. Finally, I walked back dozens of feet from the cairn, switched to a 70-200 zoom lens and made a third image at 70mm (photo 6.1c). In this final image the mountain starts to tower over the cairn. Although the cairn is roughly the same size in all three photos, notice how the background becomes more prominent and larger with the use of a longer lens.

The lesson here is twofold: use your feet to get different perspectives from different focal lengths of lenses, and use your knowledge of foreground to background relationships to make better mountain photos. If you want your hiking buddy to be dwarfed by a background mountain, use a longer lens setting to take his photo. On the other hand, if you want a cluster of alpine wildflowers to take centre stage and the mountains to be a distant background, then a shorter lens setting or wide-angle lens is your answer. So don't just stand there and zoom to make photos, choose your perspective first, walk to where you need to be, and then pick the most appropriate focal length of lens.

*Top left – Detail of coal cart from Lower Bankhead (Canon EOS-1Ds, 70-200mm lens at 163mm, 2.5 seconds at f-22) **Bottom left** – Mount Rundle and Two Jack Lake (Mamiya 645 Pro-TL, 45mm lens, Singh-Ray Gold-N-Blue Polarizer™, Singh-Ray 3-stop soft-edge grad, Velvia 50 slide film) **Right** – Mount Inglismaldie and Lake Minnewanka (Canon EOS-1Ds, 20mm lens, 1/80 at f-16, Singh-Ray 2-stop hard-edge grad)*

when the lake is backlit, and at sunset, when the peaks are coloured by the setting sun. Don't expect glass-calm water for mirrored reflections, though. This big lake is always a bit windy.

Palliser Viewpoint — Kilometre 7.6

True, there are good views of Lake Minnewanka and the Palliser and Fairholme Ranges from this location. But it's more likely that a road-block of sleepy bighorn sheep will distract you. Don't bother honking — they'll just ignore you. You might as well just pull over and watch the show. The Minnewanka herd is so laid-back; they often appear to be the work of a taxidermist, stuffed and propped up along the side of the road! In fact, they seem so tame that I have seen folks try to pet them or get their photos taken with arms wrapped around an animal's neck. Such heedless behaviour is sure to make the sheep spring to life, kicking and head-butting anyone in sight, pointedly reminding everyone that, despite appearances to the contrary, these are still wild and potentially dangerous animals. Keep a respectful distance and do not harass or feed the animals, no matter how calm they appear to be.

Two Jack Lake Picnic Area — Kilometre 8.4

If the dawn is clear, head here for a winning shot of Two Jack Lake with Mount Rundle glowing in the background. Many spots along the shoreline will work as a foreground, but my favourites include the tiny island at the left end of the parking lot, and the larger island with the tall spruce at the right side of the picnic area.

If you have a canoe, you can paddle to the other side of the lake to photograph sunrise light on Cascade Mountain, or snap a midday polarized portrait of the same peak. You can also get to the far shore via the 2.3 kilometre Two Jack Canal trail that starts off from the Johnson Lake Road bridge.

The Two Jack Lakeside campground, a little farther down the road,

Left – Johnson Lake and Cascade Mountain (Canon EOS-1Ds, 24-85mm lens at 62mm, 1/8 at f-20, Singh-Ray Warming Polarizer Plus, Singh-Ray 1-stop hard-edge grad) *Right* – Oxeye daisies, Benchland Meadows (Canon EOS-1Ds, 24-85mm lens at 82mm, 1/4 at f-22)

is a wonderful place to camp (check in before 1 p.m. to secure a lake-side site), and it provides views across the lake that are good at both sunrise and sunset.

Johnson Lake — Kilometre 10.8

A short side road off the Minnewanka Loop leads to Johnson Lake, an east-west running lake that is Banff's most popular swimming hole. A footpath completely circles the lake. Mornings (from sunrise to late morning) are most productively shot from the north bank, where, half-way along, a high slope looks down on the lake with eye-level views to Mount Rundle. At the far end of the lake (1.4 kilometres), long views back to Cascade Mountain also look best in the mornings. At sunset, you can catch the waning light falling on the Fairholme Range from the parking lot end of the lake. Common loons, red-necked grebes, muskrats, and belted kingfishers are frequently seen here as well, so bring along a telephoto lens to capture some wildlife portraits. Even when the other lakes in the area are wind-ruffled, Johnson Lake is often calm because it is so well sheltered.

Benchland Meadows — Kilometre 11.5 to 12.0

About one kilometre past the Johnson Lake Road junction, a wide expanse of meadow on either side of the road opens up to views of Cascade Mountain and Mount Rundle. In summer, ox-eye daisies fill the meadows, providing a nice flowered foreground for your mountain photographs.

Mount Norquay Scenic Drive

Where: Take the western exit for Banff off the Trans-Canada Highway, which leads both to Vermilion Lakes Drive and Mount Norquay Scenic Drive.
When: Late afternoon to sunset.

How: Your destination is the "green spot", a large open meadow five kilometres up the Mount Norquay Road. A parking area near a stone wall will signal your arrival. With a short telephoto lens (e.g., 35-135mm) you can photograph an aerial view of the town of Banff, with Mount Rundle and the Goat Range in the background, all without breaking a sweat, straining your knees, or even having to don hiking boots. Often there will be bighorn sheep sunning themselves in the grassy meadow, making it a perfect place to snap some wildlife portraits with the broad Bow Valley below.

Vermilion Lakes Scenic Drive

Where: The chain of three Vermilion Lakes is found on the south side of Vermilion Lakes Drive. To get there from Banff, take the Mount Norquay Road and turn left just before the Trans-Canada overpass at the west edge of town. Access from the Trans-Canada is from the

Photo Tip: Capturing Ephemeral Light

Tunnel Mountain and the Fairholme Range from the second Vermilion Lake (Mamiya 645 Pro-TL, 80mm lens, Fuji Velvia 50 slide film)

Of all the locations discussed in this book, the Vermilion Lakes is the place most likely to produce amazing shows of light, especially to the east, where the not-too-distant prairie allows low light to skim across the mountains and to underlight overcast skies. The moral of the story is to get up for *every* sunrise, especially here, even if the sky is heavily overcast. Because the mountains block the view of the eastern horizon, you'll never know if there will be great light until it happens. Rather than risk missing the ephemeral light, just get up and get on location.

Often you will be rewarded for your efforts. With this image, I awoke to light rain and heavy, grey skies. I went out anyway, shivering in the cold, blue dawn. Just as I was about to give up and head to town for coffee, the sky underlit with dramatic beams of light. I managed to expose three frames before the light fizzled and the rain turned to a steady downpour. No-one else was out that morning, due to the weather, but, because I persisted and went out anyway, I have a unique and memorable image.

Left – The view from the green spot on Mount Norquay Scenic Drive
(24-85mm lens at 35mm, 1/2 at f-22, Singh-Ray 2-stop hard-edge grad)
Right – Mount Rundle and the second Vermilion Lake in winter (Mamiya 645
Pro-TL, 35mm lens, Singh-Ray Gold-N-Blue Polarizer™, Singh-Ray 2-stop hard-
edge grad, Fuji Velvia 50 slide film)

western interchange into Banff.

When: This is one of those rare places that looks good in any season,
and at all times of the day. The Vermilion Lakes run east to west and
photography is done from the north shoreline, giving dramatic side-
light at both sunrise and sunset. Most photographers prefer evening
light, when the sun paints warm light on the western face of wedge-
shaped Mount Rundle. About an hour or two before sunset, the water
often calms to a mirror-like finish, making perfect reflection shots
possible. Early mornings are also good for reflection shots, and often,
after a cool evening, ground fog or mist will linger to add drama to the
scene. Even midday can be productive for photographers, especially
as the sky begins to load up with the big, white, puffy cumulus clouds
that are so common in the spring and summer. In winter, pockets of
water stay ice-free due to warm underground springs. These provide
crystalline-edged reflecting pools for exciting image possibilities.
Often, when photographing the lakes, I'll arrive at dawn and photo-
graph until dusk, stopping only at midday for a hearty lunch in Banff.

How: There are as many approaches to photographing the Vermilion
Lakes as there are photographers. I recommend spending a few hours
just scouting the shoreline of each of the three lakes. This is easily
done, as Vermilion Lakes Drive hugs the north shore of all three lakes.
Although there are many "classic" vantage points (the dock at the first
lake, the stand of dead spruce between the first and second lake, the
stumps at the western edge of the second lake, and the marshy area of
the third), the shorelines are so varied that it is easy to find a position
that appeals to your individual tastes.

Another way to get to viewpoints that other photographers can't
reach is to bring waders and wander among the wet vegetation and
pools of water to find a spot to call your own. Be sure not to wander
into an area if there are already photographers on the shore shooting
that scene. They may start throwing rocks at you.

Because the Vermilion Lakes are among the most famous

Cascade Mountain over Cascade Gardens (Canon EOS-1Ds, 24-85mm lens at 24mm lens, 1/4 at f-20, Singh-Ray Warming Polarizer Plus, Singh-Ray 2-stop hard-edge grad)

Photo Tip: Use Props to Spice up Your Photos

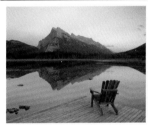 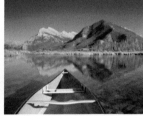

Left – Mount Rundle from the dock at the first Vermilion Lake (Mamiya 645 Pro-TL, 45mm lens, Singh-Ray 3-stop soft-edge grad, Fuji Velvia 50 slide film)
Right – Mount Rundle and Sulphur Mountain with canoe from the third Vermilion Lake (Mamiya 645 Pro-TL, 45mm lens, Singh-Ray Warming Polarizer Plus, Fuji Velvia 50 slide film)

Even though no two days are the same and no two photographers are alike, most of the photos we see from the Vermilion Lakes look similar. There are many ways to make your photos look different from everyone else's, but one of the easiest is to use props. I brought along a deck chair for a day of photography at the Vermilion Lakes. I shot the chair in various locations along the shore and ended up with images that invite the viewer into the scene — and that look a little different from the many images we see from the same location. I have also used a canoe at the lakes to provide a compositional counterpoint to the natural scene. Viewers feel like they can step into the boat and paddle into the scene. I often use things like snowshoes, a hiker's feet, skis, a tent, a backpack, or people to add foreground interest to the grand scenic. Because the props have specific functions, the resulting photos offer more story-telling and can be more interesting to the viewer than straight landscape photographs.

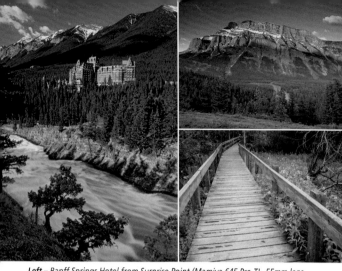

Left – Banff Springs Hotel from Surprise Point (Mamiya 645 Pro-TL, 55mm lens, Singh-Ray Warming Polarizer Plus, Singh-Ray 2-stop hard-edge grad, Fuji Velvia 50 slide film) **Top right** *– Mount Rundle at sunrise from the Hoodoos viewpoint trail (Mamiya 645 Pro-TL, 45mm lens, Singh-Ray Warming Polarizer Plus, Singh-Ray 3-stop hard-edge grad, Fuji Velvia 50 slide film)* **Bottom right** *– The Marsh Boardwalk trail (Canon EOS-1Ds, 24-85mm lens at 32mm, 3.2 seconds at f-22, Singh-Ray Warming Polarizer Plus)*

photographic icons in the Canadian Rockies, and because they are so close to town, expect to share your space with plenty of other tourists and photographers (except when shooting 5 a.m. June sunrises). Courtesy, respect, and common sense should rule the day. Everyone has equal rights here. When shooting with other folks around, always be conscious of how your actions and behaviour will affect the experience of others. Allow them to enjoy their peaceful sunset without being overly talkative or pushy. The golden rule applies here: "do unto others as you would have them do unto you."

Banff Townsite

Where: Getting to Banff is the easy part. Finding the specific locations listed below is a little harder, but stopping at the Banff Information Centre at 224 Banff Avenue will score you maps of the town and the park to help you navigate your way.

When: Any time of day or season.

How: Within the town of Banff, there are numerous locations to interest outdoor and nature photographers. Listed below are the ones that have the widest appeal.

Banff Avenue

The two-block stretch of Banff Avenue between Wolf and Buffalo Streets is world-famous, not only for its shopping, but also for its photogenic appeal. Classic views of Banff Avenue are best taken looking north towards Cascade Mountain during midmorning to late afternoon, when either the west or east side of the street is lit by the sun.

Bow Avenue

Head south on Banff Avenue, and take the last right onto Buffalo Street just before crossing the bridge. Park in the public lot on the left side of

Photo Tip: Painting with Light

Few techniques will inspire as many "oohs" and "aahs" as light-painting. All you need is a camera capable of making long exposures (30 seconds or more) and a flashlight (larger, more powerful flashlights work better than pocket flashlights). For your first attempt, find a subject that can be lit easily with a few swipes of your flashlight. Usually, something bigger than a breadbox but smaller than a car works best. Large boulders, cairns, canoes, small docks, park benches, or small buildings all make good subjects. Set up your composition and focus using a sturdy tripod before it

Cairn at Lake Minnewanka lit with flashlight at dusk (Canon EOS-1Ds, 20mm lens, 30 seconds at f-16)

gets too dark. Be sure to include enough background around your subject so your subject will stand out against the rest of the dusky scene. Once your flashlight can light your subject (or part of it) brighter than the ambient light, it is time to begin. Use your camera to meter the brightness of the dusk scene, without the flashlight turned on, and set the exposure accordingly. If your meter does not measure low levels of light, set your camera to "bulb" or "time" exposure, your aperture to f-16 and try these four exposure times with your ISO set to 100: 15 seconds, 30 seconds, one minute, and two minutes. One of these settings will usually work well in most situations. However, if you are using faster ISO settings on your digital camera, or your film camera is loaded with high sensitivity film (ISO 400 or 800), your images will be overexposed using these settings. Light-painting is best done with slower-speed ISO film and digital settings, as the

longer exposure times allow you more time to completely paint light over your subject.

Open up the camera shutter using a cable release, and then sweep your flashlight over the subject, painting it with large strokes of light until the flashlight has lit the whole subject. You will have however long your camera shutter is open to complete painting the subject with light. The appeal of light-painted photographs lies in the uniqueness of each attempt: no two pictures will ever be exactly the same. The light will be splotchy and uneven as your brush strokes of light dart and hesitate over the subject. Some parts of the subject will glow with overexposure; other parts will be dark and mysterious. The contrast between the yellow light of the flashlight and the metallic blue of dusk also heightens the mystery. Have fun, and while you're out, watch for bats sweeping across the night.

Top left – Hot spring along the Discovery Loop (Canon EOS-1Ds, 24-85mm lens at 64mm, 25 seconds at f-18, Singh-Ray Warming Polarizer Plus)
Bottom left – Golden-mantled ground squirrel (Canon EOS-1N, 300mm lens, f-5.6, Fuji Provia 100 slide film) *Right* – Yellow-bellied sapsucker (Canon EOS-1N, 300mm lens, Fuji Provia 100 slide film)

the street; from here, stroll along the paved path, heading upstream, for views to Mount Norquay with the Bow River as your foreground.

Cascade Gardens

Go south on Banff Avenue, cross the bridge, turn left, and then take the first right onto Mountain Avenue, then right again. Here you will find a lovely five-acre rock garden full of a variety of wild and domestic species of flowers. Come here in overcast light for great flower portrait opportunities. Or, if it is sunny, visit the gardens from midmorning to early evening for views north across the flowers and pools of water to Banff Avenue and Cascade Mountain.

Surprise Corner

Take Banff Avenue south towards the Bow River. Turn left on Buffalo Street and follow the road as it turns into Tunnel Mountain Drive. At the sharp bend in the road, continue straight ahead into the small parking lot. Cross the road to a specially-built viewing platform, where you will be rewarded with striking views of the Banff Springs Hotel perched across the river above Bow Falls. I prefer the view offered back down the road about 100 metres, where the trees along the bank open up to provide clear views of the Bow River, Bow Falls below, and the Banff Springs Hotel above. The best light for this scene is early to midmorning, or when the hotel lights up brightly against the blue light of dusk.

Hoodoos Viewpoint

Follow Tunnel Mountain Drive until you come to the well-marked Hoodoos viewpoint. A 600-metre walk takes you to three viewing platforms with panoramas of the Bow and Spray Valleys and views down to the hoodoos. These geological landforms are a conglomerate of silt, gravel and boulders held together by dissolved limestone. You can photograph them from the viewing platforms (the farthest one provides the best views), or you can hike down one of many feeder

trails to the base of the hoodoos for close-up views. The best light is in general in the morning as eastern light spills across the Bow Valley.

Cave and Basin

Follow Banff Avenue south, cross the bridge over the Bow River, turn right onto Cave Avenue, and continue until you reach the Cave and Basin parking lot. Natural history buffs, especially, will enjoy this splendid rare ecosystem. A microcosm of rich marshland warmed by thermal springs provides a habitat where watercress grows in January, where robins are resident year-round, and where the endangered, minute, Banff Springs snail makes its home.

At the Cave and Basin, four hikes give you close-up views of the thermal pools and the unique flora and fauna of the area. The 500-metre Discovery Loop is good for those interested in seeing the thermal pools. The Marsh Boardwalk, a 600-metre loop, features views of the unique flora indigenous to the hot springs. The Marsh Loop (2.3 kilometres) provides fine views across the marsh to nearly all the major mountains in the area (best in mornings and evenings). It is also a fine place to photograph waterfowl from the wooden blind at the end of the marsh. Finally, the Sundance trail parallels the Bow River for additional views east and west to distant peaks.

Sulphur Mountain Gondola

Go south on Banff Avenue, cross the bridge, turn left, and then take the first right onto Mountain Avenue. Continue right along until you reach the gondola parking lot. The gondola zips you up to a futuristic-looking teahouse at the top of Sulphur Mountain. From here, an easy boardwalk leads you along the ridge of Sulphur Mountain to Sanson Peak. All along the way the views are grand, but most photographers prefer the views from the abandoned meteorological station. Be sure to bring a polarizing filter to help cut through the atmospheric haze. Also, you would be wise to take along a telephoto lens, because there are abundant and friendly least chipmunks, golden-mantled ground squirrels, Clark's nutcrackers, and bighorn sheep. Please do not feed the wildlife. It is illegal and makes the animals dependent on handouts. The gondola runs almost all year-round, with one two-week closure in January for maintenance. I recommend either taking the first car up in the morning, or going up in late afternoon or early evening and coming back on the last car down.

Bow Falls and the Banff Springs Golf Course

Take the left lane of Banff Avenue south to the bridge over the Bow River, turn left onto Spray Avenue, and follow this to your next left, where that road will take you to Bow Falls and the golf course. The falls rumble down a long inclined bed of rock and end in a large pool where the Bow and Spray Rivers merge. Because the falls face south, they are best lit by the midday sun, but they also look good in overcast or dusk light. The Bow River turns abruptly to the east below the falls, with views to the Fairholme Range for good photography from early evening to sunset.

For striking views of the Banff Springs Hotel with the Bow River in the foreground, walk across the bridge near the falls, and follow the paved path along the shore of the Bow River for about one kilometre

for long views back to the hotel (best from midmorning to midday).

The golf course road obviously takes you to the golf course, but it also makes a one-way loop through a low bench featuring meadow, forest and riverside views. Along the way, you can photograph the picturesque links of the Banff Springs Golf Course, rock climbers (look for the small gravel parking area on your right, at the base of Mount Rundle), rafters on the Bow River, or the ever-present elk that are residents in the area. I have also had good luck photographing forest birds that seem especially tame here.

Bow Valley Parkway

Where: The Bow Valley Parkway (Highway 1A) begins about 5.5 kilometres west of the western exit from Banff.

When: Any season, any light, any time, except from March 1 to June 25, when there is a travel ban every evening from 6 p.m. to 9 a.m. to protect sensitive wildlife.

How: The short answer is just to drive the parkway and you'll find photos worth making. The slow speed limit of 60 kilometres per hour (enforced rigidly by park wardens) and the relatively low traffic volumes encourage visual discovery, simply because you are more apt actually to see photographic opportunities than you would be when cruising at 90 kilometres per hour on the busier Trans-Canada Highway. For the specifics of where, when and how, the following details should be helpful. Distances are measured from the east end of the parkway and its junction with the Trans-Canada Highway. Distances in brackets are measured from the west end of the parkway, near Lake Louise.

Backswamp Viewpoint — Kilometre 3.0 (47.7)

This popular stop overlooks a vast marshland and the Bow River with views to the Sundance and Massive Ranges. Although it's a good place to stop and look for distant wildlife (especially coyotes and wolves in winter), as a landscape photo destination, it falls short in my eyes. I have seen many photographers working here, so maybe I am missing something; your best bet is to check it out for yourself. There is an alternate — and in my opinion, a better — vantage point about 200 metres farther west, just before the split in the highway.

Muleshoe Picnic Area — Kilometre 5.4 (45.3)

Overlooked by many photographers as "just another picnic spot in the woods", Muleshoe dishes out plentiful rewards for those who are patient and observant. For big landscapes, hike from the picnic grounds down across the railway tracks to the banks of the Bow River. Follow the riverbank right or left for scenes over the river to the distant peaks (best in the morning or evening).

A tall stand of white-barked aspen trees at the picnic site is worthy of a few frames of thoughtful abstraction. The trees have prominent black scars from elk rasping the bark off the trunks to supplement their meagre food supplies of winter. The result is an interesting black-and-white pattern on the tree trunks that works well for making more abstract or "painterly" looking photographs. As you can imagine, Muleshoe is a good location to watch for elk all year round, but especially in the winter.

Left – *Coyote (by Wayne Lynch, Nikon F4, 600mm lens, 1/250 at f-5.6, Kodachrome 64)* **Top right** – *Muleshoe area (Mamiya 645 Pro-TL, 80mm lens, f-22, Singh-Ray Warming Polarizer Plus, Fuji Velvia 50 slide film)*
Bottom right – *Sawback burn and aster flowers (Canon EOS-1N, 28-70mm lens, f-16, Singh-Ray Warming Polarizer Plus, Fuji Velvia 50 slide film)*

Directly across the highway from the parking lot, look for a small trailhead sign designating the Muleshoe trail. This seldom-hiked route climbs through the remnants of a 1993 Parks Canada prescribed burn and up a bare ridge. If you turn left at the top of the ridge you can connect with a parallel ridge taking you back down to the picnic area in a horseshoe-shaped (or is that a muleshoe-shaped?) loop.

The Muleshoe trail is usually snow-free by late April, and it not only gives you a fine aerial perspective over the Bow Valley, but it also traverses through charred and blackened trees, open wildflower meadows, and clumps of aspen trees. As a bonus, every time I have hiked here I have seen deer, elk, and bighorn sheep, the latter happily sunning themselves on the sunny slopes. I always end up doing the same thing as the sheep. Sitting in the sun, chewing my cud, I marvel at how easy it was to leave the bustling crowds of Banff behind. But be careful; there is a crowd of another kind here: the eight-legged variety. A hike up the Muleshoe trail in the spring may net you some unwanted little passengers in the form of ticks. Be sure to remove any ticks from your skin and clothing immediately, as they have the potential to carry and transfer Rocky Mountain spotted fever.

Sawback Prescribed Burn — Kilometres 5.6–10.4 (40.3–45.1)

This five-kilometre section of the parkway passes through a fire started by Parks Canada in 1993. Prescribed burns like this one help to regenerate meadows and aspen stands that have been slowly disappearing over the years, due to fire suppression policies that failed to consider the value of forest fires in a healthy ecosystem. The benefit to photographers is the creation of a stark and graphic landscape of black, grey, white, and rust-tinged tree trunks set in an understory meadow of lush green and colourful wildflowers like asters and fireweed. On an overcast and calm day, it is easy for me to get lost for hours as I make photos of the graphic shapes and colours to be found along this section of the parkway.

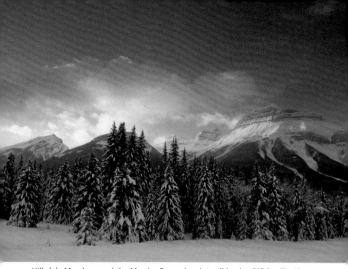

Hillsdale Meadows and the Massive Range in winter (Mamiya 645 Pro-TL, 45mm lens, f-22, Singh-Ray Warming Polarizer Plus, Singh-Ray 2-stop hard-edge grad, Fuji Velvia 50 slide film)

Hillsdale Meadows — Kilometre 12.2 (38.6)

Wide-open meadows with scattered stands of aspen trees, all hemmed in by the Sawback and Massive Ranges, leave little to challenge photographers. Show up in the morning or evening, screw on a polarizer and shoot. Want more? Sprinkle in the golden fall colours and a bugling bull elk (third week in September) and you'll have a cover shot worthy of any national outdoor magazine…if you remember to shoot a vertical composition! Also, be sure to watch for northern flickers that nest in cavities of the aspen trees.

Pilot Pond — Kilometre 15.1 (35.6)

West of Hillsdale Meadows, the parkway splits into two separate lanes for several kilometres. At the end of this split (kilometre 16.6), make a U-turn and head back towards Banff. Look for the parking area on the right about 1.5 kilometres along. Hidden in the forest is a small lake. There is a short, forked path here: the right fork leads to an open meadow above the lake, while the left goes down to the forested lakeshore. A lone peak, Pilot Mountain, stands sentinel over Pilot Pond. The shoreline views are tight and limited, so a wide-angle lens is a must if you want to get it all in, but fine images are fairly easy in sunrise to midmorning light.

Johnston Canyon — Kilometre 17.7 (39.3)

Johnston Canyon is a cliffhanger, both literally and figuratively. Much of the trail is a suspended catwalk that hugs the sheer cliffs of the canyon — that's the literal part. Figuratively, much like a TV cliffhanger where viewers must wait until next week for the conclusion, photographers will wait, and wait, and wait — sometimes until next week — just to get the shot. Why? Well, this is one of the most popular walks in Banff National Park, and on a bright summer's day, it is *busy*. The canyon features hanging metal catwalks, gnarled trees, plunging cliffs, a tunnel, and swirling cascades. Photographers with tripods

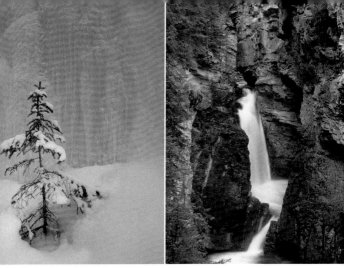

Left – *Johnston Canyon in winter (Canon EOS-1N, 70-200mm lens, f-16, Fuji Velvia 50 slide film)* *Right* – *Lower Falls, Johnst on Canyon (Canon EOS-1Ds, 24-85mm lens, Singh-Ray Warming Polarizer Plus)*

just get in the way, especially at the viewing platforms at the Lower and Upper Falls (a 1.1- and 2.7-kilometre hike, respectively). To be fair to the other visitors who come to experience Johnston Canyon, photographers should wait until the crowds disperse. It's best to go early in the morning, before the sun lights up the canyon, or later in the evening, near sunset. (Keep in mind that in summer this may be

Photo Tip: Squint Your Eyes

Film and digital sensors see contrast differently than the human eye does. Where our eyes see detail in both deep shadows and screaming highlights, film and digital sensors see only blobs of dark and light. Slide film and digital sensors have a very narrow latitude for exposure (the ability to record detail in differing values of light), so contrast is often a problem except in even, overcast light. Print film can hold some-what more detail in contrasting scenes, but is still not as capable as our eyes. In the real world, this creates a problem. Where we see colourful flowers in the shade under a tree, plus puffy white clouds in the sky, film and digital sensors will only see pure black shadows and washed-out skies. Somehow we need to be able to "see" like a camera.

The answer is to squint your eyes. Go out on a sunny day and squeeze your eyes nearly shut. What you see through the little slit is like a preview of how your camera will record the light. The shadows will go black and the highlights will remain bright. Now, if you photograph this scene, the film or digital sensor will give you an image that looks similar to the way you saw it through your squinty eyes (sans the eyelashes, of course). If the scene still looks good while you are squinting, it should look great recorded by the camera. If it doesn't look so hot, then reconsider the lighting (e.g., time of day), or try a different composition where the distribution of shadow and light is more aesthetically pleasing.

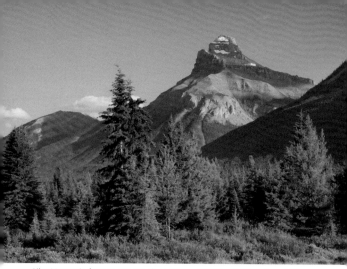

Pilot Mountain from Moose Meadows (Canon EOS-1Ds, 24-85mm lens at 77mm, 1/10 at f-16, Singh-Ray Warming Polarizer Plus)

well after 9 p.m.) In the winter, the canyon is a fairyland of bizarre frozen shapes, with far fewer tourists and loads of potential for unique photography.

Moose Meadows — Kilometre 18.7–20.2 (30.5–32.0)

It's highly unlikely you'll see a moose here, but you will see a wide, shrub-filled meadow with views south to Pilot and Copper Mountains. The best light here is sunrise to midmorning, and sunset in the summer. In the fall, the meadows become hued in a brilliant tapestry of warm colours, cloaked in frost when the night air dips below freezing.

What about the Trans-Canada?

You might be wondering why I haven't covered any photo stops along the Trans-Canada Highway between Banff and Lake Louise. The reason is simple: safety. The Trans-Canada is typically busy with vehicles in a rush to get somewhere else. It simply doesn't make sense to have folks slowing down, trying to find somewhere specific that I have recommended.

If you're interested in shooting pictures "in the fast lane" of the Trans-Canada, just watch for any spot where the Bow River edges up to the westbound lane. Pull far over as far as possible onto the shoulder of the highway and walk to the river's edge for potential images. In general, mornings and evenings offer the best light for photography. The section from Banff to Castle Mountain is frustrating because the ditch is fenced, and much of the good scenery is difficult to get to. The section from Castle Mountain to Lake Louise has no fence to impede your view... but I still don't recommend stopping here, purely for safety reasons. Personally, I have never exposed a single image along this section of highway because there are so many better, less busy, more peaceful spots in the park.

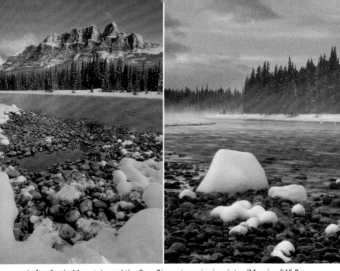

Left – Castle Mountain and the Bow River at sunrise in winter (Mamiya 645 Pro-TL, 35mm lens, f-16, Singh-Ray Warming Polarizer Plus, Singh-Ray 2-stop hard-edge grad, Fuji Velvia 50 slide film) Right – Bow River at the Castle Mountain bridge at sunset in winter (Canon EOS-1N, 28-70mm lens, f-22, Singh-Ray 2-stop hard-edge grad, Fuji Velvia 50 slide film)

Silverton Falls — Kilometre 24.0 (26.7)

Park at the Rockbound Lake trailhead and hike 700 metres to Silverton Falls, which are buried in a forested stand of lodgepole pine and balsam fir. You'll need to be a contortionist to maneuver into position for a clear shot of the falls. Half the fun is in the gymnastics, so put on your spandex, do a few deep knee bends, and see what you can score photographing here. These falls are best in overcast light.

Castle Mountain Bridge — Kilometre 24.2 (26.5)

At Castle Junction, turn left off the Bow Valley Parkway, (or right, if you're coming from Lake Louise) and follow the road for 0.7 kilometres to the Castle Mountain bridge. Park in the small lot on the left, just before the bridge. Hike over the bridge and immediately turn right and walk to the edge of the river. Once there, let your gaze soak up one of the iconic photographic locations of the Rockies. In the summer, Castle Mountain is sidelit by late morning, frontlit all afternoon, and sidelit again at sunset. In winter, the castellated peaks are sidelit at sunrise and frontlit at sunset. Great shots can be had at any of these times, but I prefer sunset in the summer and sunrise in the winter. Just a short distance upriver, Altrude Creek trickles into the Bow River. Follow this creek upstream for small pools and eddies that work well as intimate foregrounds to Castle Mountain. Or you can head under the bridge and walk downriver a short distance for views east to the Sawback and Massive Ranges.

Storm Mountain Viewpoint — Kilometre 26.5 (24.2)

Although I am not a big fan of this viewpoint west to Boom and Storm Mountains, I have seen a number of great images produced here by other photographers. It all comes down to being here when the elements of light and atmospheric conditions converge to turn the otherwise mundane into the extraordinary. Your best chances for this to happen are in the morning or evening.

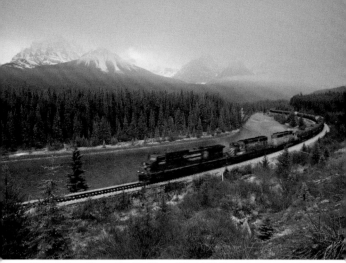

Morant's Curve (Canon EOS-1Ds, 20mm, 1/60 at f-5.6, Singh -Ray 2-stop hard-edge grad)

Morant's Curve — Kilometre 45.8 (11.2)

This view is one made famous by Nicholas Morant, who photographed the Rockies extensively in the 1930s and '40s for the Canadian Pacific Railway. The high peaks of the Bow Range, an S-curve in the railway tracks, an eastbound train, and good light are the requirements for this classic photo stop. The tracks curve from north-south to east-west, so the Bow Range will be lit by warm light at sunrise, sidelit by midday, and backlit at sunset. Choose your favourite type of light, set up your composition, and wait for the distant whistle of an eastbound train.

Lake Louise

Where: A well-marked interchange off the Trans-Canada Highway will take you into the village of Lake Louise. Continue straight ahead, up the hill, where the road will deposit you into a vast parking lot near the shores of Lake Louise.

When: The lake is usually ice-free from late May well into October. The best light is from sunrise to midday.

How: Lake Louise is probably one of the most photographed natural landscapes in Canada. Day after day, in every season, photographers line up along the eastern shore of Lake Louise, hoping to capture the sweet morning light as it paints warm hues on Mount Victoria in the background. Even bleary-eyed, bed-headed hotel guests shuffle out in slippers and bathrobes to snap the alpenglow on the peaks reflected in the calm waters of Lake Louise. You'll see plenty of flashes popping as compact point-and-shoot cameras try in vain to "auto-expose" the huge, shadowed lake. Then there are the professional photographers, who have packs full of gear costing in excess of what most visitors have paid for their motorhomes. For me, it is almost more fun people-watching than actually shooting! If you want solitude, you had better go shoot elsewhere, but if you want the ultimate Rockies postcard, Lake Louise at sunrise should be high on your list of priorities.

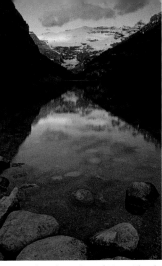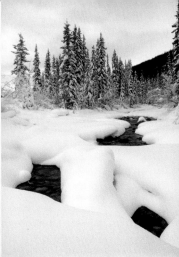

Left – Lake Louise and Mount Victoria (Mamiya 645 Pro-TL, 35mm lens, f-22, Singh-Ray 3-stop soft-edge grad, Fuji Velvia 50 slide film) **Right** *– Winter scenic from the outlet stream at Lake Louise (Mamiya 645 Pro-TL, 35mm lens, f-16, Singh-Ray Gold-N-Blue Polarizer™, Fuji Velvia 50 slide film)*

There seem to be three favourite sites for most photographers: the outlet stream, the shoreline between the outlet stream and the boat dock, and the boat dock itself. If you just want a simple reflection shot of Mount Victoria, it really doesn't matter where on the shore you shoot from. But if you want flowing water, jumbled rocks, or canoes as a foreground, then one of the spots mentioned above is a must. Fortunately, there is plenty of elbow room, and many photographers find camaraderie with other sunrise-shooting companions. Friendships can develop as advanced photographers help novices with advice on how to shoot the scene. Best of all, the location is close to coffee and snacks, so it is easy to munch and sip away while the incredible light plays over the scene.

You will need some technical expertise if you wish to expose the brightly lit peaks and the shadowed lake properly at the same time. If you haven't already read chapter 3, "Capturing the Light", you should do so before attempting sunrise at Lake Louise. You will need to use grad filters, or the digital merging of highlight and shadow exposures, to capture the full range of tones in a Lake Louise sunrise. Otherwise, part of your scene will be noticeably over- or underexposed.

Photo Tip: Kneeling or Standing?

At Lake Louise, photographers adopt one of two postures for shooting: kneeling or standing. Which is better? The short answer is: neither. The long answer is that a tripod is always the best option. As impressive as it is, the alpenglow on Mount Victoria is still relatively dim. Shots of the lake and distant peaks will invariably be blurry if you shoot hand-held.

A tripod not only improves image sharpness, it allows you to fine-tune your composition carefully, and use small apertures (e.g., f-22) for maximum depth of field. As well, it will hold your camera in position as you wait for the light to go from good to great — or leave you with your hands free to sip that freshly brewed latte.

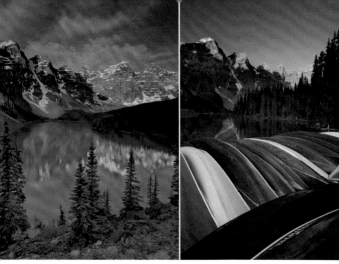

Left – Moraine Lake and Wenkchemna Peaks at dawn (Mamiya 645 Pro-TL, 35mm lens, f-16, Singh-Ray Warming Polarizer Plus, Singh-Ray 2-stop hard edge grad, Fuji Velvia 50 slide film) Right – Moraine Lake from the boat dock (Canon EOS-1Ds, 20mm lens, 1/2 at f-22, Singh-Ray 3-stop hard-edge grad)

Moraine Lake

Where: Moraine Lake is accessible along a well-marked road two kilometres west of Lake Louise Village. The road is open to vehicle traffic from late May through early October. In winter months, it is open and groomed for cross-country skiing.

When: The peak season for photography at Moraine Lake is early summer (late June and all of July) when the sun rises furthest to the north, nicely lighting up the northeast-facing Wenkchemna (or Ten) Peaks. At this time of year, the lake will be full of water from the melting snowpack, but the peaks will still be frosted with a dusting of snow.

How: The "classic" photo of Moraine Lake is taken from the rock pile, a large moraine of boulders at the northeast end of the lake near the parking lot. This view gives a panoramic sweep of the lake and the Wenkchemna Peaks. If you wait until midmorning, when the sun rises to light the lake along with the peaks, you'll get that famous blue-sky, emerald-lake image so commonly depicted in calendars, postcards, and on the sides of rented motorhomes.

Get up to the lake for sunrise and often you will be rewarded with dramatic orange light sweeping the tops of the Wenkchemna Peaks. You'll need to be on location before 6 a.m. in June or July if you want to capture this early-morning light show. As well, you'll need to put into play all your technical expertise to pull off a useful shot at sunrise. The contrast between the brightly lit peaks, the dark conifers, and the shadowed lake is extreme, beyond the ability of either film or digital sensors to record it all.

Another favourite vantage point is from the canoe dock, where you can fill the foreground with the repeating patterns and colours of rental canoes. Once the light strikes the lakes and the canoes, put on a polarizing filter to help saturate the colours in the scene even more. When the boathouse opens, get a friend or family member to paddle out on the lake for some nice images of a red or yellow canoe set against a robin's-egg blue lake.

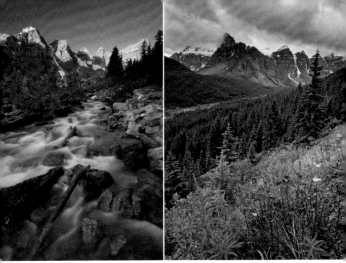

Left – *Moraine Lake from the outlet stream (20mm lens, 1/2 at f-22, Singh-Ray Gold-N-Blue Polarizer™, Singh-Ray 3-stop hard-edge grad)* *Right* – *The view of the Valley of the Ten Peaks a few kilometres before reaching Moraine Lake (Canon EOS-1N, 20mm lens, f-22, Cokin pink grad, Fuji RFP 50 slide film)*

If you're looking for another foreground option, try incorporating the outlet stream of Moraine Lake into your composition. The water cascading over jumbled boulders provides a fluid dynamic to an otherwise static portrayal of the lake. Exposure times longer than 1/15 of a second will ensure that the moving water takes on a wispy appearance in the final photo.

Wherever you decide to photograph at Moraine Lake, the scenery will demand an all-inclusive treatment. In 35mm format, the best bet is a lens in the 17-24mm range. If you use anything longer, you'll miss parts of the vista. Longer lenses are useful, however, for detail shots and abstractions of the landscape. But for those classic, "near foreground, distant background" images, a wide-angle lens set at f-22 is mandatory.

Chapter 7
Kootenay National Park

Highway 93 South, also known as the Banff-Windermere Highway or the Kootenay Parkway, snakes through 96 lovely kilometres of Kootenay National Park. In my opinion, this is easily one of the most scenic drives in the Canadian Rockies, second only to the Icefields Parkway. Yet few photographers take the time to explore its wealth of photo possibilities. Perhaps the reason that Kootenay is overlooked is the lack of a major frontcountry destination. There are no glaciers to drive to, no lodges by turquoise lakes to stay at, and no mountain towns with souvenir shops to visit. Indeed, if it were not for the hot springs at Radium, I doubt there would be much to attract most visitors, but Kootenay has much to offer photographers. Because this highway runs north and south, morning and evening light are exceptional, with both east- and west-facing peaks available to capture the dawning and waning light of the day. In addition, the wide shoulders along the highway make stopping anywhere an easy task. Here are a few of my favourite views along the way. Note: all distances are measured from the intersection of Highway 93 with the Trans-Canada Highway in Banff National Park.

Vermilion Pass, Vermilion Burn (1968), and Tokumm Creek Burn (2003)

Where: There are five viewpoints within Vermilion Pass, of which two provide panoramic overlooks. One is a designated brake-check stop on the east side of the highway, about six kilometres from the north end of the Kootenay Parkway. The other is the Vista Lake viewpoint at kilometre 8.2. Both are good positions for getting 360-degree views of the pass and surrounding peaks. Then there are the Continental Divide/Fireweed trail parking lot at kilometre 10.0, an expansive meadow on the east side of the highway at kilometre 12.9, and the Stanley Glacier trail at kilometre 13. All provide further views into Vermilion Pass and also close views of the Vermilion Burn of 1968 and the Tokumm Creek Burn of 2003.

When: The brake-check and Vista Lake viewpoints look best from sunrise to midmorning, or from late afternoon to sunset. The Fireweed trail is best in overcast light and is good for older forest regeneration images. Stanley Glacier is best hiked in the morning or evening.

How: Distant peaks framed with the spines of old burned trees are the classic shots to be had from Vermilion Pass. A short telephoto zoom (e.g., 35-135mm) is perfect to get precise framing of the tree spires and peaks. The same lens is a good choice along both the Fireweed and Stanley Glacier trails to make abstract scenes of burned tree trunks. When I visited the Stanley Creek area in 2004 to make the images for this book, the Tokumm Creek fire had left the forest skeletal and charred. Over the next few years, the Stanley Glacier trail will be blazing with colour — purple aster, fleabane and vetch, yellow groundsel, and pink fireweed — as life returns to the burned forest. If you make a visit with wildflowers in mind, you'll want to hike here when it is calm and overcast. But if you are more interested in photographing Stanley

Left – The Guardwall from the second bridge on the Stanley Glacier trail (Canon EOS-1N, 20mm lens, f-16, Singh-Ray Gold-N-Blue Polarizer™, Singh-Ray 2-stop hard-edge grad, Fuji Velvia 50 slide film) **Top right** *– Fireweed in fall colours along the Fireweed trail (Canon EOS-1N, 28-70mm lens at 28mm, f-22, Singh-Ray Warming Polarizer Plus, Fuji Velvia 50 slide film)* **Bottom right** *– Tokumm Creek Burn (2003) along the Stanley Glacier trail (Canon EOS-1Ds, 28-70mm lens at 40mm, 2 seconds at f-22, Singh-Ray Gold-N-Blue Polarizer™)*

Glacier itself (a 4.2 kilometre hike), you'll want a nice sunny morning.

Besides providing great access to a burned forest, the Stanley Glacier trail features soaring peaks, a tumbling cascade, steep-walled cirques, and a hanging glacier. Even if you don't do the whole hike, at least try to make it to the second bridge over Stanley Creek (about 2 kilometres) to see the looming "guardwall" of black limestone over

Photo Tip: Get Hyper-Focused!

To get the maximum possible depth of field from your wide-angle lens, set the aperture on your lens to f-22, and then focus your lens manually to the distance in feet indicated on the chart below (Focal Distance at f-22). The resulting photo will be in sharp focus from one-half the distance set on the lens to infinity.

For example, with a 20mm lens set at f-22 and focused to 2.3 feet, the range of sharp focus in the scene will span the distance from 1.15 feet in front of the camera to infinity. Once you focus your lens manually to the proper distance, do not refocus or use auto-focus while photographing your chosen scene.

Hyperfocal Distance Chart

Lens	Focal Distance at f-22	Range in Focus
15mm	1.3 feet	0.65 feet–infinity
16mm	1.5 feet	0.75 feet–infinity
17mm	1.7 feet	0.85 feet–infinity
20mm	2.3 feet	1.15 feet–infinity
24mm	3.3 feet	1.65 feet–infinity
28mm	4.5 feet	2.25 feet–infinity
35mm	7.0 feet	3.5 feet–infinity

Left – Marble Canyon (Mamiya 645 Pro-TL, 45mm lens, f-16, Singh-Ray Warming Polarizer Plus, Fuji Velvia 50 slide film) *Right* – Numa Falls (Canon EOS-1Ds, 28-70mm lens at 28mm, 5 seconds at f-22, Singh-Ray Warming Polarizer Plus)

the creek and surrounding flower-filled meadow. It is best to get to this bridge as early as possible because the guardwall looks best in the morning sun. If you hike all the way up, don't stop at the rocky scree at the official trail's end, but make the scramble up the faint pathway through the scree to the hanging amphitheatre for a surprising Shangri-La of gurgling water in a verdant mossy meadow.

If hiking isn't your thing you can still see and photograph the guardwall from the roadside meadow at kilometre 12.9 (best sunrise to mid-morning).

Marble Canyon

Where. A signed stop and campground at kilometre 17.0.

When: Best in overcast light.

How: This one is simple. Show up in overcast light and hike to the top of the canyon. Seven bridges cross the 600-metre long canyon, each providing an aerial view of the plunging chasm below. A tripod is mandatory if you want to make the long exposures necessary to penetrate to the depths of the canyon. I find that wide-angle to short telephoto lenses work well here. The Tokumm Creek fire wreaked havoc in this canyon, closing it for much of 2003 and 2004 and it is likely to be closed throughout 2005 as well, so crews could cut down dangerous snags and repair bridges. By the time it reopens, Marble Canyon will be a fine destination not only for its twisted gorge, but for its superb wildflowers, especially the dense clumps of fireweed and aster that commonly colonize after a fire.

After the hot springs at Radium, Marble Canyon is the most popular spot in Kootenay, so expect crowds. If you want some elbow room, be sure to get there before 9 a.m., or visit later in the evening. If you are an early riser, hike the 800-metre trail to arrive at the head of the canyon for sunrise, when you can capture Tokumm Creek in the foreground and fiery hues on the Vermilion Range in the background.

Paint Pots (Canon EOS-1Ds, 70-200mm lens at 200mm, 1/6 at f-16, Singh-Ray Warming Polarizer Plus)

Paint Pots and Numa Falls

Where: Both areas are signed; the Paint Pots are located at kilometre 20.0 and the Numa Falls picnic site at kilometre 24.5.

When: The Paint Pots area looks good throughout the day. Numa Falls is best in overcast light or at midday on a sunny day, when both sides of the canyon will be evenly lit.

How: The one-kilometre Paint Pots trail leads through an area of red and yellow clay ochre beds and ends at three mineral pools known as the "Paint Pots." The area is located in an open meadow along the Vermilion River. A suspension bridge spans the river to reach this sacred native site, where First Nations peoples used the red earth to decorate teepees, clothing, and their bodies, and to create rock paintings. Peaks circle the site, so it is possible to include mountain backdrops in your compositions. I prefer sunrise and early morning for better light and fewer people, but an evening or sunset stroll will be just as rewarding photographically. A polarizer is recommended to help reduce reflective glare from the water and to saturate the orange, red, and yellow colours of the mineral deposits.

Don't expect to see water plunging down a steep-sided cliff at Numa Falls. Instead, you'll see a footbridge over Numa Creek, where churning water boils down a straight chute carved out of the rock. It is interesting photographically, but the word "falls" is a bit overstated.

Verendrye Burn (2003) and Floe Lake

Where: From kilometre 30.0 (near the Floe Lake trailhead) to kilometre 42.0, the Verendrye Creek Fire just about touches the pavement.

When: Best from sunrise to midmorning, and overcast days.

How: This is a fine location to explore the results of a forest fire. You can make images of the skeletons of burned trees set against the peaks of the Rockwall to the west, or create intimate abstracts of new growth or coloured wildflowers, such as fireweed or Indian paintbrush,

Left – Oxeye daisy (Canon EOS-1Ds, 300mm lens, 1/20 at f-4)
Right – The Rockwall and the Verendrye Creek Burn at Verendrye Creek
(Canon EOS-1Ds, 24-85mm lens at 28mm, 4 seconds at f-22, Singh-Ray 3-stop
hard-edge grad)

against the blackened trunks of burned snags. Just cruise the highway and stop anywhere that appeals to your visual tastes. This scenic backcountry spot is reached by a 10.7 km trail that is closed in 2005 to repair fire damage. Check with Parks before planning a visit here. It is considered by many to be the most scenic backcountry lake in all the Rockies. Sunrise on the Rockwall over Floe Lake is an iconic backcountry photo that is on the wish list of many photographers.

The Wildlife Photographer's Park

The two best destinations for wildlife photography in the Canadian Rockies are Jasper and Kootenay National Parks. Jasper's reputation is well known among wildlife shooters, thanks to its hotspots at Wilcox Pass, the Athabasca Valley, and the Maligne Lake Road. In Kootenay, wildlife is just as abundant, and it's easily accessible along the entire length of the Kootenay Parkway.

In spring (May and June), the ditches along the parkway often attract hungry black bears grazing on lush succulent grasses, sedges, and wildflowers. One of the bears' favourite early-season snacks is the dandelion, on which the bruins feast like folks at an all-you-can-eat dinner buffet. I have seen as many as six different bears dining on ditch salad during one morning drive in the park. If you've never seen a bear, a drive along the Kootenay Parkway in spring should solve the problem.

Besides the bears, deer and elk are also abundant along the highway. A good place to check is the McLeod Meadows area. Moose are often spotted in the Simpson River area; mountain goats frequent the mineral lick near Hector Gorge; bighorn sheep are common in the spring and fall in Sinclair Canyon, and coyote sightings are common almost everywhere. The Kootenay Parkway is also one of your best bets for wolf sightings. In short, if wildlife is high on your priority list for photography, you need to visit Kootenay National Park.

Hawk Ridge (Canon EOS-1Ds, 24-85mm lens at 73mm, 1/8 at f-20, Singh-Ray Warming Polarizer Plus)

Hawk Ridge

Where: Between Kootenay Park Lodge and the Simpson River trail (kilometres 40.9 to 47.0).

When: Best from midafternoon to sunset.

How: Hawk Ridge rises to the east of the highway, behind the meandering Vermilion River, like a long, knobby backbone. Wherever the river skirts the highway, there is the potential for great photos. Just pick an oxbow, or a braided channel in the river, and you'll have a strong foreground for composing an image.

Mount Wardle and Hector Gorge

Where: Between the Simpson Monument at 47.5 kilometres and the Hector Gorge viewpoint at 57.2 kilometres is a stretch of road cradled by Mount Wardle to the west and Spar Mountain to the east. Here you'll find an animal lick (look for moose) at kilometre 48.5, Wardle Creek at kilometre 50.7, a scenic oxbow in the Vermilion River at kilometre 52.9, and a goat lick at kilometre 56.2.

When: Late afternoon to sunset for views to the east and north, and sunrise to midmorning for views of Mount Wardle up Wardle Creek.

How: Whenever I have seen grizzly bears in Kootenay National Park, it has been along this stretch of highway, so be sure to have your camera and telephoto lens handy. Even if you don't see a bear, it is quite likely that you'll see a moose or a goat, especially if you cruise through here in the morning or evening. For landscape images, just look for interesting foregrounds with open views to the distant peaks; there are plenty of potentially wonderful images along this section.

The Kootenay River and the Mitchell Range

Where: From the Kootenay River Bridge at kilometre 60.5 to the Kootenay River picnic area at kilometre 80.9, the highway flanks the Kootenay River, providing numerous opportunities for grand views

Photo Tip: A Portable Wildlife Photography Blind

Left – Grizzly bear (by Wayne Lynch, Nikon F4, Nikkor 600mm, 1/250 at f-5.6, Fuji Velvia 50 slide film) Right – Mountain goat (Canon EOS-1N, 300mm lens 1/50 at f-5, Fuji Provia 100 slide film, converted to black-and-white and toned in Photoshop)

If you happen to have forgotten your commando make-up, your camouflage outfit, or your night vision goggles back in the hotel room, don't fret. You won't need any of that macho stuff to approach wildlife in the Canadian Rockies. You have everything you need right there in your vehicle. Wild animals along the busy park highways pay little attention to vehicles, and often will continue to ignore you even if you pull up beside them. This makes roadside wildlife photography very easy: just roll down the window and shoot. Here are a few pointers to help you make using your "portable blind" safer and more effective to use.

Your safety, the safety of other motorists, and the animal's safety should be your primary concern. When many folks catch sight of a wild animal, they just stop dead in their tracks with no consideration to safety. I can't count the number of times I have encountered vehicles parked in the middle of the road, sometimes even on the crest of a hill or around a blind curve. This is

just begging to be hit by another driver. Always park on the shoulder, put on your flashers, and don't park anywhere where other motorists will not have ample warning of your presence. If it is not safe to stop (on a curve, on a steep hill, anywhere there is no highway shoulder) please don't!

If you see vehicles parked on the edge of the highway, please slow down. Numerous times I have watched in horror as motorists zipped by parked vehicles, unaware that an animal was just about to step out onto the highway from between parked vehicles. On separate occasions, I have seen a black bear, an elk, and a bighorn sheep killed this way. Such carelessness is inexcusable.

If the animal seems stressed by the presence of your vehicle, it may move away from you, try to hide behind some bushes, or act aggressively towards the vehicle. These are important signals for you to heed, and you should drive away whenever you see these warning signs of stress. I have seen male bighorn sheep and elk

Photo Tip: A Portable Wildlife Photography Blind

Moose (Canon EOS-1N, 300mm lens 1/60 at f-5, Fuji Provia 100 slide film)

actually charge — and damage — vehicles that got between them and their females during mating season. Don't pressure animals by continually moving your vehicle a few feet every time the animal moves — if you do, you just might earn a souvenir dent with which to remember your mistake.

Remain in your vehicle. Although deer, elk, sheep, and goats may act like domestic livestock and seem tame, you must remember you are dealing with wild animals. Countless times I have watched overzealous photographers jump out of their vehicles and walk right up to the animal to snap a photo. I have frequently seen an over-excited photographer trying to pose his or her family right beside a testosterone-charged, grumpy bull elk. No wonder people get gored, charged, and attacked by wildlife. Use your head!

At other times, an animal — especially an elk or sheep — may be so oblivious to your presence that getting a good photo seems impossible. The animal just won't stop grazing, won't look your way, or has its back turned to you. Resist the temptation to whistle, yell, or honk your horn. These animals are not here for your entertainment; so don't expect them to perform on command. You are in their home. Treat them with respect and be as unobtrusive as possible. If you are patient, just waiting and watching, you'll get far better, more natural-looking photographs than if you push the animal to respond. Harassment of wildlife is against park policy and causes severe stress to the animals, especially in winter and early spring when their energy reserves may be at a critically low level. No photo can justify the poor treatment of wild animals.

Once you are safely parked, and it seems the animal is calm and accepting of your presence, you can then enjoy making images from the comfort of your vehicle. Use a rolled-up coat, a pillow, a beanbag, or a commercial window camera-mount to steady your lens against the frame of your open car window. Turn off the engine to reduce vibrations being transferred to your camera, and, more importantly, to enjoy the moment in peace and quiet. Ask all the passengers riding with you to speak softly and remain still. Enjoy the fact that you get to participate in a small window of the animal's life. Getting good photos is nice, but it should always be of secondary concern. The welfare of the animal and the safety of other park visitors should always be your primary consideration. Happy and safe shooting!

to the peaks in the east.

When: Best from early afternoon to sunset.

How: Drive this section of road looking for interesting foregrounds (flowers, meadows, river channels, reflecting pools, river oxbows) against which to set the Mitchell Range. This section of highway is the most abundant with wildlife, and if you don't see at least one deer or elk during a morning or evening drive, send me this page of the book and I'll eat it.

McLeod Meadows campground at kilometre 76.9 is a fine spot to set up base camp for several days of productive photography. From this campground, you have quick access to this scenic section of the park and its abundant wildlife, and from the campground you can hike two kilometres to Dog Lake for nice reflections of the Mitchell Range in evening light.

Consider Not Stopping

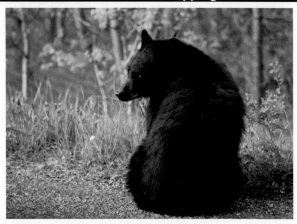

Black bear on the side of the Icefields Parkway (Canon EOS-1N, 28-70mm lens at 70mm, f-4, Fuji Provia 100 slide film)

In the past, whenever I saw a bear on the side of the road, I would pull over to watch or photograph it. Lately, my attitude has changed profoundly. These days, when I see a bear in the parks, I drive by and leave the animal in peace. After watching bears and their behavioral responses to vehicles and tourists, I have concluded that stopping to watch them has a negative impact on the animal. Not only does it often cause stress, aggression, and displacement from prized food sources, it also teaches bears bad habits like food begging, and, worse, loss of fear of people. Roadside traffic jams also create a hazard for bears that walk between parked cars out into oncoming traffic. Parks Canada statistics tell us that, from 1993 to 2003, 125 bears have been killed on the roads in the mountain national parks. So now, when a see a bear in the ditch, I slow down to pass it safely, and I appreciate that I got to see a wild bear, and I leave it to go on with the business of survival. I hope you'll do the same.

Left – The Mitchell Range and the Kootenay River in late April (Mamiya 645 Pro-TL, 45mm lens, f-22, Singh-Ray Gold-N-Blue Polarizer™, Singh-Ray 3-stop hard-edge grad, Fuji Provia 100 slide film) ***Top right*** – View of peaks from the Kindersley/Sinclair Col (Canon EOS-1N, 28-70mm lens, Singh-Ray Warming Polarizer Plus, Fuji Provia 100 slide film) ***Bottom right*** – The hot springs at Radium (Canon EOS-1Ds, 28-70mm at 37mm, 1/320 at f-5)

Sinclair Pass and Sinclair Canyon

Where: From the Kootenay Valley viewpoint at kilometre 88.5 to the Kootenay Park exit at kilometre 104.0, the highway runs east-west through the narrow and scenic Sinclair Canyon.

When: Any time, but overcast and midday light are best.

How: There are few pull-offs and no shoulders along here. This makes roadside photography difficult and dangerous. When you do see a parking spot, pull off and explore. In general, you'll be shooting more intimate scenes along the edges of creeks, under the canopy of the forest, or along the margins of the canyon walls.

My favourite day-hike in the area is the Kindersley Pass trail, which climbs up Kindersley Creek to the Kindersley–Sinclair Col for 360-degree aerial panoramas of the peaks in Kootenay, Banff, and Mount Assiniboine Parks. Continue your hike down Sinclair Creek where you'll meet the highway for a short jaunt west to your vehicle. The total hike is about 18 kilometres, with a fair amount of elevation gain, so you must be pretty fit to do this hike in a day.

Another nice stop is immediately west of the Iron Gates Tunnel at the main parking lot for Radium Hot Springs, which features views to rust-red cliffs to add nice variety to your Rockies portfolio. Come back at dusk and try your hand at long-exposure, headlight and taillight streaks of cars funnelling through the narrow gap in the canyon just west of the hot springs.

Chapter 8
Yoho National Park

E very guidebook on the Canadian Rockies reminds us that Yoho is the Cree word for "awe", and that awe is an apt adjective for describing this park. I agree: Yoho, although the smallest park covered in this book, is easily one of the most scenic. But photography in Yoho is not as easy as it is in Banff, Jasper, Kootenay or Kananaskis. The 46-kilometre stretch of the Trans-Canada Highway that runs through Yoho is heavy with fast-moving traffic. The highway has few pull-offs, and the shoulders are often dangerously narrow. In short, leisure sightseeing and photography along this highway can be a frustrating and risky proposition.

There are three roads in Yoho that feature less traffic and more scenic possibilities for the photographer. These are the Yoho Valley, Emerald Lake, and Wapta Falls roads. But really to see the best of Yoho, photographers need to get away from the roads, because, of all the parks in the Rockies, Yoho has the greatest concentration of outstanding hiking trails. So buff up your boots, grab some granola bars, shoulder your pack, and get ready to walk a little farther for those stunning shots we all crave.

Lake O'Hara
Where: 11 kilometres west of Lake Louise — or 15 kilometres east of Field — is the Lake O'Hara parking lot. From here, a shuttle bus runs from mid-June to October to take hikers into the Lake O'Hara area.

When: Any time of the day in June though September, with prime times being late July and early August for alpine flowers, and mid-September for the forests of subalpine larch trees in their autumn finery.

How: The Lake O'Hara area, although road-accessible via a shuttle bus, is really considered a backcountry destination, unlike most other areas covered in this book. Getting to Lake O'Hara requires detailed planning (see side-bar), but it's worth it: the scenery there is absolutely the best that the Canadian Rockies has to offer.

This area is not for the faint of heart. Not only will the scenery set your heart a-pounding, the trails will, too! Almost every trail — with the exception of the Lake O'Hara Circuit — is a knee-busting, lung-bursting, heart-banging affair that takes you to dizzying scenery amongst alpine meadows, sparkling lakes, and towering peaks.

If you go, plan to stay at least three full days, whether you do it frugally in the Lake O'Hara campground or in luxury at the Lake O'Hara Lodge (tel. 250-343-6418). Make sure you do at least these three hikes: Opabin Plateau to Opabin Lake, the Lake McArthur trail, and the Lake Oesa trail. If you can only manage a single day-hike, I would recommend the Opabin Plateau.

Lake O'Hara itself is best in afternoon or sunset light; the others are good all day long. Indeed, it would be easy to do a whole book on specific times and places for photography on the hikes in this area. But once you are there, photo opportunities just jump out all over the place, so just follow your instincts. This is truly one of those "f-8 and be there" locations.

Getting to Lake O'Hara

Left – *Mount Huber, Lake O'Hara and Mary Lake from All Soul's Prospect (Canon EOS-1N, 20mm lens, f-22, Singh-Ray Warming Polarizer Plus, Fuji Velvia 50 slide film)* *Right* – *Opabin Terrace Pools from Opabin Plateau (Mamiya 645 Pro-TL, 35mm lens, f-16, Singh-Ray 2-stop soft-edge grad, Fuji Reala 100 print film)*

Access to Lake O'Hara is well controlled in order to protect the fragile alpine area from overuse. The road to Lake O'Hara is restricted-access; it's open only to shuttle buses and hikers in summer, and cross-country skiers in winter. So you either have to walk or ski there (11 kilometres on the road) or make arrangements to catch the bus.

To catch the bus please note:

1. The bus usually runs only from mid-June to early October, and has two morning departure times and two afternoon return times. These times may vary from year to year, so be sure to check on the Yoho Park website (www.pc.gc.ca/pn-np/bc/yoho) or check for current information at the Field Visitor Information Centre. Also note that you are restricted to two bags or packs per person as "luggage" on the bus (25 kilograms total weight is the personal limit).

2. Reservations are highly recommended, and can be made three months in advance by phoning 250-343-6433. While you cannot book earlier than three months in advance, you also shouldn't wait to book, since the limited spaces sell out almost as soon as they become available. Be prepared to redial that number often before getting through! The reservation desk opens at 8 a.m. mountain time.

3. Small numbers of seats and campsites are set aside for people without advance reservations. Phone the number above the day before you plan to visit if you want to try to get one of these spots. (Good luck!)

4. You can show up at the Lake O'Hara parking lot before the bus leaves to see if you can take advantage of any last-minute cancellations.

5. Failing all that, your last option is to carb up and make the long, slow slog up the road, as there is no restriction on how many people can hike into Lake O'Hara.

Hiking with Camera Gear

I've seen photographers hiking the trails of Yoho with all manner of gear, from oversized single-strap shoulder bags, to aluminium studio cases. And these same folks are dressed in jeans and leather jackets, and wearing loafers or high heels. Wilderness photography demands wilderness gear, not clothing and equipment that are more suited for the mall or studio. Mountain weather and mountain terrain are unpredictable and unforgiving. It is best to be prepared, especially if you plan to venture out for a day-hike into the amazing alpine environs of the Rockies. Here are a few guidelines to help the uninitiated.

1. **Less is more.** Take the minimum amount of camera gear necessary. On day-hikes, a single all-purpose zoom lens (e.g., 24-85mm) is all I need. If I know that spotting wildlife is a good bet on a hike, I will also throw in my lightweight 300mm f-4 lens. I also bring a few rolls of film or digital media, a polarizer, a cable release, and a lightweight tripod. There have been times when I wished I had a certain piece of equipment along — a different lens or a flash, for example — but I can usually cover everything I want to with this small arsenal of gear. In the past, I have carried big packs with all my gear on long day-hikes. All I succeeded in doing was sapping myself of energy. I had nothing left over to do good photography or enjoy the experience of the hike.

2. **Use a proper backpack.** Most camera packs are designed only to haul camera gear; few have enough space or compartments for food, water, and clothes. Because of this, I use a hiker's daypack, which has plenty of room for everything, including my tripod and camera gear. Many shooters hike with a shouldered tripod and camera. This is fine for short jaunts, but for longer hikes, or on steep sections, I want my camera and tripod inside my pack so my hands are free to scramble up the trail, or so I can use hiking poles.

3. **Consider using hiking poles.** Because I am always trying to cut down on weight when hiking, many people are surprised that I recommend hiking poles. But on long hikes where there are steep sections, nothing will save your knees and help you hike more safely (especially at stream crossings) than a pair of strong but lightweight hiking poles. If you plan to do lots of hiking, be sure to purchase poles with shock absorbing tips, as this feature is definitely worth the extra expense. When shooting, or walking on flat stretches, I just strap the poles to the side of my pack.

4. **Plan for rain and wind.** Even if the day dawns gloriously sunny, there is a good chance that by afternoon it will be raining. And even if it doesn't rain, once you reach the alpine, it is often cool and windy. I can't tell you how many times I have seen hikers in shorts and t-shirts shivering away on a high mountain ridge. It is hard to be creative and make fine images if you are freezing.

5. **Wear appropriate clothing.** Cotton and denim are killers. If it is cold and you get wet, you can quickly develop dangerous hypothermia. Wool, fleece, or polypropylene fabrics are the best bets in the mountains because these fabrics wick moisture away from your body,

Hiking with Camera Gear

insulate while wet, and, best of all, dry quickly. When I hike, I always wear a polypro shirt and pants, and I always have a lightweight fleece, extra shirt, and waterproof jacket in my pack. Proper hiking boots are also important. Do not hike in running shoes or street shoes. You need boots with proper ankle support and rugged soles. And don't forget a hat and sunglasses.

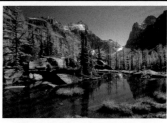

Opabin Terrace Pools and Mount Hungabee (Mamiya 645 Pro-TL, 45mm lens, f-16, Singh-Ray Warming Polarizer Plus, Fuji Velvia 50 slide film)

6. **Pack for an emergency.** I always have a small stuff bag in my pack that contains emergency gear. A whistle, small mirror, space blanket, waterproof matches, compass, penlight, and basic first aid kit should be in everyone's daypacks. Should you trip and fall, get lost, or get injured on your hike, you'll need a few supplies to tide you over until help comes or you find your way out.

7. **Bring snacks and water.** Even if you only plan to be gone a couple of hours, a few snacks and some water will be welcome. It doesn't take long to work up a huge appetite while hiking, especially in the mountains. For me, the greatest joy in hiking is the reward of food at the top. Nothing beats sitting in the sun on a mountain pass, feasting on well-deserved goodies.

8. **Be bear aware.** Chances are good you'll never even see a bear while hiking. You are more likely to get killed driving to the trailhead than you are being attacked by a bear once on the trail. But in my years of solo hiking, I have had enough close encounters that I am extremely vigilant about bears, and lately cougars as well. People have been killed in these parks by both animals, so a dangerous encounter is not out of the realm of possibility. Both animals generally avoid groups of two or more humans, so your best line of defense is never to hike alone. In enclosed bush, make plenty of noise to announce your presence. Keep children between adults on the trail and have your pets leashed. Always stay away from any animal remains you encounter. An aggressive grizzly defending its kill is not something you want to experience! Should you see a bear, do not threaten it, yell at it, or run from it. Just calmly announce your presence in a conversational and friendly voice and slowly back away. This strategy has worked for me countless times. With cougars, things are different. If one attacks — an extremely rare event — you must fight it off, because it considers you dinner. I carry both bear spray and a knife handy in the unlikely event of an attack (I carry it on my hip so it is readily accessible). Don't let the very remote possibility of a deadly encounter sway you from hiking in the Rockies. With a little common sense and vigilance; you'll have no worries.

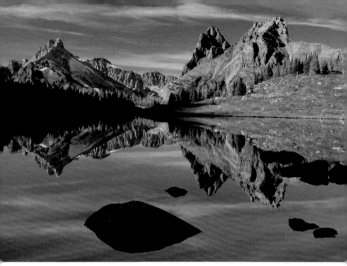

Wiwaxy Peaks and Cathedral Mountain from the Opabin Plateau (Canon EOS-1N, 20mm lens, f-22, Singh-Ray Warming Polarizer Plus, Singh-Ray 2-stop soft-edge grad, Fuji Velvia 50 slide film)

The best tip I can give you is to reduce your photography gear to the bare essentials. Hauling around a heavy camera pack will soon sap you of creative energy. I usually opt for a camera, a lightweight tripod, and a single wide-angle zoom (e.g., 24-85mm) for my hiking excursions in the Lake O'Hara area. You'll also want to be able to carry your tripod in your pack so you have free hands to scramble over the trails, especially if you attempt the Huber Ledges, All Soul's Prospect, or Yukness Ledge Alpine Routes (all three highly recommended!).

I also recommend bringing extra batteries and lots of film or digital media. It is easy to burn through the imagery here, and dead cameras and low film supplies are a common ailment to photographers at Lake O'Hara. I have seen a single roll of film bartered for a full meal of pasta, a bottle of wine, *and* the promise of doing camp dishes for the remainder of the trip. You can't imagine what fresh batteries will cost you!

The Yoho Valley Road

Where: The turnoff to the Yoho Valley Road is three kilometres east of Field.

When: The road is open from mid-June to October, and photography is good here at any time of the day.

How: Although there is interesting potential all along this 14-kilometre drive, most people are interested mainly in seeing Takakkaw Falls or in gaining access to the Yoho Valley backcountry at the end of the road. This is probably a good thing, as it is narrow and winding, with few pull-offs for roadside photography. Here are some of the highlights for photographers:

Meeting-of-the-Waters Viewpoint

Here, viewers are treated to a top-down view of the confluence of the Kicking Horse and Yoho rivers. These two white, foaming torrents rip over car-sized boulders and smash together in a steep-sided canyon.

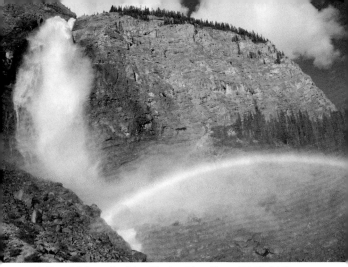

Takakkaw Falls in evening light with mist rainbow (Canon EOS-1Ds, 24-85mm lens at 30mm, 1/50 at f-13, Singh-Ray Warming Polarizer Plus)

Very impressive! Views from the river's edge are thunderous and wild, and at times dangerous. Unfortunately, the high views from the parking lot are mostly obscured by trees, but a few openings let you squeeze off shots of Cathedral Crags to the southeast (best midafternoon to sunset) and to Mount Ogden to the north (best midday to early evening).

Yoho Valley Road Switchbacks

A few kilometres past the Meeting-of-the-Waters is a three-tiered S-curve in the road, comprised of two very tight switchbacks that can cause much stress and panic among drivers encountering them for the first time. People in regular-sized vehicles don't have much problem negotiating the two 180-degree hairpin turns. But if you're in a motorhome, you'll need to be skilled at driving in reverse to negotiate through the switchbacks. At the first turn, inch your front bumper to the guardrail and then back up the road (in the appropriate lane!) to the next turn. Then inch your back bumper to the guardrail and proceed forward up the rest of the hill. The process is repeated in reverse on the way down. It's exciting to watch, especially when two motorhomes or tourist buses are working the switchbacks in opposite directions at the same time. Needless to say, trailers are not allowed on the Yoho Valley Road.

Takakkaw Falls

The main draw of the Yoho Valley is Takakkaw Falls, one of the highest waterfalls in North America. You can see the cascading water about two kilometres before you reach the parking lot, and there are a number of openings that provide good views for photography. The best of these is located about 300 metres before the turnoff sign for the Whiskey Jack hostel. On the right side of the road is a paved pull-off, perfect for framing the falls with a medium telephoto lens (e.g., 70–200mm.) This spot is good from midday to sunset.

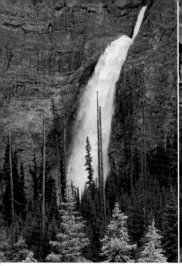
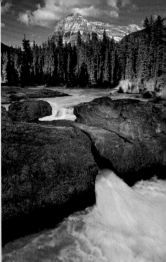

Left – Takakkaw Falls from Yoho Valley Road (Canon EOS-1Ds, 70-200mm lens at 126mm, 1/13 at f-20, Singh-Ray Warming Polarizer Plus) **Right** – The Natural Bridge at sunset, photographed from the footbridge (Mamiya 645 Pro-TL, 55mm lens, f-16, Singh-Ray 2-stop hard-edge grad, Fuji Velvia 50 slide film)

At the main parking lot, a path runs south along the Yoho River with many views to the falls. A bridge crosses the river and follows Takakkaw Creek to the foot of the falls. Although this is a busy place, it doesn't feel crowded, thanks to the many good places to shoot from. The falls face west, so they are well lit from midday to sunset. My favourite time to shoot them is in the evening, when the setting sun colours the spray at their base with rainbows. Bring lots of lens tissue, a waterproof wind-breaker, and as much patience as you can muster if you plan to chase rainbows at the base of this towering spray of water.

If you like waterfalls, then some backcountry hiking up the Yoho Valley trail will net you views of Point Lace Falls (2.7 kilometres), Laughing Falls (4.8 kilometres), and Twin Falls (8.3 kilometres). For close-up views of Emerald Glacier, an alpine meltwater lake, and stunning alpine meadows, hike the Iceline trail from the Whiskey Jack hostel to the Lake Celestine connector trail (5.6 kilometres one way). Both trails are good any time of the day. Be forewarned that these are all backcountry destinations and should be attempted by those experienced and equipped for such long and strenuous hikes.

The Emerald Lake Road

Where: 1.6 kilometres west of Field is the Emerald Lake Road junction. This 9.3-kilometre road offers several stops for roadside photography, including the Natural Bridge, located on the left side at kilometre 2.4. Also accessible from the Natural Bridge parking lot is a gravel road that runs 2.3 kilometres to a stunning picnic area amid the confluences of the Emerald, Amiskwi, and Kicking Horse Rivers. And at the end of the drive Emerald Lake itself is nestled beneath the President Range.

When: The best light at all three locations is from late afternoon to sunset, as the setting sun warmly lights the south and west facing peaks of the area.

How: The eroded limestone funnel that makes up the Natural Bridge

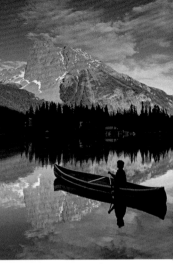

Top left – *Close-up of small, dry rock pool below the Natural Bridge (Canon EOS-1Ds, 28-70mm lens at 70mm, 0.5 seconds at f-22)* ***Bottom left*** – *Close-up of rock patterns below the Natural Bridge (Canon EOS-1Ds, 70-200mm lens at 180mm, 0.4 seconds at f-16)* ***Right*** – *Mount Burgess and Emerald Lake at sunset (Mamiya 645 Pro-TL, 45mm lens, f-16, Singh-Ray 2-stop soft-edge grad, Fuji Velvia 50 slide film)*

is most easily photographed under overcast skies, but if you visit here on sunny days between noon and early evening, the overhead sun will light the canyon evenly. For the technically adept, photography at sunrise or sunset can be a worthwhile challenge, as underlit clouds or alpenglow on the distant peaks can add flavour to the imagery. You may need to use grad filters or digital merging of highlight and shadow exposures to make these sunrise/sunset photos recordable on film or digital media.

The Natural Bridge is a popular stop, especially for tourist buses, so — unless you arrive early or late in the day — you will be sharing the area with plenty of other folks. The footbridge provides one of the best vantage points for photography, but vibrations from visitors walking on the bridge will make sharp photos with a tripod impossible. Shoot between the waves of tourists walking across the bridge.

If you want a little solitude, just cross the footbridge and head down-stream a few hundred metres to a lovely spot I call the "rock garden." A jumble of rocks, eroded channels, and chiselled pools makes abstract photography easy here. It is best visited when water levels are low (May and September), exposing more of these interesting features.

The picnic area accessible from the Natural Bridge parking area is as good at sunrise as it is at sunset, with views looking east to Mount Stephen and Mount Dennis, and south to the Ottertail Range. The road opens in mid-June; if you visit earlier than that you may need to hike to the picnic area to grab those great shots. About halfway down on the left side is a small meadow with a mineral lick. Look here for wildlife, especially moose that come to replenish their sodium levels after a winter diet of dry twigs.

The main attraction on the Emerald Lake Road is, of course, the lake. This lovely lake is best in evening light, when the low angle of the sun lights triangular-shaped Mount Burgess and rectangular-shaped Wapta Mountain.

My favourite location at Emerald Lake is the alluvial fan at the north end of the lake (a two-kilometre hike from the parking lot). Here, braided streams, stunted snags, pockets of flowers, and numerous reflecting pools bring to life a myriad of foreground possibilities. If you get here for sunrise, you will often be rewarded with alpenglow on Emerald and Michael Peak. Even at midmorning, the light at the north end of the lake is often sublime.

While you're at Emerald Lake, be sure to visit Hamilton Falls, a 700-metre hike from the south end of the Emerald Lake parking lot. This long, thin waterfall is best shot in overcast light. If you are more ambitious and want an all day, eye-popping, thigh-pumping trek, be sure to do the 20-kilometre Emerald Triangle (Yoho Pass, Burgess Highline, and Burgess Pass trails).

Leanchoil Hoodoos and Deerlodge Marsh

Where: In Yoho, the best stuff is on the hiking trail, and these two spots are no exception. The trailhead to both is located within the Hoodoo Creek campground. In the off-season, park your vehicle at the entrance to the campground and hike in. Deerlodge Marsh is a ten-minute stroll from the trailhead. The hoodoos are 3.1 kilometres away of which the last half is a steep grunt. *Note: the Hoodoo Creek area is slated to be closed during the 2005 season for forest thinning, so check at the Field Information Centre before heading here.*

When: The hoodoos are best in overcast or midafternoon light, while Deerlodge Marsh is an evening-to-sunset location.

How: Deerlodge is the historic site of the first warden cabin in the park (1904), and it is located beside a large, marshy area. The marsh provides great opportunity for reflection shots of Mount Vaux and Chancellor Peak. I have had good luck photographing waterfowl here. Waterproof footwear will ensure dry feet as you explore for foregrounds or birds along the soggy shore.

The Leanchoil Hoodoos look like giant gravel sentinels with limestone helmets, or maybe long-necked reptilian-skinned aliens with tiny heads. Wherever your imagination takes you, these fascinating forms make for interesting photography. Near the hoodoos, the trail goes two ways; the lower way takes you to views below the hoodoos, and the upper way takes in views at eye level and above the hoodoos. I prefer the upper trail, but, if you have the energy, try both for a greater variety of angles on these amazing landforms.

Wapta Falls and Wapta Marsh

Where: Five kilometres from the west gate of the park is the Wapta Falls Road. About 500 metres along on the left side is Wapta Marsh, and at kilometre 1.8 (the road's end) is the trailhead for Wapta Falls (a 2.4 kilometre hike).

When: Both the falls and the marsh are best photographed from late afternoon to sunset.

How: A polarizer is a must for this location, since the setting sun

Opposite top – Leanchoil Hoodoos from upper trail (Canon EOS-1Ds, 28-70mm lens at 55mm, 1/10 at f-11, Singh-Ray Warming Polarizer Plus)
Opposite bottom – Blue-winged Teals at Deerlodge Marsh (Canon EOS-1N, 300mm lens, f-5.6, Provia 100 slide film)

Wapta Falls and Mount Vaux (Canon EOS-1Ds, 28-70mm lens at 50mm, 1/8 at f-11, Singh-Ray Gold-n-Blue Polarizer™)

sidelights Mount Vaux and Chancellor Peak. For Wapta Marsh, water-proof footwear is handy unless you enjoy soggy feet. For Wapta Falls, bring plenty of lens tissue, as there is a tremendous amount of spray lofting off the falls. As well, if you plan to shoot at sunset, remember that the hike back to the parking lot takes about 30 to 45 minutes through fading twilight, so a flashlight and bear spray are wise insurance. In May and September, water levels are low enough that you can wander over to the treed island for head-on views of the falls. In summer, there will be less shoreline to explore because the riverbed is full of water, but the falling water will be bigger, louder, and more impressive.

Chapter 9
The Icefields Parkway

The term "drive-by shooting" might have been coined expressly for the wide shoulders of the Icefields Parkway, where you can stop almost anywhere at random and shoot memorable images. This 230-kilometre road (Highway 93 between Lake Louise and Jasper) winds alongside the eastern spine of the Rockies, skirting hanging glaciers, turquoise lakes, churning rivers, buttressed peaks, and abundant wildlife. It's enough to make a photographer dizzy with possibilities. And it's almost pointless for me to catalogue the "best spots," because everywhere is fantastic. But the beauty here is so overwhelming that first-timers often need a bit of direction to focus their efforts, so here I've listed all the iconic photography stops along the parkway, as well as a few of my own "secret" stops. Note: all distances are measured from the junction of the parkway with Highway 1, the Trans-Canada Highway, near Lake Louise. Numbers in brackets are the distances to the same place measured from the Jasper end of the parkway where Highway 93 meets Highway 16.

Herbert Lake

Where: A well-marked roadside lake and picnic area at kilometre 3.1 (226.5).

When: Best from sunrise to midmorning.

How: I love this little lake. In the mornings, its calm surface is perfect for making mirrored reflections of the imposing Bow Range to the west. Often a light mist rises from the lake, and — combined with the right light and an interesting sky — creates superlative results. In mid-June, when the days are longest, first light on the peaks arrives as early as 5 a.m., so it's no wonder I rarely see other photographers here. Even by midmorning, when the light spills across both the lake and the background peaks, most photographers are in such a rush to get to other locations (Bow Summit, Peyto Lake, and the Columbia Icefield) that few stop here to make images. That's a shame, because Herbert Lake, in my view, is one of the most picturesque lakes in the Rockies.

As you leave Herbert Lake and drive north, look for a wide curve in the parkway at about kilometre 10.3 (219.3) where Mount Hector looms over the parkway to the north, and Mount Temple sparkles in the morning light to the south. Pull over here for an opportunity to make portraits of these peaks.

Mosquito Creek

Where: Marked campground and hostel at kilometre 24 (205.6).

When: Good throughout most of the day, especially sunrise and sunset.

How: This is a good place to stay (both the campground and hostel are open year-round), because it provides quick access to the southern portion of the Icefields Parkway from Herbert Lake to Bow Summit. Besides being a good base, the area surrounding the campground is filled with photographic potential. Both the Bow River and Mosquito Creek provide nice riparian foregrounds for capturing the

Left – Herbert Lake and the Bow Range (Mamiya 645 Pro-TL, 45mm lens, f-16, Singh-Ray 2-stop soft-edge grad, Fuji Velvia 50 slide film) *Right* – Paintbrush and valerian at Molar Pass (Canon EOS-1N 28-70mm lens, f-22, Singh-Ray Warming Polarizer Plus, Fuji Velvia 50 slide film)

surrounding peaks: Bow Peak, Dolomite Peak, and Mount Hector. Spend a bit of time strolling along the banks of both streams and you'll soon find locations that suit your taste for both morning and evening shoots. It's easy to do a full day of photography here. First, capture sunrise on Bow Peak from the shores of the Bow River. Then, plan a day-hike up the Mosquito Creek trail to the alpine tundra of Molar Pass, which is 10 kilometres one way and is best in July to September. Finally, capture the golden tones of the setting sun skimming across Mount Hector or the Dolomite Peaks and reflected in the Bow River or Mosquito Creek.

Bow Lake and Bow Summit

Where: The Icefields Parkway parallels Bow Lake from kilometre 33.1 to 36.0 (193.6 to 196.5) with major pull-offs at 33.1 kilometres (signed — Crowfoot Glacier viewpoint), Bow Lake picnic area (unsigned — 34.5 kilometres) and Num-Ti-Jah Lodge turnoff (signed — 35.9 kilometres).

When: Best from sunrise to midday or evening to sunset. The lake usually does not thaw until mid-June.

How: The Crowfoot Glacier viewpoint is popular for snapping shots of the Crowfoot Glacier on Crowfoot Mountain. Every motorhome and bus coming up the parkway discharges its occupants here, so the crowd can be a bit overwhelming. For a little solitude, follow the footpath from the parking lot down to Bow Lake's meandering shore-line, which offers a mossy carpet of wildflowers, bubbling brooks and grand views to Crowfoot Mountain. This is one of my favourite spots along Bow Lake and is excellent from sunrise to midmorning.

Across the highway from the Crowfoot Glacier viewpoint is the parking lot for the Dolomite Pass/Helen Lake trail. This is one of the premier hikes in the Rockies, and is fairly easy as alpine hikes go. In the six-kilometre hike to Helen Lake, you pass through nearly four

Left – Bow Lake from the shoreline below the Crowfoot Glacier viewpoint (Mamiya 645 Pro-TL, 45mm lens, f-22, Singh-Ray Warming Polarizer Plus, Singh-Ray 2-stop soft-edge grad filter, Fuji Velvia 50 slide film) **Right** *– Fireweed below Mount Crowfoot at Bow Summit from the Num-Ti-Jah public parking area (Canon EOS-1N, 20mm lens, f-22, Singh-Ray 2-stop hard-edge grad filter)*

kilometres of wildflower-filled meadows (best in late July and early August). Wildlife photographers will love the marmots at Helen Lake; they are like fluffy dogs that just want to snuggle in your lap (well, more likely eat the crumbs you have dropped from your lunch!). Pikas, white-tailed ptarmigans, and Columbian and golden-mantled ground squirrels also frequent the area, so pack your telephoto lens along on this hike.

The Bow Lake picnic site is the other popular site for photography of Bow Lake. For simple reflection shots of Crowfoot Mountain, it's is hard to beat. However, I prefer to shoot sunrise at Bow Lake further up the highway, along the Num-Ti-Jah Road. Park at the Num-Ti-Jah public lot and wander the north shore of the lake, looking south to sidelit Crowfoot Mountain and Bow Peak. A polarizer will saturate the colours in the scene and make any clouds in the sky pop. As well, there is often a great display of magenta fireweed here in the summer and fabulous displays of fall colours in September. You can also make fine images of Num-Ti-Jah Lodge framed against Mount Jimmy Simpson.

If you want a pleasant five-kilometre hike, the Bow Glacier trail skirts farther along the north shore of Bow Lake and up to the crusty moraine at the base of Bow Glacier. This hike is good any time of day, but I like it best in the evening, to catch the sun colouring Cirque and Dolomite Peaks to the east.

Finally, between the Num-Ti-Jah Lodge turnoff and the Peyto Lake turnoff at kilometre 40.7 (188.9) is a vast willow-filled meadow on both sides of the highway that turns into a kaleidoscope of colour in September. As well, the meadows are a favourite stomping ground for grizzly bears in late May and early June and then again in autumn.

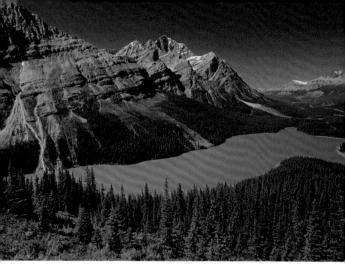

Peyto Lake in early afternoon light (Mamiya 645 Pro-TL, 45mm lens, f-16, Singh-Ray Warming Polarizer Plus, Fuji Velvia 50 slide film)

Peyto Lake

Where: Signed turnoff at kilometre 41.5 (188.1).

When: Sunrise and midday to midafternoon.

How: The aerial view of Peyto Lake from the wooden viewing platform is a Canadian Rockies icon. From the parking lot, it is a 400-metre stroll through mixed wildflowers (July and August) in a subalpine forest to the popular viewpoint. Expect big crowds, as this is always one of the busiest stops along the parkway. You can get some fun photos of people jostling to see the famed view from the platform. Fortunately, numerous footpaths skirt the open slopes of Mount Jimmy Simpson, offering many alternative (and less crowded) viewpoints for those willing to hike a short distance. Wherever there is a rock pile amongst these open views, you'll find a fat marmot waiting for its portrait to be taken, so don't forget to bring a telephoto lens with you. Otherwise, to get everything in — from Peyto Lake in the valley below to the heights of Cauldron Peak above — you'll need a wide-angle lens.

This is one of the few scenes in the parks that is best shot under brilliant midday light from around noon to 2 p.m. The sun high overhead creates toplight that highlights the textures of the steep slopes of Cauldron Peak and reflects off the glacial flour suspended in the water to give brilliant turquoise hues to Peyto Lake. If you prefer sunrise, you'll be rewarded with no crowds and orange-hued peaks above a shadowed lake.

Finally, look directly east across the parkway from the Peyto Lake turn-off for a gravel road. It leads to a meadow area that, in early summer, is a meltwater pond surrounded by blooming glacier lilies. It's a perfect spot for evening and sunset reflections of Observation Peak to the east and distant Bow Peak to the south.

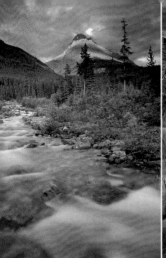
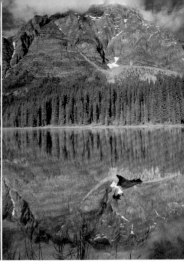

Left – Mount Weed and Silverhorn Creek at sunset (Canon EOS-1N, 20mm lens, f-22, Singh-Ray 2-stop hard-edge grad, Fuji Velvia 50 slide film) Right – Chephren Lake and Mount Chephren (Canon EOS-1N, 20mm lens, f-22, Singh-Ray Warming Polarizer Plus, Singh-Ray 1-stop hard-edge grad filter, Fuji Velvia 50 slide film)

Silverhorn Creek and Mistaya Lake

Where: A signed turnoff on the west side of the parkway to an overflow camping area at kilometre 52.0 (177.6).

When: Sunrise and midday for Mistaya Lake, evening and sunset for Silverhorn Creek.

How: This little gem is almost always passed over, From the overflow parking lot, a small footpath heads west for about one kilometre through the forest to little-seen (or photographed) Mistaya Lake. In the evening, cross the parkway and walk a short distance up Silverhorn Creek to capture the setting sun on the spine of Mount Weed, using the lacy flow of the creek as your foreground.

Waterfowl Lakes

Where: Views of both Upper and Lower Waterfowl Lakes can be had from four unsigned viewpoints and via the signed Waterfowl Lakes campground area in the stretch of highway between kilometres 56.0 and 60.0 (169.6 to 173.6).

How: The first access point to Waterfowl Lakes is from an unsigned parking area on the west side of the parkway at kilometre 56.0 (173.6). Here, trees obscure the views of upper Waterfowl Lake, so most travelers just drive on. From the parking area, it is a five-minute walk down to the shore, and photographers will be rewarded not only with grand scenery, but also with the possibilities of seeing wildlife. The lake's namesake waterfowl do frequent the area, as do black bears, and, even more often, moose. At sunrise, early risers are commonly rewarded with orange peaks rising out of mist from the lake.. As well, Upper Waterfowl Lake has a varied and visually intriguing shoreline, with plenty of reeds, rocks, and clusters of flowers available for foregrounds.

A wonderful campground on the south shore of Lower Waterfowl Lake is located at kilometre 57.5 (172.1). I recommend camping here

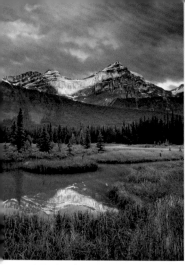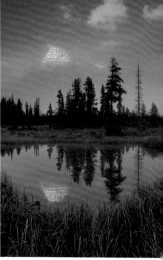

Left – Epaulette Mountain at sunrise from the Mistaya Oxbow (Mamiya 645 Pro-TL, 35mm lens, f-16, Singh-Ray Warming Polarizer Plus, Singh-Ray 2-stop hard-edge grad, Fuji Velvia 50 slide film) **Right** *– Mount Chephren rising from the mist at the Mistaya Oxbow, Mamiya 645 Pro-TL, 35mm lens, f-22, Singh-Ray Warming Polarizer Plus, Singh-Ray 3-stop soft-edge grad, Fuji Velvia 50 slide film)*

if the campsite is open (usually from late June to mid-September), but often there are temporary closures due to bear activity in the area. The campground provides easy and quick access to both Upper and Lower Waterfowl Lakes, and also to Chephren Lake (a 3.9 kilometre hike) and Cirque Lake (a 4.6 kilometre hike).

Back on the parkway, the main viewpoint for Lower Waterfowl Lake is at kilometre 58.4 (171.2). This is where most visitors snap photos of Waterfowl Lakes, but there are two smaller and less frequently used viewpoints 1.0 and 1.5 kilometres farther north. From any of these overlooks, great images can be made any time from sunrise to midmorning. Be forewarned that, about two hours after sunrise, the glass-like surface of the lake will be destroyed as breezes waft down the Mistaya Valley.

Good images can also be made from the north ends of both lakes at sunset, when the sun splashes colour onto the peaks of Mount Patterson to the south, and Mount Noyes to the east.

Mistaya Oxbow

Where: An unmarked pull-off on the west side of the parkway at kilometre 63.2 (166.4).

When: Best from sunrise to midmorning.

How: This is one of my favourite "secret spots." I rarely see anyone stopped here, except for the occasional picnicker. Since I have never seen a published photograph from this spot (except my own), it must pass under the radar of most other professional photographers. During the high water runoff in the early summer, the Mistaya River overflows, creating a small oxbow reflecting pool that sits below the highway. The light show can be fantastic here at sunrise. Epaulette Mountain, the Kaufmann Peaks, and Mount Chephren create a formidable backdrop, while this horseshoe-shaped oxbow creates plumes of mist on cool mornings to add atmosphere and mystery to the scene.

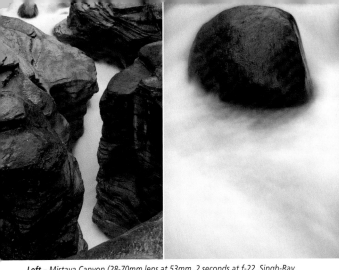

Left – *Mistaya Canyon (28-70mm lens at 53mm, 2 seconds at f-22, Singh-Ray Gold-n-Blue Polarizer™ rotated to gold)* **Right** – *Boulder in the Mistaya River (28-70mm lens at 70mm, 4 seconds at f-22, Singh-Ray A13 Warming Polarizer Plus in combination with Singh-Ray Gold-N-Blue Polarizer™)*

In mid-June, the sun kisses the peaks as early as 5 a.m., so, assuming you arrive from Waterfowl Lakes campground 5.7 kilometres south, you'll still need to drag yourself from your sleeping bag by 4:30 a.m. No wonder I never meet anyone else here!

Mistaya Canyon
Where: A signed pull-off on the west side of the parkway at kilometre 71.5 (158.1).
When: Best at sunrise or when overcast.
How: If I had to pick my favourite slot canyon in the Rockies, this would be the one. Not only is it impressive, it is unencumbered by barriers, handrails, fences, or interpretive plaques. Even on busy days, the numbers of visitors here are small relative to the canyon's more popular cousins: Marble Canyon in Kootenay, Johnston Canyon in Banff, and Maligne Canyon in Jasper.

As with most canyons, it's best to photograph here on overcast days when the light is more even and film and digital sensors can record the wide range of tones in the canyon better. Early risers can capture first light on Mount Sarbach as a backdrop to the sinuous depths of Mistaya Canyon in the foreground.

The Howse Valley
Where: Roadside turnouts on the west side of the parkway from kilometre 75.0 to 80.8 (148.8 to 154.6).
When: Sunrise to midmorning, and evening to sunset.
How: Five sites provide panoramic views of the Howse Valley. The wide bridge over the North Saskatchewan River at kilometre 75 (154.6) gives photographers not only views southwest into the Howse Valley, but also views northeast into the White Goat Wilderness Area.

North of the bridge, on the left side, there are two scenic overlooks: one at the road gates (75.9 kilometres) and one at the Howse Valley

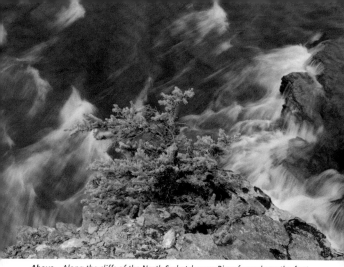

*Above – Along the cliffs of the North Saskatchewan River from above the foot-bridge on the Glacier Lake trail (Canon EOS-1Ds, 28-70mm at 65mm, 1/6 at f-22, Singh-Ray Gold-N-Blue Polarizer™) **Opposite** – Mount Amery and fireweed from the avalanche slope viewpoint (Mamiya 645 Pro-TL, 35mm lens, f-22, Singh-Ray 2-stop hard-edge grad, Fuji Velvia 50 slide film)*

picnic area (76.4 kilometres). Both of these overlooks provide 180-degree views of the peaks that arc above the Howse Valley.

A less-frequently visited viewpoint can be reached via the path from the Glacier Lake parking lot (signed at kilometre 78.0). Follow the path for about five minutes, then take the first fork to the left and follow this fork up a treeless hill to a high overlook. From here, you can make nice panoramic images of the distant peaks. Return to the main trail and continue on for another 800 metres to a long footbridge spanning the North Saskatchewan River for clear views of Mount Sarbach, Mount Amery, and Mount Wilson. If you want a wonderful overnight backpacking destination, make plans to hike to Glacier Lake (9.1 kilometres) and capture both sunset and sunrise from its shores.

Three kilometres north of the Glacier Lake parking lot is a hidden gravel road on the west side of the highway that leads to the banks of the North Saskatchewan River and good views of Mount Sarbach, Survey Peak, and Mount Erasmus.

Rampart Ponds and Graveyard Flats

Where: Unsigned viewpoints on the west side of the parkway from kilometre 90.0 to 99.8 (129.8 to 139.6).

When: Sunrise to midday, and evening to sunset.

How: This 10-kilometre stretch of road provides access to some really stunning scenery and the possibility of wildlife. Both bears and moose are regulars here, so have your telephoto lens handy. Most of the action is on the west side, where an extensive marshland is known as the Rampart Ponds. In this area, too, the North Saskatchewan River is a shifting course of braided channels along a wide alluvial fan. The reflecting pools and coursing river channels provide interesting foregrounds to frame the high peaks.

At kilometres 90, 90.7, and 91 (138.6, 138.9, 139.6), just north of Rampart Creek campground, three pull-offs provide easy access to the

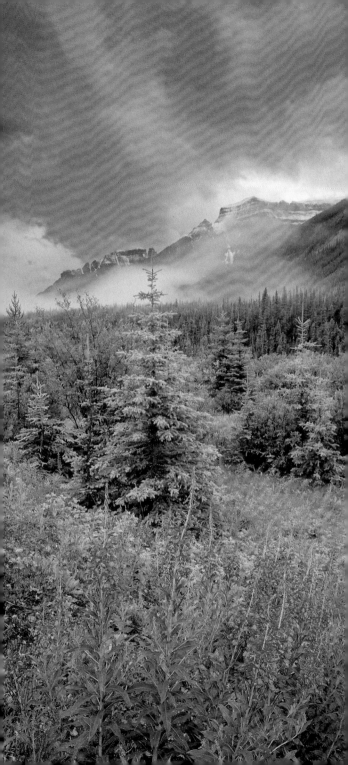

Left – Mount Amery reflected in the Rampart Ponds (Mamiya 645 Pro-TL, 55mm lens, f-22, Singh-Ray Warming Polarizer Plus, Fuji Velvia 50 slide film)
Right – The Weeping Wall (Canon EOS-1Ds, 20mm lens, 1/250 at f-5, Singh-Ray Warming Polarizer Plus)

Rampart Ponds. Here, reedy ponds, shallow pools, partly submerged rocks, and profuse wildflowers — elephant's head, paintbrush, white dryad, and willowherb — will add graphic interest to any composition. The best light is usually from sunrise to midmorning, but I have also made some wonderful images here when a cloudy sky underlights with colour from the setting sun.

Graveyard Flats, which begins at kilometre 93.5 (136.1), is an area devoid of vegetation. It's a broad plain of weathered driftwood, old bones, and endless gravel for those interested in pursuing more abstract imagery.

At kilometre 99.3 (130.3), there is an unmarked pull-off with an interpretive sign explaining avalanche slopes. There are good displays of wildflowers by late July and nice views of Mount Amery any time. Finally, the Coleman picnic area at kilometre 99.8 (129.8) offers more than just a diversionary stop for snacks. The Columbian ground squirrels and ravens that live here are very friendly and approachable, and sometimes mountain goats can be seen across the highway on the slopes of Mount Coleman.

Waterfall Alley

Where: Between kilometres 105.6 and 114.2 (115.4 to 124), there are four major waterfalls and three deep canyons.
When: Best in overcast light, but good possibilities exist at some locations all day from sunrise to sunset.
How: Okay, waterfall junkies, here you can get your fix, photographing veil-like cascades and tumultuous torrents below, alongside and atop sheer cliffs that are sure to get your stomach churning as heavily as the whitewater beneath you.

Your first stop is the Weeping Wall at kilometre 105.6 (124). From the pull-off at the side of the parkway, you can see delicate strands of water floating down the huge rock face of Cirrus Mountain. Sure, you

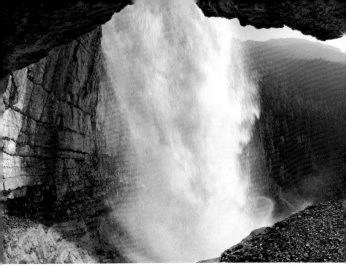

Panther Falls from hanging ledge behind the falls (Canon EOS-1Ds, 15mm fisheye lens, 1/100 at f-11)

can snag some telephoto shots from the road, but why not get right up against the wall for a bug's-eye view of the falling water? Take the short walk from the parking lot and cross the highway. For neck-breaking views of the feathery falls, forget the tripod, just lie on your back and shoot straight up! If you have a friends or family members with you, posing them against this wall and shooting straight up will make them look like serious mountain adventurers in some remote and nameless wilderness.

The Weeping Wall looks good in almost any light, but it really shines in bright sunlight (midday to sunset). I prefer the last two hours before sunset here, when the warm light on the misty falls creates multihued rainbows that float along the towering cliffs. In winter, the Weeping Wall becomes a frozen playground for ice climbers. The red and yellow jackets that adorn most ice climbers add spicy colour to the wall of blue and white ice clinging tenuously to the cliff. In late summer and fall the Weeping Wall all but dries up, so May and June are the best months for photography.

If it is overcast, be sure to stop at the Nigel Creek Bridge at kilometre 109.3 for top-down views into this gorge. Park at the north end of the bridge on the right side of the highway, just past the guardrail. Hike across the small open meadow and slide down the steep embankment into the gorge. Once here, you will have fine views up and down the canyon and access to swirling rapids, circling eddies, and plunging waterfalls. This spot is safer — and better photographically — in the late summer and fall, when water levels are lower, providing more exposed rocks for shooting platforms and as foreground subjects.

One kilometre north of the Nigel Creek Bridge is a small road on the left side of the highway; it leads to an old bridge crossing the North Saskatchewan River. There is a small parking lot here suitable for cars, trucks or vans. I have seen RVs having serious trouble trying to get out of this parking lot, so consider this a fair warning. From the old bridge, you can photograph the twisted gorge that swallows the river

Left – The Weeping Wall (Canon EOS-1Ds, 70-200mmlens at 200mm, 1/6 at f-220, Singh-Ray Warming Polarizer Plus) **Right** *– Panther Falls from the hanging ledge (Canon EOS-1Ds, 20mm lens, 1/10 at f-16, Singh-Ray Warming Polarizer Plus)*

into a deep limestone crevasse. Continue past the bridge for about 500 metres to see a long, jumbling, rambunctious cataract that tumbles down Mount Saskatchewan (good in overcast or midmorning to midday light).

Still haven't had enough of crashing waterfalls? Well, hang onto your hats, because the best is yet to come! At the top of the "Big Bend," park at the second pull-off to the north at approximately kilometre 113.2 (116.4). A sign at the viewpoint points to Bridal Veil Falls across the valley. Most visitors snap a shot of these distant falls and then happily drive on, not realizing that just below the parking lot thunders one of the highest and most impressive falls in Banff National Park: Panther Falls. Oh, prepare thyself…for this will surely be a spiritual awakening! Are you ready?

From the Bridal Veil Falls sign, proceed to the right and walk to the lower end of the parking lot. Look for a footpath that heads down the steep slope. At the first switchback, a smaller feeder trail continues straight ahead and leads to a hanging ledge, eye level with Panther Falls. With sheer cliffs above, a looming precipice below, and a wall of water thundering directly in front of you, this is one of the most exciting spots along the Icefields Parkway. The narrow hanging ledge leads you right under the falls where you can stand and photograph the distant peaks from behind a moving curtain of water. Does it get any better than this? Needless to say, this is a dangerous and scary spot, so take necessary precautions. Besides the obvious danger of slipping off the ledge and plunging head first into the canyon below, there is the possibility of loose rocks falling on you from the cliffs above. Visit at your own peril.

From the hanging ledge, return to the switchback and follow the main trail down into the canyon bottom. Walls of mist billow off the falls and drench the valley, so photography becomes a wet proposition. Bring plenty of lens tissue! If you arrive here on a sunny morning, about two to three hours after sunrise, the low sun cresting over Cirrus

Mountain will create rainbows shimmering in the mist that more than compensate for the inconvenience of wet gear.

If all this danger has you worried about visiting Panther Falls, you can still experience them more safely from above. From the upper end of the parking lot, follow the informal paths to Nigel Creek, where a left turn takes you into a shallow canyon with some marvellously twisted potholes and swirling pools — great for abstract photography in overcast light. Or turn right and follow Nigel Creek downstream, where the canyon ends abruptly and Nigel Creek plunges 180 metres down in a powerful but graceful arch to the valley below. From this high vantage point, you can photograph Nigel Creek as it disappears into a hole and then re-emerges, plunging to the rocks far below.

After the heart-thumping thrills of Panther Falls, you might need to calm yourself. One kilometre farther north on the parkway is the Nigel Pass trailhead parking lot. Park here and follow Nigel Creek

Photo Tip: Watch the Eyes!

Boreal chickadee (Canon EOS-1N, 300mm lens, fill flash, 1/60 at f-5.6. Fuji Provia 100 slide film)

As the old saying goes, "the eyes are the windows to the soul." Nothing will make a wildlife portrait come to life faster than a sharp focus on the eye. When composing animal photos, try to place the face, and especially the eye, in the frame according to the rule of thirds (see page 34, in chapter 4). We will accept an image where the rest of the animal's face or body is blurred, as long as the eye is sharp. A "sparkle" of light in the eye is also desirable to give the animal life. Waiting to shoot until you see this catch-light in the animal's eyes will really improve your photos. If the animal is in shade, is under overcast light, or is back-lit, you can use a flash to add the critical life-light to the eyes. If you set your flash to underexpose by about two stops, the flash will not overpower the natural light, but will still add a distinctive catch-light to the animal's eye.

Snow cups on the Saskatchewan Glacier (Canon EOS-1N, 300mm lens, f-22, Fuji Velvia 50 slide film)

downstream a few hundred metres to a small but visually appealing waterfall. Ah, safe and sound, a perfect place to relax and make some tranquil imagery!

Parker Ridge and Hilda Creek

Where: Kilometre 118.0 (111.6) for the Parker Ridge trailhead, and kilometre 119.1 (107.8) for the Hilda Creek hostel parking lot.

When: Any time.

How: The Parker Ridge trail (2.4 kilometres to the top) is a popular summer walk to high alpine meadows. There is no point in even attempting this hike until the ridge is snow-free (July), and the absolute best time is late July or early August, thanks to the abundant wildflowers. But be prepared for wind. If you have thoughts of spending the day shooting close-ups of alpine wildflowers, forget it, unless you are looking for "artistic" renditions with blotches of colour created by dancing flowers blowing in the breeze. Occasionally, you might get lucky with a calm day, but you'd be better off packing a windbreaker and lip balm anyway. Do lug your telephoto lens up the path with you, as you'll often see ground squirrels, pikas, ptarmigans, mountain goats and golden eagles. From the top of the ridge, you'll get aerial views of the Saskatchewan Glacier, the largest glacier in the area, nearly two kilometres wide in places. For me, the best thing about the hike is the way the climb stimulates the appetite. Be sure to pack plenty of snacks and water. That way, if we meet on the trail, you'll have some to share with me.

If it is too crowded on Parker Ridge and you want a little isolation, try Hilda Creek instead. Park at the large gravel parking area just north of the Hilda Creek hostel on the east side of the highway. From here, hike down below the parking area for good views of Hilda Peak and Mount Athabasca with Hilda Creek as a foreground (sunrise to midday light is good). Or, for evening and sunset photography, you can find good views east to Cirrus Mountain and the Brazeau Range.

Wilcox Pass, looking down the Tangle Creek Valley (Mamiya 645 Pro-TL, 45mm lens, f-22, Singh-Ray Warming Polarizer Plus, Fuji Velvia 50 slide film)

Columbia Icefield

Where: Anywhere along the highway from the Banff-Jasper park boundary (Sunwapta Pass at kilometre 122.0, or 107.6 kilometres from Jasper) to the Stutfield Glacier viewpoint at kilometre 135.8 (93.8).

When: Any time.

How: This one is easy: just cruise the parkway and images will practically yell at you to be taken. However, here are a few spots that I really like. They may also work well for you.

The Wilcox Pass trail, accessible from the Wilcox Creek campground (kilometre 124.0), is one of the premier hikes in the Rockies. It gets you up into the alpine really fast (2.5 kilometres), and provides nosebleed views of the Athabasca Glacier and the Icefield region all the way along to the height of the pass at kilometre 4.0. From there, you can meander through the high alpine pass between Nigel Peak and Mount Wilcox, ending up at Tangle Falls some eight kilometres farther down the track. But really fine images can be made in the first four kilometres. Rolling meadows filled with flowers and dotted with krummholz (dwarfed, crooked trees) provide graphic foregrounds for the backdrop of Mounts Athabasca and Andromeda and the Snow Dome. The ultimate time for landscape photography at Wilcox Pass is during the first two weeks of September, when the pass is yellow, orange and red with fall colours from the dwarf birch, alpine willow and bearberry bushes. The best light is from sunrise to midday and from evening to sunset.

Wilcox Pass is also a mecca for wildlife photographers, especially those interested in capturing full-curl bighorn rams. I have never been up the pass without seeing bighorn sheep. And the animals are so used to hikers that they are very approachable. Serious wildlife photographers make the epic trek up Wilcox Pass twice: during prime fall colours for kaleidoscopic backdrops, and in November for the annual sheep rut, in which the rams fight each other for access to ewes through a ritualized and thunderous head-butting routine. Also seen

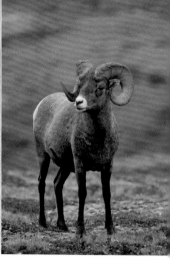

Left – Snow Dome and Athabasca Glacier from Wilcox Pass in fall (Mamiya 645 Pro-TL, 45mm lens, f-22, Singh-Ray Warming Polarizer Plus. Fuji Velvia 50 slide film) Right – Bighorn ram (Canon EOS-1N 300mm lens, Fuji Provia 100 slide film)

on the pass are mountain goats, white-tailed ptarmigans, Columbian and golden-mantled ground squirrels, marmots and pikas, so lugging a telephoto lens up the pass is definitely worth the extra sweat. I usually take two lenses: a 24-85mm zoom for scenics and a 300mm lens for wildlife. Serious wildlife shooters consider a 300mm lens to be a "wide-angle" lens, so they might balk at my suggesting such a short lens for critters. But the animals on the pass aren't skittish, and my 300mm f-4 is a very compact lens. I prefer to use my energy for photography, instead of hefting a big 600mm f-4 up the pass and risking a coronary in the process.

A road opposite the Icefield Centre at kilometre 126.5 (103.1) leads up and over a rocky moraine to the toe of Athabasca Glacier. Here you can photograph reflections of the surrounding peaks in Sunwapta Lake or hike up the footpath to walk on the glacier. Caution! For your own safety, please stay on the marked trail. If you want more ice time, and are visiting between April and October, you can take a Brewster Ice Explorer (a bus modified for glacier travel) onto the glacier. Call 1-877-423-7433 for reservations. The best photography at the Icefield is from sunrise to midday and evening to sunset.

Three roadside pull-offs north of the Icefield Centre provide further access to mountain views and wildlife viewing. These are best from midmorning to midday and again in the evening. The first is the Sunwapta Canyon viewpoint at kilometre 133.0 (96.6), a popular site to see and photograph bighorn sheep (mostly ewes and lambs), the occasional mountain goat and the ever-present ravens. The second viewpoint is Tangle Falls at kilometre 134.2 (95.4), a picturesque layered waterfall on the east side of the highway (best in overcast light). A trail from the falls climbs about four kilometres to the north end of Wilcox Pass, where you'll be rewarded with stunning alpine scenery. In the winter, Tangle Falls is a training ground for novice ice climbers. The last viewpoint in the Icefield region is the Stutfield Glacier viewpoint at kilometre 135.8 (93.8). You can also stop on the shoul-

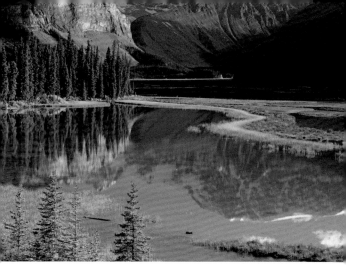

The reflecting pool near the Beauty Creek hostel (Mamiya 645 Pro-TL, 150mm lens, f-22, Singh-Ray Warming Polarizer Plus. Fuji Provia 100F slide film)

der of the highway at the bottom of the hill by the Sunwapta River for another view to the Stutfield Glacier. Grab your telephoto from either spot for nice portraits of the glacier.

Beauty Creek and Stanley Falls

Where: Kilometre 142.5 to 145.0 (84.6 to 87.1).

When: Sunrise to midmorning, evening to sunset, and overcast days.

How: If it is overcast, be sure to make the 1.4-kilometre hike up Beauty Creek Canyon with its eight tumbling cascades, finishing at photogenic Stanley Falls. The route starts from a small gravel pull-off on the east side of the highway two kilometres before reaching Beauty Creek hostel at kilometre 142.5 (87.1). Few folks hike here, so it is a pleasant diversion for quiet photography.

If it is a clear morning or a sunny evening, head a half-kilometre past the Beauty Creek hostel and look for a large reflecting pool sandwiched between the highway and the Sunwapta River on the west side of the parkway. This little pool at Beauty Creek is a Canadian Rockies photographic icon. There are no signs, no pull-offs, nor any indication that this spot has spawned thousands of amazing photographs from many different shooters. The funny thing is, I have shot here a dozen times myself, and have never met another photographer.

Quartzite Boulder Pile

Where: Kilometre 155.3 (74.3).

When: Midmorning, late afternoon, or on overcast days.

How: Pink, red, orange, and grey boulders covered with crusty lichen litter both sides of the highway from a large rockslide. For photographers with a more abstract leaning, this area provides ample opportunity to create compositions of colour, texture and pattern. A small reflecting pond on the east side of the road adds further flavour to rock abstractions. In the winter, the boulder pile becomes an

Reflecting pond at the quartzite boulder pile (Canon EOS-1Ds, 70-200mm lens at 126mm, 1/2 second at f-22)

undulating field of rounded mounds as the deep snow softens the rocks into sensuous curves.

Sunwapta Falls
Where: Signed turnoff at kilometre 175.7 (53.9).
When: Overcast days, or midday to midafternoon on sunny days.
How: I am not that keen on Sunwapta Falls. I am sure great images can be created here, but this waterfall and canyon don't excite me visually. I'd much rather hike the extra two kilometres downriver to Lower Sunwapta Falls, which is a three-tiered cascade in a twisted canyon. The lower waterfall offers more varied views and a little more solitude for focused image-making. Every time I visit Sunwapta Falls, I end up making close-ups in the forest rather than photographing the falls and canyon. But don't let my lack of enthusiasm sway you. Many photographers rave about Sunwapta Falls, so you owe it a visit to judge for yourself.

Buck, Osprey and Honeymoon Lakes
Where: Signed stops at kilometre 178 (51.6) for the Buck and Osprey Lakes trail and kilometre 179.3 (50.3) for Honeymoon Lake.
When: Midday to sunset.
How: The great thing about photography is how subjective and personal it is. A photo that moves one person might bore another to tears. The same is true for locations. One photographer I know classifies Honeymoon Lake as "one of the premier photography locations in the Canadian Rockies." That's pretty lofty praise, but it doesn't resonate with me. I think Honeymoon Lake is a nice, quaint mountain lake with pretty views east to the Endless Chain Ridge. Again, don't let my jaded views sway your opinion; you need to see the lake for yourself. There is a small campground on the shores of Honeymoon Lake, so put up your tent or park your RV and watch the evening light play across

Top left – Snow-covered boulders at the quartzite boulder pile (Canon EOS-1N, 300mm lens, Fuji Provia 100F slide film) **Bottom left** – Weathered root along the trail to Sunwapta Falls (Canon EOS-1N, Canon 100mm macro lens, f-22, Fuji Velvia 50 slide film) **Right** – Northern saw-whet owl, Honeymoon Lake (Canon EOS-1N, 300mm lens, f 8.0, fill flash, Fuji Provia 100 slide film)

the scene. Honeymoon Lake is also a good place to see moose. If you want further possibilities, follow the shoreline from the north end of the campground to the north side of the lake for good views of Mount Confederation and the Mitchell group (best in early evening light). If you get a good photo of Honeymoon Lake, send it to me and prove that nice images can be made here.

To get to Buck and Osprey Lakes, park at the trailhead at kilometre 178 (51.6). Buck Lake is only 400 metres down the trail. Osprey Lake is a bit further at 1.5 kilometres, and halfway there you will also walk by the southeast shore of Honeymoon Lake. Best light for both Buck and Osprey Lakes is midafternoon to sunset, but I usually end up making images of flowers or wildlife rather than photographing the lakes.

Mount Christie, Mount Fryatt and the Athabasca River

Where: Multiple views on the west side of the highway from kilometre 184.2 (45.4) to the Athabasca Falls turnoff at kilometre 199.2 (30.4).

When: Sunrise to midmorning.

How: Just get up at first light and drive this stretch of highway. (Stay at either Honeymoon Lake or Mount Kerkeslin campground for quick access to this area). Four major mountains — Mount Christie, Brussels Peak, Mount Fryatt, and Whirlpool Peak — provide opportunities for stunning photographs when coupled with the Athabasca River, which parallels the road here. I probably have enough pictures from this section of the parkway to publish an entire book, but, interestingly, I rarely encounter other photographers here. Either this section appeals only to me, or else other shooters are busy with better-known sunrise locations in Jasper. Two of my favourite spots are at kilometre 187.1 (42.5) and 189.5 (40.1), where 180-degree vistas open up along the river. Another great position is the elevated Athabasca River/Goat Lick viewpoint at kilometre 192.9 (36.7) — watch for mountain goats here.

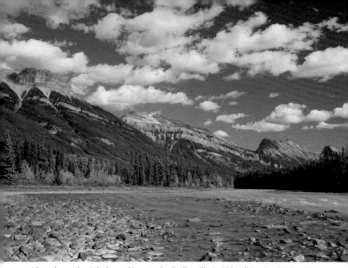

View down the Athabasca River to the Endless Chain Ridge (Mamiya 645 Pro-TL, 55mm lens, f-16, Singh-Ray Warming Polarizer Plus, Fuji Velvia 50 slide film)

And, finally, 500 metres north of the Mount Kerkeslin campground turnoff is another wide opening along the Athabasca River that looks great from sunrise to midmorning.

Athabasca Falls

Where: Signed turnoff at kilometre 199.2 (30.4).
When: Overcast days, midday, or evening to sunset.
How: Can you imagine the crowd at a Rolling Stones concert? The one at Athabasca Falls will be only slightly smaller. With my phobia of big crowds, it's a wonder I have any shots from here at all! But, by planning my visits for first thing in the morning or late in the evening, I almost always have the place to myself. Although the rushing falls and deep canyon are the major draw, I enjoy the area below the falls even more. A path to the river leads through an abandoned water channel that, itself, makes an interesting subject for photography. On sunny evenings, you can capture last light on Mount Kerkeslin with the falls as an impressive foreground. If you are more gregarious than I, or just like people-watching, plan your visit for midmorning to midday, when countless tourist buses headed for the Columbia Icefield stop for their obligatory 15-minute visit to the falls.

Horseshoe Lake

Where: Signed turnoff at kilometre 202.6 (27).
When: Any time.
How: Often you'll get more here than just mountain scenery; this is a favourite swimming and skinny-dipping hole for Jasper's boisterous youth. Photographers who don't mind the occasional flash of flesh will find a veritable visual feast waiting here. Reminiscent of the north shore of Lake Superior in Ontario, Horseshoe Lake is a gunmetal-blue body of deep water, surrounded by large slabs of slanted rock plates which are perfect to dive from. Nestled amongst the rock

cliffs are scattered lodgepole pines — some pencil-straight, some with contorted trunks — that give this lakeshore a fairy tale look. Abstract photographers will love this lake. However, it is difficult to make a classic "lake-and-mountain-peaks reflection" shot here, except from the lake's northern end, where you can photograph Mount Kerkeslin rising above the lake (best in the evening).

Photo Tip: Don't Forget the Intimate Details

Top – Strawberry leaves after a fall frost (Mamiya 645 Pro-TL, 80mm macro lens, f-16, Fuji Velvia 50 slide film) **Bottom left** *– Water drop in lupine leaves (Canon EOS-1N, 100mm macro lens, f-8, Fuji Velvia 50 slide film)* **Bottom right** *– Leaf frozen in puddle (Canon EOS-1Ds, 100mm macro lens, 0.8 seconds at f-22)*

It's easy to be entranced by the grand vistas of the Canadian Rockies. With place after place offering drop-dead views, many photographers, including myself, seem to focus only on getting "the big picture." That's a shame, because often right beneath us are intimate details that would make wonderful photographs and tell a more complete story of the Rockies, if only we took the time to look. A lone leaf frozen in a shallow puddle, a grey jay's feather resting on a bed of lodgepole pine needles, red strawberry leaves outlined in frost after a cool fall night, the tracks of a coyote in a sandbar along the river often tell us just as much as — or more than — the photos of soaring peaks over alpine lakes. So yes, make those big stunning scenery images, but also look a little closer, nose to the ground, for the intimate details to complete your Rockies story.

Photo Tip: Shoot the Highway

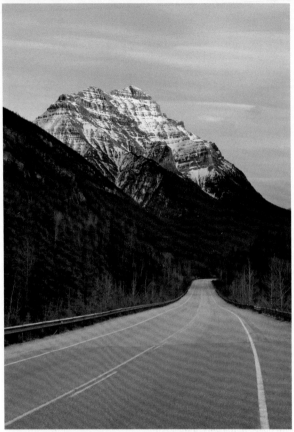

Mount Kerkeslin and the Icefields Parkway (Canon EOS-1Ds, 28-70mm lens at 65mm, 1/3 at f-16, Singh-Ray 2-stop hard-edge grad)

The Icefields Parkway is one of North America's most scenic drives. Thousands of images a day are made from the shoulders of this amazing route, yet few photographers include the highway as part of their compositions. This is surprising, since many viewers connect more with an image when there is something familiar in the photo that allows them to imagine participating in the scene. A wild landscape image showing no hand of man will resonate less with someone from Los Angeles, New York, or Tokyo than will the same scene with a winding highway curving through the foreground. Urban dwellers can easily imagine driving down such a highway and experiencing the scene if you include the road in the photo. Without the road, they have no familiar point-of-reference with which to judge your photo. For mountain photos with more universal appeal, consider including some human references such as a highway, a dock, a rowboat, a park bench, a tent or people.

Top left – Athabasca Pass viewpoint in April (Canon EOS-1Ds, 28-70mm lens 70mm, 1/13 at f-16, Singh-Ray 1-stop hard-edge grad) *Top right* – Lodgepole pine trees on the shore of Horseshoe Lake (Canon EOS-1Ds, 70-200mm lens at 70mm, 1/3 at f-22, Singh-Ray Warming Polarizer Plus) *Bottom left* – The Athabasca River below Athabasca Falls (Canon EOS-1Ds, 70-200mm lens, 1 second at f-22, Singh-Ray Warming Polarizer Plus) *Bottom right* – House wren with fresh bugs (Canon EOS-1N, 300mm lens, f-5.6, fill flash, Fuji Velvia 50 slide film)

Don't be confused by the maze of paths found here. All of them eventually lead to some part of the lake's varied, horseshoe-shaped shore. Because there are so many angles and viewpoints here, you can find something to shoot in any light, any time of the day.

Athabasca Pass and Mount Edith Cavell Viewpoints

Where: Two separate viewpoints located about 400 metres apart at kilometre 204.8 (24.8).

When: Sunrise to midday.

How: These two high standpoints give good views to the many distant peaks in the area. A telephoto lens is great here for making peak portraits, or for shooting multiple exposures across the scene to make a single, long panoramic photo. It helps if you have an RV, so you can climb up on the roof for an even better high-angle perspective.

Wabasso Lake and Valley of the Five Lakes

Where: Signed stops at kilometre 215.3 (14.3) for Wabasso trailhead, and kilometre 220.7 (8.3) for the Valley of the Five Lakes trailhead.

When: Midmorning and evening.

How: Both hikes are 2.5 kilometres long and provide nice easy walks through varied terrain. Wildlife abounds (elk, bear, muskrat, grouse, deer, and waterfowl), so be sure to bring a telephoto lens with you. The Five Lakes trail is especially popular with hikers and bikers, so solitude is not to be expected, except early and late in the day. However, this is a good place to recruit models for mountain lifestyle photography.

Kayaker at the rapids at Becker's Chalets (Canon EOS-3, 300mm lens, 1/800 at f-5.6, Kodak Supra 400 print film)

Athabasca River Bridge and Becker's Chalets

Where: Kilometre 222.0 (7.6) for the bridge and 224.3 (5.3) for Becker's Chalets.

When: Any time.

How: The Athabasca River bridge provides grand views to the north (Pyramid Mountain) and to the south (Mount Edith Cavell and Mount Kerkeslin), so it's good either at sunrise or sunset. The bridge area also serves as a launch site for canoeists, kayakers and whitewater rafters, who ultimately end up crashing through the rolling rapids that churn alongside Becker's Chalets. Park on the east side of the parkway near Becker's and head downstream about 500 metres to the biggest rapids. The best rapids occur in June, when the water levels are high. I always ask permission before I photograph anyone on the river.

Chapter 10
Jasper National Park

When asked which of the Canadian Rocky Mountain national parks is my favourite, I state with no hesitation, "Jasper National Park." At 10,800 square kilometres, Jasper is the largest of the mountain parks, and yet it receives fewer than half the visitors of Banff, so it is far more peaceful. It has a greater abundance of wildlife than Banff, is richer in opportunities for nature photographers, and, to my eyes, it is also much more scenic. Please note that a large portion of Jasper National Park has already been covered in chapter 9, the Icefields Parkway section of the book. This chapter will cover locations around the Jasper townsite, along Highway 93A, Highway 16, and up the Maligne Lake Road.

Highway 93A
Where: 7.5 kilometres south of Jasper on Highway 93 (the Icefields Parkway) is the intersection to Highway 93A.
When: Best in mornings and evenings.
How: This 24-kilometre stretch of road is a remnant of the original Banff-Jasper Highway — Jasper's version of Banff's Bow Valley Parkway. This slow, narrow, winding drive takes you through some quiet, intimate settings, past abundant wildlife — elk, moose, and deer are almost always seen — and to one of the most impressive mountain scenes in the Canadian Rockies accessible by vehicle: Mount Edith Cavell. Listed below are the specifics. All distances are from the north end of Highway 93A from its junction with Highway 93.

Marmot Basin Road — Kilometre 2.4
This 11-kilometre drive up to Marmot Basin ski area is worthwhile, especially in May and June, when black bears frequent the ditches, munching happily on spring greens.

Mount Edith Cavell Road — Kilometre 5.2
First, a warning: the 14.5-kilometre road up to the base of Mount Edith Cavell is narrow and winding, with many tight switchbacks. Moreover, it is covered with potholes, frost heaves, and broken pavement. Motorhomes and trailers are not allowed. If you prefer or need someone else to do the driving, small group tours are given daily from Jasper (ask at the visitor centre in town). One way or another, you must get yourself up that road to experience one of the most outstanding photographic destinations in the Canadian Rockies.

The classic shot of Mount Edith Cavell can be had from the footbridge at the north end of Cavell Lake from sunrise to midmorning. Park at the Astoria River/Tonquin Valley trailhead parking lot on the right side of the road, opposite the Mount Edith Cavell hostel, and walk 300 metres down to the footbridge. From here, you can wander the shoreline of Cavell Lake looking for the perfect composition.

The second favourite option for photographers is to continue to the main parking area at the end of the road, and hike a short distance on the Path of the Glacier trail (either the upper or lower loop) until a

117

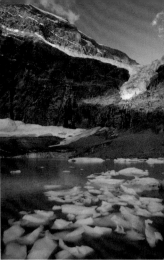

Left – Cavell Lake and Mount Edith Cavell (Mamiya 645 Pro-TL, 55mm lens, Singh-Ray 3-stop hard-edge grad, Fuji Velvia 50 slide film) **Right** – *The meltwater lake at the base of Angel Glacier and Mount Edith Cavell (Canon EOS-1Ds, 20mm lens 1/5 at f-16, Singh-Ray 3-stop soft-edge grad)*

nice foreground appears. The lower trail follows a braided stream up to a meltwater lake about 800 metres from the parking lot. The upper one loops to the same spot, but takes a higher route through a large rockslide. Either route is productive, but most photographers opt for the lower one because it is less strenuous, and because most shooters prefer flowers and moving water to a boulder field for a foreground. The majority of photographers never make it to the meltwater lake for sunrise. That's a shame, because here you can capture orange alpenglow reflected in a turquoise lake dotted with mini-icebergs from off Angel Glacier. This is truly an amazing location, with the formidable face of Mount Edith Cavell peering down from directly overhead. The only way to get the icebergs, the lake at your feet, and the glowing peak above your head into a single photo is with a wide-angle lens (20mm or wider). If you use a longer lens, you'll crop out part of the vista. Of course, you may prefer to concentrate on detail shots of the glacier, or the patterns of ice in the water, and, if so, a short telephoto zoom is perfect for this purpose.

After sunrise, it's worthwhile to hike up to Cavell Meadows; you can choose to take either a four- or an eight-kilometre loop. Your rewards are plentiful: eye-level views to Angel Glacier, meadows dotted with summer wildflowers, and tons of entertaining furry critters (pikas, marmots, chipmunks and ground squirrels).

Although most photographers consider Mount Edith Cavell a sunrise destination, great images can be made here in almost any light. Overcast light is great for intimate abstraction, flowers, and wildlife. Sunny evenings are also perfect for the play of shadow and light across the surrounding peaks, so if you are not a morning person, there's no need to fret. Just get up the road to Edith Cavell — fine images are waiting to be made any time. The Cavell Road is open from mid-June through October.

Top left – Hoary marmots, Cavell Meadows (Canon EOS-1Ds, 300mm lens, 1/125 at f-5.6) *Bottom left* – Ice formation on the Athabasca River, late October (Canon EOS-1N, 100mm macro lens, f-16, Fuji Provia 100F slide film) *Right* – Whirlpool River and Whirlpool Peak (Mamiya 645 Pro-TL, 55mm lens, Singh-Ray Gold-N-Blue Polarizer™, Singh-Ray 2-stop hard-edge grad Fuji Velvia 50 film)

Athabasca River Views — Kilometre 10.2 to 13.1

About one kilometre south of the Wabasso campground, the Athabasca River edges up to the highway, offering views downriver to Mount Hardisty and Mount Kerkeslin that look good in evening light. These views continue — sometimes obscured by trees — all the way to the Meeting of the Waters picnic area at kilometre 13.1. I find it most productive to photograph this area during low water (May, September, and October), when more of the river's shoreline is exposed for plenty of interesting close-up opportunities. I have also had good luck photographing wildlife along this stretch of the road.

Moab Lake Road — Kilometre 8.9

The seven-kilometre drive to Moab Lake feels isolated and wild, more like a back road in the Yukon than a road in a busy national park. About 3.8 kilometres along, there is a nice view down the Whirlpool River to Mount Hardisty (best from late afternoon to sunset). A 500-metre stretch starting at kilometre 4.1 provides views upstream to Whirlpool Peak. These are best from sunrise to midmorning, and at sunset in June and July. Moab Lake itself is a pretty little lake most popular with fishermen. Strong images can be made here, with the most remarkable views about ten minutes along the lakeshore trail past the boat dock. Back on 93A, immediately south of the Moab Lake Road, is the Whirlpool River bridge with views upstream to Whirlpool Peak. This is a favourite spot of mine for sunrise and sunset in summer.

Leach Lake (kilometre 19.6)

This small kettle lake with a picnic area and dock is best photographed from the road. Here, you can capture reflections of Whirlpool Peak and Mount Fryatt at first light, or at sunset in the summer months. From the picnic parking area, the mountain views disappear, but the lake has strong potential for intimate photography of its forested shoreline and sparkling waters.

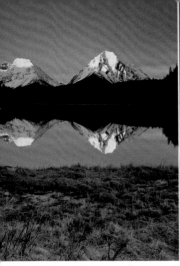

Left – Whirlpool Peak and Mount Fryatt (Mamiya 645 Pro-TL, 55mm lens, Singh-Ray Gold-N-Blue Polarizer™, Singh-Ray 3-stop hard-edge polarizer, Fuji Velvia 50 film) **Right** *– Whirlpool Peak from the third Fryatt Pond (Mamiya 645 Pro-TL, 80mm lens, Singh-Ray Warming Polarizer Plus, Singh-Ray 2-stop soft-edge grad, Fuji Velvia 50 slide film)*

Fryatt Ponds — Kilometre 20 to 22

Just south of Leach Lake are two small reflecting ponds — one on each side of the road — that offer perfect sunrise views of Whirlpool Peak and Mount Fryatt (right side), and of Mount Kerkeslin at sunset (left side). A third pond, two kilometres south of the first two, is one of my favourite "secret spots" in Jasper. This pond is a real charmer. I have spent numerous mornings here, just watching the mist rise over the bushy, cobwebbed shore and hoping that a moose would trundle into the scene for the ultimate Rockies postcard.

Geraldine Fire Road — Kilometre 23

This 5.5-kilometre road serves as a gateway to some really fine hikes into the Fryatt Valley, up to Geraldine Lookout, and into the Geraldine Lakes area. At the Fryatt Valley trailhead parking lot, roadside shooters can find several marshy ponds that make good reflecting pools for sunset photography of Mount Kerkeslin.

Athabasca Falls — Kilometre 23.7

This location is covered in the Icefields Parkway chapter (see page 93).

Jasper Park Tramway

Where: follow the Icefields Parkway (Highway 93) south from Jasper for 2.4 kilometres and turn right, onto the Whistlers campground and Jasper Tramway Road. Follow the road to the tramway parking lot.

When: The tramway runs from mid-April to mid-October; the hours of operation vary over the season, but in general the tram is open from morning to dusk.

How: This is the highest tramway in the Canadian Rockies, rising to an elevation of 2,285 metres. A trail climbs from the upper terminal to the summit of Whistlers Mountain at 2,464 metres for those

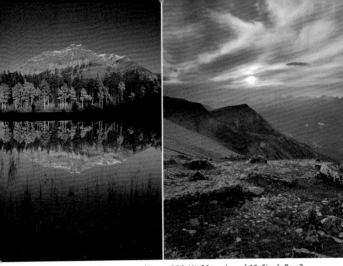

Left – Mount Kerkeslin at sunset (Canon EOS-1N, 20mm lens, f-16, Singh-Ray 3-stop soft-edge grad, Velvia 50 slide film) R ight – Sunset from Whistler Mountain (Canon EOS-1Ds, 24-85mm lens at 24mm, 1/8 at f-22, Singh-Ray 3-stop hard-edge grad)

interested in going to the very top of the mountain. Circular panoramic views, expansive alpine meadows, ptarmigans, ground squirrels, and marmots make this a special place for photography. For the best light, go up on the first tram of the day. Or, if you are not an early riser, take a tram later in the evening, to capture sunset, and return on the last tram back.

Old Fort Point and Lake Beauvert

Where: At the intersection of Connaught Drive and Hazel Avenue, turn south and cross the railway tracks. Continue past Jasper's industrial area, cross Highway 16, and then watch for the signs at the first left directing you to Old Fort Point and Lake Beauvert.

When: Best in mornings and evenings.

How: A high, bare ridge, Old Fort Point provides a promontory view of the Athabasca Valley. The route up the ridge begins from the parking lot on the right side of the road immediately past the bridge over the Athabasca River. It's a bit of a lung-burner getting to the top, but there are worthwhile rewards for photographers (mornings and evenings are best). If you don't want to hike up the ridge, the views from either side of the river near the parking lot and from the bridge are also good at sunrise and in the evenings. Lake Beauvert is just a little farther along, at the end of the road. It houses Jasper Park Lodge on the far shore, the golf course on the right shore, and a forested left shore, home to many resident elk. A path circles the lake, so photography here is good throughout the day. I like Lake Beauvert best at sunrise, with views to Pyramid Mountain from the golf course, and then again at dusk, when the warm lights of Jasper Park Lodge contrast with the blue of twilight.

Photo Tip: Heed the Boy Scout's Motto and "Be Prepared"

Timber wolf (Canon EOS-1Ds, 300mm lens, 1/80 at f-5.6)

Whenever I travel in the Canadian Rockies, I make it a habit to have my camera and telephoto lens within quick reach for roadside wildlife photography. While shooting for this book, I became a little lax in following my own advice. Once, after numerous 5 a.m. risings, I slept in until 8 a.m. to catch up on some much-needed sleep. Because it was later in the morning and I figured I had missed the best light, I left my camera packed away in the back of my camper.

Five minutes later, four furry things streaked across the road ahead of me. As I approached the spot, I noticed a cow elk swimming in the Athabasca River. Another flash of movement caught my eye and there, right below the shoulder of the highway, swimming fiercely against the raging current, was a timber wolf! Nearby, two more wolves paced the riverbank, quartering the elk as it floundered in the strong current. I thought to myself, "Should I dig out my camera gear and chance missing the action, or, even worse, scaring off the wolves? Or should I just sit and watch this rare event play out?" I chose the latter and watched for several minutes as the swimming wolf paddled heroically upstream only ten metres from my vehicle. The elk struggled, but finally reached the far shore, and the wolves gave up the chase. The wolf climbed out of the water and up the bank, and stood on the shoulder of the road, backlit in the morning sun as the steam rose from its wet fur. It was no more than five metres away from me.

"Aaargh! Why didn't I grab the camera?" I agonized. With a powerful shake that sprayed water all over the pavement, the wolf jogged over to its pack mates, and the group ran along the ditch parallel to the road. Finally, I dug out my camera, slapped on a 300mm lens and drove past the wolves. I pulled over and waited. I managed to get a single panned shot of one of the animals as it jogged by. As I sat on the side of the road, shaking with excitement, I vowed never again to leave my camera buried deep in my vehicle while driving in the Rockies.

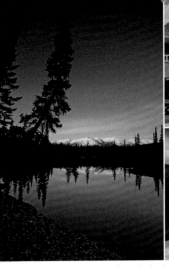

Left – The Trident Range from the backwaters of the Athabasca River near the Old Fort Point bridge (Canon EOS-1N, 20mm lens at f-11, Singh-Ray 2-stop hard-edge grad, Fuji Velvia 50 slide film) **Top right** – Connaught Street and Whistler Mountain (Canon EOS-1Ds, 24-85mm lens at 82mm, 1/30 at f-16, Singh-Ray Warming Polarizer Plus) **Bottom right** – The Trident Range at sunset from Patricia Lake (Mamiya 645 Pro-TL, 45mm lens, Singh-Ray 1-stop hard-edge grad, Fuji Velvia 50 slide film)

Connaught Drive and Patricia Street

Where: Connaught Drive is the main thoroughfare through Jasper. Patricia Street parallels Connaught Drive, but it is one block north.

When: Midmorning.

How: If you want images of the streets of Jasper with mountain backdrops, your best locations are Connaught Drive and Patricia Street. The south sides of each street provide good views to Whistler and Pyramid Mountains that look best in midmorning light. Don't forget to use a polarizer to help reduce reflections and saturate colours in the scene.

Pyramid Lake Road

Where: From Connaught Drive in Jasper, turn west on Cedar Avenue, which in two blocks becomes Pyramid Avenue and then Pyramid Lake Road.

When: Sunrise to midday, and evening to sunset.

How: Pyramid Mountain, provides the distinctive backdrop to both Patricia and Pyramid Lakes; the area is accessible from the Pyramid Lake Road. Easily the most photographed lakes in the Jasper area, these two bodies of water — along with Cottonwood Slough — are Jasper's versions of Banff's Vermilion Lakes. Every sunrise, without fail, photographers make the pilgrimage to the shores of these lakes to snap first light on Pyramid Mountain. Where is the best spot? Well, mostly that's a matter of personal preference, but here are a few worth checking out.

Cottonwood Slough — Kilometre 2.2

This is Jasper's best birding locale, and binocular-toting birders outnumber photographers here. Most photographers are not keen on the

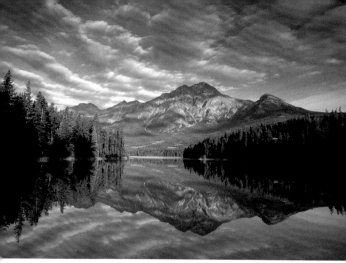

Pyramid Mountain and Pyramid Lake from the sheltered bay (Mamiya 645 Pro-TL, 45mm lens, Singh-Ray Warming Polarizer Plus, Singh-Ray 1-stop hard-edge grad, Fuji Velvia 50 slide film)

wet, marshy shoreline here. Nor do they appreciate Pyramid Mountain being partly obscured by a high rise of land to the right, so they move on to Patricia and Pyramid Lakes. However, Tim Fitzharris took one of the best photographs I have ever seen from this spot; so don't be too quick to write off Cottonwood Slough as a promising photo destination.

Patricia Lake — Kilometre 4.2

Patricia Lake is an easy favourite amongst photographers, thanks to its accessible shoreline parking; the direct, uncluttered views to Pyramid Mountain; and the famous "aspen saddle" that turns brilliant gold in the fall. There is also an official parking and picnic area that offers views southwest to the Trident Range. When this mountain range is snow-capped — in May, for example, or after an early September snowstorm — the alpenglow at dawn on these peaks can be exquisite. This same parking lot is also an entry point to the trail that skirts the northwest shore of the lake, ideal for evening views back to the Maligne and Colin Ranges to the east. Paths also lead into the "aspen saddle" for those who wish to explore this mature stand of trees or look for rutting elk in the fall.

Pyramid Lake — Kilometre 6.5

Pyramid Lake offers sandy beaches, a boat dock with rental canoes, a footbridge to an island, and rocky and forested shorelines, all perfect as strong foregrounds for the grand vista to Pyramid Mountain. If you want the famous views but a little more isolation, park at the end of the road (which parallels the lake for 1.5 kilometres) and hike along the shoreline for about 10 minutes to the lake's outlet stream, where a really nice narrow bay perfectly frames Pyramid Mountain in the background. This bay is also a great place to see loons, and it is the most sheltered spot on the lake, so it's perfect for making reflection photos, even on windy days.

Photo Tip: Try Long Exposures for Misty Effects

Top – *Stumps in the Whirlpool River (Canon EOS-1Ds, 1/80 at f-4)*
Bottom – *Stumps in the Whirlpool River (Canon EOS-1Ds 1/13 at f-22)*

If you want imagery that is ethereal and painterly, the simple solution is to lock your camera on a tripod and use long exposures with moving subjects. For example, a waterfall photographed at 1/250 of a second will have the water spray frozen in motion. The same waterfall photographed at 1/15 of a second will have the water showing up as long, veil-like streaks. With a four-second exposure, the water will look like more like mist or fog floating across the scene. How do you get these long exposures? First, stop your lens down to its smallest aperture (the biggest number, e.g., f-22). Then, screw a polarizer onto your lens to reduce further the amount of light coming into the camera. If you have a second polarizer, add it to the first one and rotate them separately until the scene almost blacks out (be sure to focus on the scene before adding the filters!). Even on sunny days, with your lens stopped down to f-22 and with two polarizers on your lens, you'll likely get exposures in the _ to two-second range with ISO 100 settings. Cloudy days will net you even longer exposure times. If you don't have a polarizer or two, you'll need to shoot the scene at dusk or twilight to get long exposure times. Remember, any moving subject will yield ethereal results. Clouds zipping across the sky will become wispy elongated streaks in long exposures. Grass blowing in the wind will become a pastel blur of colour. A solid, immovable object such as a rock, tree trunk, or mountain will provide a sharp recognizable "visual anchor" to contrast with the fluid movement of the clouds, water, or grass. Without a sharply focused still component to the photo, the moving elements will be just a wash of blur without context.

Left – *Coyote at Lake Annette (Canon EOS-1N, 300mm lens, f-8, Kodak Supra 400 print film)* *Right* – *The Maligne Lake Road and the Trident Range from near the Maligne Canyon turnoff (Mamiya 645 Pro-TL, 80mm lens, Singh-Ray Warming Polarizer Plus, Fuji Velvia 50 slide film)*

Maligne Lake Road

Where: The Maligne Lake Road begins 1.7 kilometres east of Jasper's east exit on Highway 16.

When: Any time, any light, any season.

How: The Maligne Lake Road is one of my favourite drives in the Canadian Rockies. Every time I drive these 45 kilometres into the heart of Jasper National Park, I come away with memorable images. For wildlife enthusiasts, the Maligne Lake Road is a premier destination, with strong possibilities of sighting wolves, caribou, moose, deer, coyotes, bighorn sheep, eagles and bears. I have yet to make a trip up here and not see at least one of these animals. The stunning scenery, especially at Medicine and Maligne Lakes, combined with the guarantee of wildlife sightings, makes this drive an absolute "must-do" for nature photographers.

Jasper Park Lodge and Lake Annette Road — Kilometre 0.3

Well, if you're looking for a great place to roast a weenie or to go for a swim, Lake Annette is for you. As a photographic destination, Lake Annette is too park-like and manicured for my tastes. With so many splendid "wild" lakes around Jasper, I rarely opt to visit this busy lake. However, one of the best photos of a bull elk I have ever seen was made along the sandy beaches of Lake Annette. The elk was standing next to the lake, bugling in the fog, its breath misty, its body backlit by the rising sun. The moral is that any location can be superb, given the right conditions. A trail circles Lake Annette, so good angles can be found any time of the day. Coyotes are commonly seen in the Lake Annette area. Jasper Park Lodge is at the end of the road, and if you're into golfing, luxury hotels, or fine dining, this is the place to visit.

Maligne Canyon — Kilometre 2.3 to 6.3

There are six bridges that span Maligne Canyon, starting with First Bridge at the top, and ending with Sixth Bridge, some 3.7 kilometres

Left – *Maligne Canyon (Mamiya 645 Pro-TL, 45mm lens, Singh-Ray Warming Polarizer Plus, Fuji Velvia 50 slide film)* **Right** – *The Maligne River and the Colin Range at sunset in winter (Canon EOS-1N, 20mm lens, f-22, Singh-Ray Gold-N-Blue Polarizer™, Singh-Ray 2-stop hard-edge grad, Fuji Velvia 50 slide film)*

farther down the Maligne River. You can gain access to the Maligne Canyon trail from three signed parking areas: Sixth Bridge, Fifth Bridge, or First Bridge (the main parking lot). Most photographers prefer the section starting at First Bridge and continuing downstream to Fourth Bridge. The canyon is most impressive in this section, thanks to the many potholes, deep depressions, and narrow passageways here. Overcast days provide the best light for shooting into the depths of the canyon, but it will still be necessary to use a tripod for the long exposures required. Fifth Bridge is popular in winter as a starting point for the famous "Canyon Crawl," where adventurous visitors shimmy up the frozen Maligne River and into the depths of Maligne Canyon. Reminiscent of an Arizona slot canyon, only full of hanging snow and ice, the Maligne Canyon in winter is a photo opportunity not to be missed. Sixth Bridge is well below the canyon, but provides good views northwest for sunset views of silhouetted peaks and underlit clouds along the Athabasca River.

The Big Hill — Kilometre 10.6

A high hill offers views directly west to the Queen Elizabeth and Maligne Ranges. In winter, this is a great place to photograph snow-frosted trees. During cool summer mornings, ground fog often lingers here in the valley, creating wonderful mood and atmosphere for stunning photography. For safety, use the vehicle pull-off on the right side about 200 metres farther down the hill. About 100 metres past the parking pull-off, a bridge spans a deep gorge. In winter, you can hike down to the mouth of the gorge and follow the frozen water upstream for your own private "canyon crawl." Road bikers from Jasper love the Maligne Lake Road for training, and the Big Hill is a favourite spot for them.

Maligne River Picnic Site — Kilometre 14.8

This is a premier photo stop in the winter. The Maligne River runs

The shoreline views from below the Medicine Lake picnic area (Mamiya 645 Pro-TL, 55mm lens, f-11, Singh-Ray 3-stop hard-edge grad, Fuji Velvia 50 slide film)

though snow-capped boulders like cobblestones, which are perfect for making interesting abstractions or for use as a foreground to frame sunset on the tail of the Colin Range. In summer, the shallow water flowing over the rocks makes a perfect home for the American dipper, a slate-grey, robin-sized bird that uses it wings to "fly" underwater in pursuit of aquatic insects. The bobbing and dipping of this boisterous bird is entertaining, but photographing the bird as it bounces and flits around is sure to frustrate even the most patient photographer.

Medicine Lake — Kilometre 21.1 to 28.0

The road runs alongside Medicine Lake for nearly seven kilometres, and good images can be had anywhere along this stretch. Be sure to watch for the herd of bighorn sheep that seem to hang out perpetually in this area. As far as landscape photography is concerned, I prefer the Medicine Lake picnic area at kilometre 21.1 for its grand vistas. A path leads from the parking area down along the boulder-strewn west end of the lake. The views up the lake to the Queen Elizabeth and Maligne Ranges are beautiful from early evening to sunset.

Be aware that water levels at Medicine Lake fluctuate widely over the seasons. During the summer, water fills the basin, making the lake look large and grand. In fall, winter, and early spring, the lake is reduced to a plain of mud or snow with a small coursing of water meandering through its middle. Be sure to have your telephoto lens handy, as I have often seen wolves and caribou wandering across the flood plains of Medicine Lake, especially during the fall and winter.

At kilometre 29.2 there is a pull-off on the right-hand side. Park here and walk back down the road about 100 metres for a fine view of Medicine Lake looking northwest to the Victoria Cross Range. This spot is really nice at sunrise for first light on the distant peaks. I also like it here at sunset in the fall, when the last light of the day colours the sky and the braided channels of Medicine Lake, creating brilliant contrasts of blue and orange.

Maligne River —Kilometre 35.0

Though there are many spots where the Maligne River edges up to the road, this one is by far my favourite. The river lines up with the Maligne Range in the background, making a postcard-perfect scene from sunrise to midmorning. The forest along the edge of the river is one of my favourite places to explore the intimate life provided by the flora of the forest floor. Mushrooms, lichens, mosses, orchids, berries, and shrubs all make fine subjects for close-up and detail shots.

Maligne Lake — Kilometre 44.0 to 45.3

I have probably exposed more frames of this lake than I have of most of the other lakes in the Canadian Rockies combined. I love this 22-kilometre-long lake. I find the peaks surrounding the lake particularly striking, the long views mesmerizing, and the whole ambience of the lake peaceful (in spite of the large crowds that sometimes gather here).

Photo Tip: The Overlooked Critters

Crab spider with grey fly (Canon EOS-1N, 100mm macro lens, f-8, Fuji RDP100 slide film)

With Jasper National Park being so well populated by "glamorous" wildlife like wolves, bears, caribou, and elk, it is easy to overlook the little animals. All around us — sometimes right at our feet — there are small creatures acting out the drama of survival on a smaller stage. On calm mornings, a favourite pastime of mine is to amble through a meadow, inspecting flowers and leaves for signs of "creepy-crawlers." Spiders, beetles, ants, moths, slugs, and worms all make interesting subjects for nature photographers. It is easy to get lost for hours at a time in pursuit of wildlife photos on the smaller scale. Once, I discovered a crab spider on a white flower. It was a yellow spider camouflaged in the yellow centre of the flower, waiting for some unsuspecting insect to fly in for a meal of nectar or pollen. I set up my camera and tripod and focused on the flower. I waited…and waited…and waited some more. Finally, after nearly two hours of waiting, a fly landed on the flower, and "snap", the spider had its meal, and "snap", I had my photo.

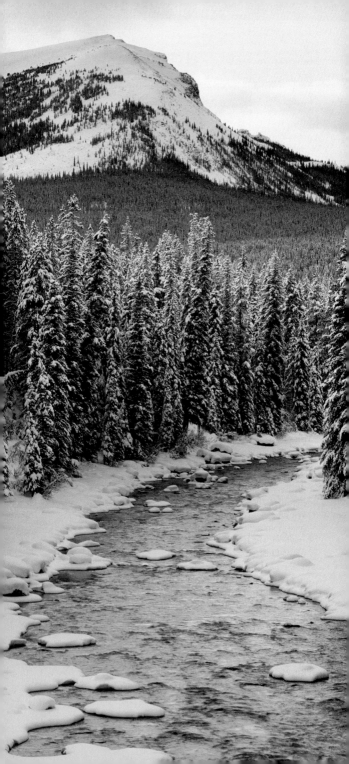

Opposite – Maligne River in winter (Mamiya 645 Pro-TL, 80mm macro lens, f-16, Singh-Ray Gold-N-Blue Polarizer™, Singh-Ray 2-stop hard-edge grad, Fuji Velvia 50 slide film) **Left** – Forest flora, Maligne River (Mamiya 645 Pro-TL, 80mm macro lens, f-22, Velvia 50 slide film) **Right** – Maligne Lake from the Maligne Lake Bridge (Canon EOS-1N, 20mm lens, f-11, Singh-Ray Warming Polarizer Plus, Singh-Ray 2-stop soft-edge grad, Fuji Velvia 50 slide film)

The good news for photographers who cherish sleep is that Maligne Lake is an evening-to-sunset photo destination. Some of my favourite spots for photography are the views towards the boathouse from the shoreline near the Maligne Lake Chalet; the view towards the Maligne River from the bridge crossing the lake's outlet; and the view from the shoreline near the public boat launch at the end of the road.

In winter, rising mist from the open water at the mouth of the Maligne River covers the shoreline trees with a sugar-coating of hoar-frost, allowing for superb photography. In my opinion, there is no finer winter photography destination than the bridge at the outlet of Maligne Lake.

One of the most famous views of Maligne Lake, Spirit Island, is only accessible by boat. Scenic boat tours depart regularly from the Maligne Lake Chalet. Or you can rent a canoe from the boathouse if you're into a three-hour paddle (one way) to Spirit Island. No wonder almost everyone takes the boat tour. The problem with the tour, though, is that you must jostle with other folks for prime real estate once you reach the lakeside platforms that offer views to Spirit Island. What's worse, you usually only have a short 10-15 minutes off the boat to make images. Sometimes you can convince boat operators to let you stay at Spirit Island and catch the next boat back, leaving you with ample time alone to compose the perfect photo. The best light for capturing Spirit Island is from late afternoon to early evening.

Highway 16 East

Where: The entire 46.3-kilometre section of Highway 16 from the junction of the Maligne Lake Road east to the Jasper Park Gates is full of excellent photo opportunities.

When: Any time, any light, any season.

How: Highway 16 travels through broad meadows; alongside the rocky and sandy shoreline of the Athabasca River; and past large lakes, mud

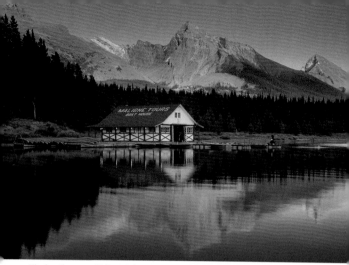

The boathouse at Maligne Lake at sunset (Mamiya 645 Pro-TL, 45mm lens, f-11, Singh-Ray 2-stop hard-edge grad, Fuji Velvia 50 slide film)

flats, windblown sand dunes, sulphur springs, rocky outcrops, and abundant wildlife. Most of the photographers I know just cruise up and down this section of highway in the mornings or evenings, stopping whenever the scenery or wildlife inspires. Listed below are a few sites that consistently provide good opportunities to photographers. All distances are from measured from the Maligne Lake Road junction at the west end of the highway.

The Colin Range and the Athabasca River — Kilometres 1.7 to 6.7

Three roadside pull-offs on the right side of the highway provide safe parking for exploration of the shores of the Athabasca River and views to the Colin Range. My favourite is the Colin Range-Athabasca viewpoint at kilometre 4.3, which provides a high perch over the Athabasca River. If you walk back along the highway about 500 metres from here, you'll discover a small pond on the east side that is a perfect reflecting pool for capturing evening light spilling across the Colin Range. I also like the Palisades picnic site at kilometre 6.7 for its foreground views of open meadows and scattered trees.

Celestine Lake Road — Kilometre 7.8

This is the place for curmudgeons and antisocial photographers. Here, you can escape the crowds and explore the seldom-visited west side of Jasper Lake while travelling along a high plateau of rolling montane grassland. The first five kilometres are paved. Along the way, you'll drive through a large stand of mature aspen that's excellent for elk and fall colours. You'll also pass by a marshy area (on both sides of the road) that is good for morning and evening scenics. At the Snaring River campground, a bridge provides east-west views along the Snaring River, good at sunrise and sunset. Past the campground, the road turns to gravel and travels past Moberly's Cabin (a historic monument) where you can photograph a partially restored cabin and a gravesite. Behind the cabin are extensive wetlands that are perfect

Left – Colin Range from Palisades picnic site (Mamiya 645 Pro-TL, 45mm lens, f-16, Singh-Ray 2-stop hard-edge grad, Fuji Reala 100 print film) **Top right** *– Aspen forest by Celestine Lake Road (Mamiya 645 Pro-TL, 80mm lens, f-22, Fuji Velvia 50 slide film)* **Bottom right** *– Colin Range reflected in pond (Canon EOS-1N, 20mm lens, f-22, Singh-Ray Warming Polarizer Plus, Fuji Velvia 50 slide film)*

for making sunset images of Hawk Mountain, Morro Peak and Mount Colin. Farther down the road, at about kilometre 14, is a controlled-access point open to one-way traffic with inbound and outbound travel reserved for specific times of the day. You may travel into the Celestine Lake area during these hours: 8-9, 11-12, 2-3, and 5-6 (day or night). Outbound travel is restricted to 9:30-10:30, 12:30-1:30, 3:30-4:30, and 6:30-7:30 (day or night).

Past the access point, the road is narrow, and often rough: it's only suitable for cars, light trucks, and vans. Vehicles with trailers and RVs are not allowed. When conditions are dry, two-wheel-drive vehicles will have no problem, but if it has been raining or snowing travel is not recommended. The road has a primitive, wild feel to it. In one section you must drive through a stream, and in another section, you hang precariously over a steep cliff at a sharp curve. Driving the Celestine Lake Road is worth the experience alone; fine photography is just the icing on the cake. But chances are good that you will make photos here, as the high grasslands look great in morning or evening light, and sheep, coyotes, deer, elk, ruffed and spruce grouse are often seen along the way. Grassland wildflowers like harebell, shooting stars, and old man's whiskers are also common. The road ends at a parking lot about five minutes' walk from the Snake Indian River. To get to pretty Celestine and Princess lakes, it is a 6.7-kilometre hike. These two lakes are best as an overnight backpacking destination, because both lakes look best in morning light. Black bears are numerous and frequently sighted along the trail to these lakes, especially in May and June, so be "bear aware."

Snaring River and the Athabasca Flats (Kilometres 7.8 to 12.8)

Back on Highway 16, between the Celestine Lake Road and the Snaring River bridge, there is abundant opportunity for both landscape photography and wildlife photography. On the east side, at kilometre 8.4, there is an unmarked gravel road that leads you through an

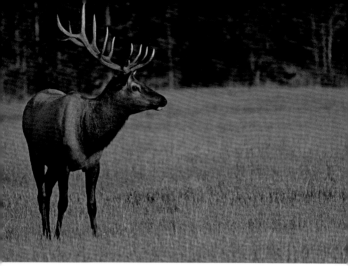

Bull elk, Athabasca Flats (Canon EOS-1N, 300mm lens, f-5.6, Velvia 50 slide film)

expanse of open meadows to the shores of the Athabasca River. This quiet spot is the perfect place to look for elk, deer, and coyotes. Nice views await landscape photographers, whether across the meadow to the DeSmet Range or across the river to the Colin Range. For folks who like to shoot outdoor recreation imagery, the numerous riverside trails here are perfect for mountain biking and hiking photos.

Farther up the highway, at kilometre 12.0, look across the railway tracks for a large, unnamed pond that seldom sees any visitors. I like shooting here either in the mornings or in the evenings, when low light skims across the lake, lighting the distant peaks in warm tones. Back on the highway from this roadside stop, look to the east. In the summer, when the water is high, the Athabasca River forms a wide bay here, while wind-blown dunes make a sandy shore, perfect for morning or evening views looking north.

Athabasca River Bridge and Moberly Flats — Kilometre 16.2 to 18.2

This two-kilometre stretch is one of the best places for landscape photography along Highway 16. The Athabasca River and several marshy ponds on the left side of the road provide nice foregrounds to frame Gargoyle, Esplanade, and Chetamon Mountains to the west (best from sunrise to midday). The parking area on the right just past the Athabasca River bridge provides access to the Overlander trail that follows the west side of the Athabasca River for 15.6 kilometres, ending at Sixth Bridge at Maligne Canyon. The first two kilometres of this trail are stunning, winding through slanted bare rocky outcrops, around stunted, gnarled trees, and over high dry montane meadows. Best light is from late afternoon to sunset. Mountain bikers, hikers, and climbers love it here, so you may be able to do some action photography as an added bonus.

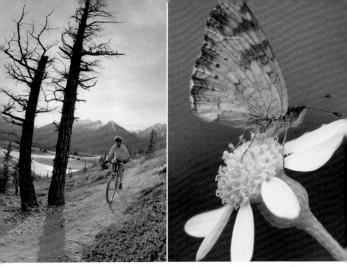

Left – Mountain biking along the Overlander trail (Canon EOS-1N, 15mm fisheye lens, f-8, fill flash, Kodak Supra 100 print film) *Right* – Butterfly in meadow area near Jasper Lake (Canon EOS-1N, 100mm macro lens, f-8, Fuji Velvia 50 slide film)

Edna and Jasper Lake — Kilometre 21.3 to 22.3

The highway is sandwiched here between Edna Lake on the east and Jasper Lake on the west. Jasper Lake is often a mudflat during spring, fall, and winter. Even in the summer, when water fills the basin, the lake is very shallow, making it a favourite wading spot for tourists wanting to cool off from the summer heat. Good images can be made here throughout the day, thanks to 180-degree views north and south across the lake. It's best in mornings and evenings.

Talbot Lake — Kilometre 24.1 to 28.6

Highway 16 follows a long natural sand dune dike paralleled by Talbot Lake to the east and Jasper Lake, mostly hidden by high sand dunes, to the west. Because you're on the western shore of Talbot Lake, the best light is from midafternoon to sunset, when the setting sun lights the western-facing peaks. I also like Talbot Lake at sunrise when it silhouettes the Miette Range to the northeast against a colourful twilight sky. There are almost always big bull elk hanging out on this narrow strip of land. Wildlife shooters often flock here, especially in late September when the elk are in prime physical form, sporting big antlers, healthy coats, and ornery attitudes. Don't get too close! Park regulations suggest you stay three bus-lengths away from wildlife.

At the southern edge of the lake, at kilometre 24.1, there is a small parking lot with a path that leads to Cinquefoil Bluff, a high grassy knoll perfect for making panoramic images of the Talbot Lake area. This is also a good spot to photograph bighorn sheep away from the busy highway. Four other roadside pull-offs are available along the five-kilometre shoreline of Talbot Lake. Each one has its own charm and attributes. My favourite one is at kilometre 27.9, about 800 metres north of the Talbot Lake picnic area. I like the reedy foreground here that leads to views across the lake towards the Miette Range.

Above – Talbot Lake (Canon EOS-1N, 20mm lens, f-16, Singh-Ray Gold-N-Blue Polarizer™, Singh-Ray 1-stop hard-edge grad, Velvia 100F slide film)
Opposite – The Glory Hole (Mamiya 645 Pro-TL, 35mm lens, f-16, Singh-Ray 2-stop soft-edge grad, Fuji Velvia 50 slide film)

The Glory Hole and Rocky River (kilometre 30.3 to 34.1)

Famed Canadian photographer Daryl Benson named this little spring on the east side of the road (kilometre 30.3) the "Glory Hole," because it consistently yields great photos at sunrise. Even when the rest of the park is cloudy, some light always seems to filter through here, colouring the clouds and casting beams of light over the rising mist of the little pond. It's as if some photo god has blessed this spot with eternal magical light. Every time I visit here at sunrise, I am rewarded with memorable photos. As an added bonus, the water in the Glory Hole stays ice-free all winter, so it's a perfect winter destination for snowy reflection images. The Glory Hole also works well at sunset, when the Miette Range turns orange from the light of the setting sun.

Two forks of the Rocky River cross the highway, one at kilometre 31.1 and the other at kilometre 34.1. Both of these crossings are worthwhile stops for landscape photography during mornings and evenings. A forest fire burned down the Rocky River Valley in 2003, with some of the burn coming right to the edge of the road. Over the next few years, this will be the place to come if you're looking for carpets of wildflowers blooming amongst the standing skeletons of charred trees.

De Smet Range Viewpoint and Disaster Point Animal Lick (kilometre 34.1 to 34.9)

For 180-degree panoramic views along the Athabasca River, the De Smet viewpoint on the west side of the highway at kilometre 34.1 is the place to stop. Best light is from sunrise to midafternoon. Up the road 800 metres, on the right side, is a parking area where bighorn sheep and mountain goats love to hang out, replenishing their sodium reserves from a natural mineral lick. Although Disaster Point was named for a number of disasters that befell horses in the early exploring days, I think it is more appropriately named for the disasters that regularly befall the wild animals that get struck by speeding motorists here. A hike up Syncline Ridge is worthwhile for lofty views up and

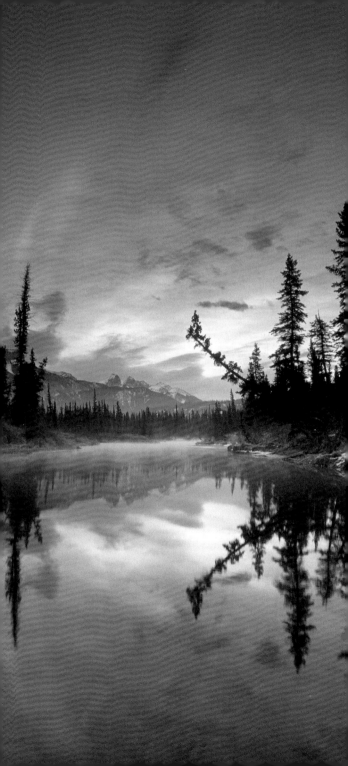

Top left – Bighorn ram along Highway 16 at Disaster Point (Canon EOS-1N, 300mm lens, f-5.6, Fuji Velvia 50 slide film) **Bottom left** – Pocahontas Ponds (Mamiya 645 Pro-TL, 55mm lens, f-16, Singh-Ray Warming Polarizer Plus, Fuji Provia 100F slide film) *Right* – The Fiddle River and the Boule Range (Canon EOS-1Ds, 20mm lens, 1/2 at f-22, Singh-Ray 2-stop hard-edge grad)

down the Athabasca Valley and for good photo opportunities with the bighorn sheep away from the side of the road.

Pocahontas Ponds — Kilometre 38.8

A vast wetland on the west side of the highway gives fine views of the Bosche and De Smet ranges for photography from sunrise to midafternoon. Waterfowl are abundant, and wildlife photographers will enjoy the challenge of getting close enough to the birds for frame-filling portraits. Herons, grebes, ducks, geese, and blackbirds are residents here in the summer.

Fiddle River Bridge — Kilometre 45.6

Here the Fiddle River runs north with big views to the Boule and Bosche ranges — perfect for afternoon to sunset photography. Just wander down along either side of the river looking for pools of water, interesting rock formations, or clusters of flowers to include in your foreground.

Miette Hot Springs Road

Where: 45.3 kilometres east of the west exit to Jasper, or 7.1 kilometres west of the Jasper Park gate on Highway 16.

When: Best in the mornings and evenings and under overcast skies.

How: The Miette Hot Springs Road, although scenic, is not conducive to photography, because the narrow, winding road has few pull-offs. It simply isn't safe to pull over and do photography here, except at these four locations:

Jasper Park Collieries

The first parking area on the right, 150 metres up the road, deposits you near the site of an abandoned coal mine. A one-kilometre paved pathway loops around a large meadow encircled by aspen trees and

Left – Punchbowl Falls (Canon EOS-1Ds, 24-85mm lens at 64mm, 1/2 second at f-11, Singh-Ray Warming Polarizer Plus) *Right* – Sulphur Creek (Canon EOS-1Ds, 24-85mm lens at 28mm, 1/2 at f-22, Singh-Ray Warming Polarizer Plus, Singh-Ray 2-stop hard-edge grad)

relics of old mine buildings. The wide views across the meadow are best in late September, when the aspen are decked out in their fall finery. The mine structures are overgrown with vegetation and are best photographed under cloudy skies.

Punchbowl Falls
There is a well-signed pull-off at kilometre 1.3, right above Punchbowl Falls. The footbridge over Mountain Creek perches right over the lip of the falls, offering photographers an aerial view down the falls. To get an eye-level view, you'll need to pass over or under the fenced barricade and follow the narrow path in the steep shale to a small natural shelf where you can stand to make pictures safely. This site is best in overcast light, the shaded light of early morning, or late evening.

Ashlar Ridge
A high viewpoint over the Fiddle River Canyon provides a striking view to Ashlar Ridge that is best photographed at midday and in the evening.

Miette Hot Springs
The hot springs will appeal to those interested in soaking in the warmest springs in the Canadian Rockies. For photographers not interested in steaming wet tourists, an 800-metre paved pathway at the end of the parking lot leads to the source of the hot springs on Sulphur Creek. Delicate wildflowers, tumbling waterfalls, misty springs, and the decaying remnants of the original hot springs "aqua court" can entertain keen photographers for hours. The best photography here is when the canyon is in shaded light (early mornings and late evenings) or under overcast skies. As an added bonus, bighorn sheep hang out in the hot springs parking lot, just waiting to have their portraits taken.

Index

Index

The Camera Store

Get the picture

The Camera Store
is proud to support
Darwin Wiggett's
**How to Photograph
the Canadian Rockies.**

We are Canada's premier
supplier of yesterday's, today's
and tomorrow's
photographic products.

The Camera Store
802 - 11th Ave SW, Calgary, AB, Canada, T2R 0E5

Ph: (403) 234-9935 Toll Free: 1-888-539-9397

Darwin trusts
The Camera Store to fulfill
all his photographic needs.

Please visit us in Calgary
or call toll free
1-888-539-9397
or visit
us on the web at
www.thecamerastore.com

About the Author

Darwin Wiggett is a full-time photographer whose specialties are Canadian landscapes, kids, animals, and outdoor recreation. His work has appeared in hundreds of publications including *Outside, Nature's Best, Geo, National Geographic Traveler, Outdoor Photographer,* and *Photo Life.* Darwin's work is marketed and sold around the world through various stock photo agencies. He is well known for his instructional articles on photography published in both print and online magazines. His past experience as a university biology instructor serves him well in teaching the sometimes arcane details of nature and outdoor photography. He and his wife, Anita Dammer, own and operate Natural Moments Photography (www.darwinwiggett.com).

Darwin's exceptional mountain photography is published by Altitude Publishing in large format in *Dances with Light: The Canadian Rockies.* (ISBN 1-55153-230-1)

Cirque Peak and wildflower meadows near Helen Lake (Canon EOS-1N, 20mm, f-22, Singh-Ray Warming Polarizer Plus, Singh-Ray 2-stop soft-edge grad filter, Fuji Velvia 50 slide film)